REMBRANDT

Michael Kitson

Phaidon Press Limited
Regent's Wharf, All Saints Street, London N1 9PA

First published 1969
Reprinted 1971, 1974, 1978
Second edition, revised and enlarged, 1982
Third edition, further revised, 1992
Reprinted 1993 (twice), 1994, 1998
© Phaidon Press 1992

A CIP catalogue record of this book is available from the
British Library

ISBN 0 7148 2743 6

Printed in Singapore

Cover illustrations:
(front) *Portrait of the Artist Jacques de Gheyn,* 1632 (Plate 8).
(back) *The Jewish Bride* (Plate 47).

REMBRANDT

Preface to the third edition

In the light mainly of the judgements in *A Corpus of Rembrandt Paintings* (by J. Bruyn and others, The Hague, Boston and London, 1982-), of which three volumes have so far been published, covering the period to 1642, ten of the forty-eight colour plates are new to this edition of the present book. I should particularly like to thank Christopher Brown of the National Gallery, London, for guiding me through the thickets of current Rembrandt research, not least for the artist's years after 1642. Martin Royalton-Kisch of the Department of Prints and Drawings, British Museum, kindly did the same for the smaller number of drawings illustrated. In addition, I am grateful to Lord Faringdon and Sir Brinsley Ford for their help in enabling a colour plate of the *Portrait probably of Pieter Six* (Plate 27) to be included, and to Douglas Smith of the Paul Mellon Centre for taking the transparency.

The introductory text, on the other hand, remains substantially as it was written for the first edition in 1969. This is not because I am unaware of the recent, more historically-based approach to Rembrandt's career and work or that I necessarily disagree with it. The stimulating book by Svetlana Alpers, *Rembrandt's Enterprise* (Chicago and London, 1988) seems to me especially valuable in this connection, although I think that, given the religious sensibility of Rembrandt's time, she takes too narrowly materialistic a view of the artist's motivation. It would have been impossible, however, to do justice to the views of Alpers and others without entirely re-writing my text, and this I felt unable to do. The introduction may therefore strike readers of the 1990s as something of a period piece. I hope, nevertheless, that it says a few things that are still worth saying.

Michael Kitson
October 1991

Rembrandt

When we stand in the Rembrandt room of a major picture gallery, what visual impressions do we receive there and how do they differ from the impressions we receive from the works of other artists in the same gallery?

To begin with, we notice dark backgrounds broken by irregular patches of light. There is more darkness than light, and the light does not often extend as far as the frame. Instead, it lies in or near the centre, where it sets off the darkness and holds most of our attention. Usually there are both blacks and whites in the picture, the blacks occurring in a robe or hat, the whites in a collar, cuffs or else in a headcloth or shirt front. The frames are also sometimes black. Black and white represent colours – the only unmodified colours in the picture – but they also register as extremes of light and dark tones.

Otherwise the paintings are rich in colour but it is not pure or evenly applied colour; nor is the composition divided into fields of discrete colours as in Renaissance or modern painting. Even in Rembrandt's early works the colours are broken and changing, like a brocade woven with gold or silver threads or like the glowing embers of a fire. In the highlights and deepest shadows the colours almost disappear. In the middle tones they deepen and become more intense in one of two directions: either towards red (vermilion or madder lake) or towards greenish-gold. It is typical of Rembrandt that he uses these colours as alternatives, not together, so that red and green seldom appear in combination. Except in some of his earliest works he generally avoids colour contrasts and complementaries and prefers colours close to each other in the spectrum. Brown, orange or yellow are mixed with or appear beside red; yellow or dull green accompany and merge into greenish-gold. Grey is also used with his two main colours. Blues, violets, pinks and bright greens, on the other hand, occur only in pale tints and in subordinate positions. His early paintings are generally cool in colour, his mature and late ones warm, with red predominating. Like the strongest lights, the strongest colours are confined to only a comparatively small part of the picture. The effect is of a surge of colour coming from within the form rather than of colour decorating the surface, defining the form's shape.

The backgrounds are also of no single colour but are made up of dull browns, greens and greys, usually blended together but in the late works sometimes laid on side by side. Unlike the backgrounds of some Italian baroque painters, Rembrandt's are never flat or opaque but are filled with atmosphere and penetrated by reflected light. (Only uncleaned paintings by Rembrandt give an impression of solid dark brown in the shadows.) These subdued background colours register as tones. Tone, or rather chiaroscuro (light and shade), is the basis of Rembrandt's art. Colour, however important and beautiful, is contingent. It may be quite strong or very restrained; some paintings are almost monochromatic, and a few are executed in grisaille (brownish grey). But whatever its strength, colour is an adjunct. The scheme of the composition is established by the chiaroscuro. Colour is applied in some parts, where it attracts the eye and heightens the emotional tension, but not in others. Only in certain late works does colour become a semi-independent medium and even predominate (Plate 42). Elsewhere it is integrated with the chiaroscuro. Chiaroscuro is the principal means both of 'keeping together the overall harmony' (as Rembrandt's earliest biographer, Sandrart, put it) and of creating a poetic mood; it is also a source of aesthetic pleasure and of luminous and striking effects in its own right. Rembrandt's mastery of chiaroscuro, in all its degrees

from the darkest darks to the strongest lights, has been acknowledged ever since his own time.

In composition, Rembrandt's paintings are essentially simple and stable and are built up from the edges towards the centre. Secondary lights, colours and forms are subordinated to primary ones. Rembrandt does not divide up the design into distinct self-contained units or distribute the interest among different areas of the picture. Visually the design obeys a principle of hierarchy. Except in his earliest works there is no sense of overcrowding or strain. Movement continues to be represented for some years afterwards (during his 'baroque' period in the 1630s) but then it too largely disappears. At all stages of his development his figures possess great authority and presence. They are set against a background which is vague and neutral enough not to compete with them yet which is everywhere visually interesting. Thus the background forms part of the design; it is not a mere backcloth. It also serves both to relax the tension which exists at and near the centre of the composition and to effect a smooth transition from the imagined world of the main action or figure to the real world of the spectator.

Elegance, *contrapposto*, the harmony and balance of parts – those foundations on which the beautiful rests in Renaissance painting – are conspicuous by their absence. Except in Rembrandt's most baroque paintings there are no swinging lines and few three-dimensional curves or forms leading the eye into depth. He sometimes borrows from, but is never dependent upon, conventional formulas of the ideal and the beautiful. He uses flat, often rather fastidious and simple shapes lying parallel to the picture surface, especially in his late period, but not graceful, sweeping contours or variations of the S-curve common to mannerist, baroque and rococo painters. When he does introduce a curving or flowing line he interrupts its rhythm with some irregular twist or sudden change in pace. Generally speaking, flowing lines are weak in Rembrandt; jagged or straight lines are strong and energetic. In some of his late works he builds up a pattern of rectangles and triangles, and occasionally a large circle or disc appears in the background (Plate 44). After the early years of his career, in keeping with his unwillingness to use a stressed contour, he tends to avoid figures and faces in profile. He prefers to contain the most interesting visual effects *within* the contour of the form, as in *The Jewish Bride* (Plate 47), in which the man's right hand and both the woman's form a pattern of hands in the centre of the composition.

To an unusual degree Rembrandt's art – not only in his portraits but also in his subject pictures – is dominated by faces; few of them are handsome and many of the most remarkable are old. Their watchful eyes are indistinct and often in shadow except for a line of light along the lids. His faces are always expressive and habitually tense. An urge to communicate thought, feeling and experience is imprinted on them. Although partly shadowed, they are seen in close-up, as if the artist were peering at them and they were returning his gaze. From the works of few other artists do we get such a sense of watching and of being watched. It is not an accident that about two-thirds of Rembrandt's paintings are portraits (including more than twenty of himself). Most of the rest in our hypothetical Rembrandt room will be scenes or figures from the Bible. In addition, there will probably be a mythological scene, a landscape and perhaps a genre scene or still life. The paintings are likely to vary greatly in size and to range from the very small to the very large.

Permeating all Rembrandt's works of whatever category and size is an air of solemnity and mystery. He is not a frivolous or merely sensuous artist, nor does he delight in beauty of colour or brushwork for their own sake. When colour and brushwork are beautiful, as they often are, they are so for expressive rather than decorative reasons. Moreover, the solemn and the mysterious are attributes of Rembrandt's style, not merely of his attitude to the subject-matter. To veil forms, textures and colours, leaving something for the imagination to fill in, is central to his method. A tone, a background, suggests more than it states; the eye can only trace out its implications so far. The world of Rembrandt's paintings is certainly as imaginary as that of any classicizing painter working in an ideal style: he seldom takes us into the open air or reconstructs a real interior. Yet, unlike the world of most imaginative painters, his is not raised above nature; it appears to us rather as an intensified version of

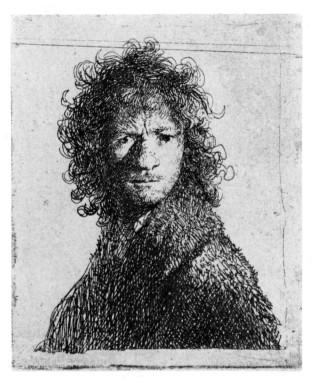

Fig. 1
Self-Portrait
1630. Etching, 7.2 x 6.1 cm
British Museum, London

nature's essential reality. Rembrandt reverses the normal procedure of idealiz-ing artists. Whereas they transform the essence of things and leave a reminder of nature in the details, he preserves reality in the essence and clothes its outward forms with a mysterious beauty and suggestiveness.

It is useful to begin thus by recalling some of the visual characteristics of Rembrandt's paintings, because for over a hundred years the praise of Rembrandt was often less aesthetic than moral – though there has been some reaction against this recently. Until about two decades ago his work was treated as the product not so much of a visual artist as of an inspired Protestant saint. The emphasis fell on his possession of qualities of character: dedication, humanity, compassion, spiritual and psychological insight, courage to ignore fashion and to refuse to flatter patrons, above all, unswerving devotion to 'the truth' – the truth about himself, his sitters and the events and characters of the Bible. These qualities were instinctively appealing. Integrity and indepen-dence of spirit in artists were perceived to be the highest good. Nor is it intrinsically an error to see Rembrandt in this light, although it is possible to exaggerate the extent to which he possessed some of the virtues attributed to him. Nevertheless, it is important to be aware of what happened. That is to say, we should realize that much of the Romantic and post-Romantic tendency of Rembrandt appreciation was due to developments in art criticism since his time and that what was seen in his work may not have been either apparent to his contemporaries or present in the consciousness of Rembrandt himself. For some reason Rembrandt is particularly susceptible to this type of retrospective interpretation. It may be partly because contemporary information about his *art* is very hard to obtain, whereas his personality – and hence by unconscious inference his mind – is deceptively accessible, through documents relating to his life, through his self-portraits, through his portraits of his family, and so on. But whatever the reason, the result was to divert attention from Rembrandt the artist to Rembrandt the man. Thus there emerged a sentimental cult of Rembrandt, which was not by any means confined to popular or old-fashioned literature; this cult presented us with Rembrandt the home-lover, the paragon of virtue, and the sage.

It is not easy to tell how far the post-Romantic Rembrandt, even without the sentimental distortions, was the invention, and how far the discovery, of later critics. It would be as foolish to ignore the insights of the past hundred and fifty years as it would be to accept them without question. What is certain is that they were made possible by a radical shift in the methods of criticism which began in the Romantic period. The practice of previous critics had been to assess the qualities of a work of art by examining the work itself; the new tendency was to look beyond the work and to seek for the key to its qualities in the artist's mind. The significance of this development for the understand-ing of Rembrandt is so great that it is worth discussing it a little further.

Until the Romantics, works of art had been assessed with reference to more or less objective criteria. They were judged by whether they were beautiful or ugly, true or false to nature, and whether or not they were executed in accor-dance with certain rules. They were examined piecemeal, under the headings of drawing, colour, composition etc. With the coming of Romanticism, stan-dards became at once more comprehensive and more subjective. Sincerity was used as a criterion of artistic judgement for the first time and new kinds of truth were brought into the argument. Was the artist true to his own inner vision and experience; that is, was he sincere? Did he, as Goethe once expressed it, 'love what he painted and paint only what he loved'? Was he true not just to the letter but to the spirit of his subject-matter? In this way the critical interest was shifted from the work of art to the artist's total vision.

As a result of these developments, what had previously been regarded as faults or at best limitations in Rembrandt came to be considered merits. His 'low' subjects and interest in and association with the poor, the old and the Jews, which had been condemned as undignified, now marked him out as the champion of the downtrodden and the oppressed; hence the concept of Rembrandt's compassion emerged. His broad brushwork and disregard of the rules of proportion and anatomy, which had been thought ignorant and eccen-tric, were now interpreted as a refusal to sacrifice his convictions for the sake of easy fame; hence arose the idea of Rembrandt's integrity. His common,

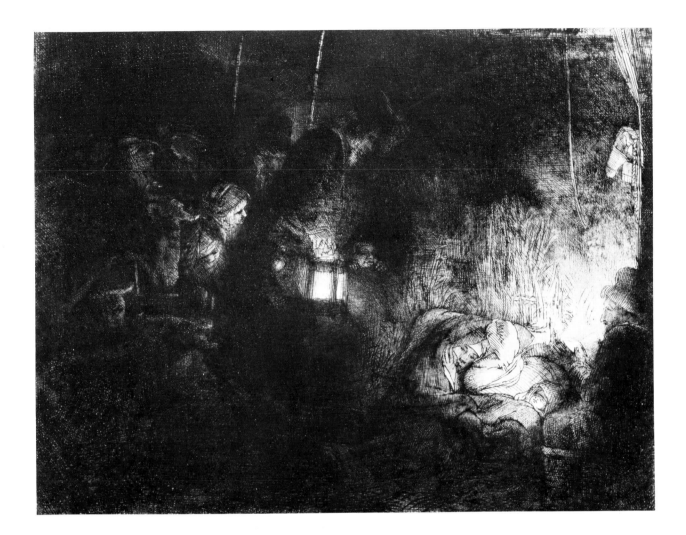

Fig. 2
The Adoration of the
Shepherds
c.1656. Etching,
14.9 x 19.6 cm.
British Museum, London

naturalistic style, once thought fit only for comic and vulgar subjects, was now felt to be better suited to scenes from the Bible than the ideal style of the Italians, since those scenes took place in humble surroundings and were enacted by humble people; hence came the discovery of Rembrandt's spiritual insight and regard for truth.

The question of the special appropriateness of Rembrandt's style for religious subject-matter is of particular interest, as it has played so large a part in modern criticism and in forming the popular image of Rembrandt even today. Probably the first to discuss this point was Goethe, in the essay from which the phrase quoted above was taken (*Nach Falkonet und über Falkonet*, 1776). This essay already contains, in essence, everything that has been said on the subject since, and says it with a moderation not always found in later writings. Rembrandt is seen as having created a new form of religious art, as valid in its way as Raphael's was in another way. Indeed, his style, in Goethe's view, had the advantage over Italian Renaissance painting in being truer to the spirit of the Bible, and hence of being fresher and more capable of communicating the Christian message with an appropriate directness and force.

'When Rembrandt represents his Madonna and Child as a Dutch peasant woman, it is easy for every educated gentleman to see that this is historically inaccurate, since we are told that Christ was born in Bethlehem of Judaea. The Italians did it better! he says. And how, please? – did Raphael paint anything other, anything more, than a loving mother with her first-born and only son? and what else could have been made of the subject? Has not mother-love in its joys and sorrows been a fruitful subject for poets and painters in all ages? But all the Bible stories have been deprived of their simplicity and truth by cold grandeur and stiff ecclesiastical propriety, and have thus been withdrawn from sympathetic hearts in order to dazzle the gaping eyes of the stupid. Does not Mary sit between the

scrolls of every altar-frame, before the shepherds, as if she were displaying her Child for money, or as if she had rested for four weeks after her confinement so as to prepare with the vanity of a lady for the honour of this visit? Now that's decent! that's proper! that doesn't fly in the face of history!

How does Rembrandt treat this subject (the late etching of the *Adoration of the Shepherds*, Fig. 2)? He places us in a dark stable; necessity has driven the mother, the Child at her breast, to share a bed with the cattle. They are both wrapped to the neck in straw and rags, and everything is dark outside the glow from a small lamp which shines on the father, who sits there with a small book and appears to read Mary a prayer. At this moment the shepherds enter. The foremost of them, who advances with a stable-lantern, peers, taking off his cap, into the straw. Was it possible more clearly to express the question: "Is this the new-born King of the Jews?"'

The key to this passage lies in the change of tone at the beginning of the second paragraph. No one before had described a composition by Rembrandt so literally and so sympathetically or had so well caught its spirit of simple humility. Here for the first time Rembrandt is presented as the painter of and for the human heart.

As has already been said, these considerations are not irrelevant or invalid. There is no doubt that Rembrandt did introduce a new kind of religious art, based on a literal rather than symbolic interpretation of the Bible. What is more, whoever looks at his work, and not only at his religious paintings but also at his portraits and even landscapes, cannot help seeing it as a moral as well as an aesthetic achievement. But while this is true, it is a method of approach to Rembrandt which lies in the background of this essay, whose purpose is, rather, to return to an older tradition of criticism and to discuss his paintings as works of art. Its theme is Rembrandt the artist. We see a painting of *The Holy Family with Angels* (Plate 22). It strikes us as simultaneously domestic and sacred, lively and serene, intimate and deeply moving. How were the tones, colours and brushmarks disposed to produce these results? This is the type of question that will chiefly concern us.

Rembrandt as an Artist

Although little information relating to Rembrandt's art (as distinct from his life) has come down to us, such as it is it is not negligible and is worth briefly recalling. It appears chiefly in the following sources: the three earliest biographies of the artist, by Sandrart (1675), Baldinucci (1686) and Houbraken (1718); the journal of Constantyn Huygens (who visited Rembrandt and his colleague Lievens in Leyden in or about 1629); a small group of letters to Huygens from Rembrandt; the inventory of his collection of works of art (comprising works both by himself and by and after other artists), weapons and curios, drawn up at his declaration of insolvency in 1656; and, last but not least, his own work. By this is meant, not his work in its entirety, but those aspects of it, particularly drawings and etchings, which reveal the personal background to his activity as a painter. This is not the place to examine these sources in detail, as the information contained in them is often indirect and would require lengthy interpretation, but some general points emerge which are worth discussing in relation to Rembrandt's practice.

Not unnaturally, the three early biographers of Rembrandt judged him by the standards of their own time. They were by no means insensitive to his qualities and they found him to be an artist of extraordinary power. They praised his colour and chiaroscuro and Houbraken particularly stressed the variety and vividness of the poses of his figures and their facial expressions and gestures. On the other hand, they criticized him for being weak in drawing and for neglecting the classical rules of proportion and anatomy, especially in his treatment of the nude. His paintings were believed to be unfinished owing to their broad brushwork and heavy impasto, and he was scarcely mentioned as a painter of religious subjects; rather, he was regarded (at least by Sandrart) as a

genre painter who mostly chose subjects to please himself from the everyday life around him.

In regarding Rembrandt in this way the biographers were applying the standards of ideal art. Nowadays it is generally agreed that where Rembrandt is concerned these standards are largely irrelevant. However, this does not mean that his attitude to them was one of simple rejection, still less that he was unaware of them. Even though he never visited Italy he had ample opportunity to study Italian paintings, drawings and engravings in collections and at auction sales in Amsterdam (as he told Huygens); he could follow the example of those of his predecessors, including his teacher Lastman, who had been to Italy; and he could read, in Dutch, Van Mander's long 'Didactic Poem' on painting, published in Haarlem in 1604 together with his *Lives of the Artists*, in which the theory of ideal art was expounded. Up to a point, in fact, this theory – sometimes called the 'classical-idealist' theory of art because of its roots in classical antiquity – must have furnished the aesthetic assumptions on which Rembrandt's own art was based, if only because there was no other articulated body of theory available, not merely in Dutch but in any European language. Two of its principles in particular apply: the doctrine of the superiority of history painting over all other genres, and the importance of illustrating a subject and depicting the emotions appropriate to it by means of gestures and facial expressions. As to the first, it should be remembered that, despite the biographers, Rembrandt was a 'history painter' hardly less than Raphael or Rubens, although of a very different kind. His works, like theirs, were scenes from sacred history and (less often) classical history and mythology – imaginative in conception, moral in content and serious in mood. So anxious was he from the first to succeed in this branch of art that he never painted a commissioned portrait in his Leyden years. It is further evident that, although there was no demand in Holland for paintings to decorate churches, Rembrandt's religious pictures, and still more his etchings, often found buyers among private collectors.

Rembrandt's interest in the illustration of the subject and the rendering of emotion is even more significant. Overtly and dramatically in his early period, more subtly in his middle and later years, Rembrandt was one of the great story-tellers in art. This did not mean only that he chose a promising situation or narrative and depicted it clearly, but also that he extracted the utmost emotional significance from it. His earliest self-portraits (see Fig. 1) are exercises in expression, and in his subject pictures throughout his career he showed feelings – in faces and in the way people stood or sat and used their hands – with a vividness and variety unsurpassed in painting. Rembrandt's skill in this art was noticed early in his career by Huygens as well as some time after his death by Houbraken. It was also the subject of the one revealing comment on art in Rembrandt's own letters, which are otherwise predominantly about money. Describing to Huygens (12 January 1639) *The Entombment* (Fig. 14) and *The Resurrection of Christ*, which he had just completed for Prince Frederick-Henry, Rembrandt states that in these two pictures he had represented 'the greatest and most natural movement' (*die meeste ende die naetureelste beweechgelickheyt*). There is some doubt whether the last word in this phrase should be translated as movement or emotion; in fact it probably implies both (there is a similar double meaning in the English word 'moving'), since mobility of poses, faces and gestures was the normal means by which emotion was expressed. In this way the phrase would be applicable not only to *The Resurrection*, in which there is a great deal of violent physical movement, but also to the outwardly calmer though equally emotional *Entombment*. It is an interesting coincidence that in the same year, Poussin was writing in the same sense (but at much greater length) to his patron, Chantelou, about the depiction of emotions in his *Gathering of Manna*.

However, Rembrandt's awareness of the theory of ideal art and his acceptance of two of its most widely known principles did not mean that he was deeply interested in this theory or that he adhered to it uncritically. Although he probably had a number of aesthetic maxims which he was fond of repeating to his pupils (who in turn passed them on in garbled form to the authors of the early biographies), it is unlikely that he possessed any fully-fledged artistic theory. And in some important respects he positively rejected the principles of

ideal art. According to both Sandrart and Hoogstraten, he laid particular stress on the imitation of nature, even going so far as to state that 'the artist should be guided by nature and by no other rules'. This, if true, would have been a direct contradiction of classical principles, according to which artists should use the rules and the example of the art of the past as a means of 'correcting' nature. Furthermore, Rembrandt was not concerned with the doctrine of decorum, that is, the matching of style to subject-matter. Nor was he committed to following the Antique, or Raphael, or the classical doctrine of ideal beauty, although he made use of all three on occasions and although his collection of works of art contained many examples of classical sculpture, either in the original or in casts, and several complete sets of engravings after Raphael. Whenever he referred to these sources in his work or painted a nude or a figure in some classical attitude, he produced a free adaptation. Even if only slightly, he undermined the system of ideal art at the point where it was most vulnerable: in its rule of internal consistency. He would interrupt the flow of a form with a quirk of realism, thicken (say) the proportion of the legs in relation to the rest of the body, or make the weight of the figure greater than its form would lead one to expect. And he did all this, unlike his Flemish and Dutch predecessors who had only half understood the classical rules, without sacrificing the organic unity of the figure or of the painting as a whole.

In his early period one can see Rembrandt almost satirizing the Antique. He represents the youthful Ganymede abducted by the eagle as a yelling, urinating baby. Two or three years earlier he had produced a black chalk drawing of a Rubensian *Diana*, in which he made the arms and legs thinner, the flesh flabbier and the face more innocent than Rubens would have done. He subsequently used this drawing as the basis of an etching, removing the bow and quiver of Diana, adding still more creases to the flesh and turning the result into a harshly realistic study of a naked young woman. The object of these exercises was surely to strike a blow against art and on behalf of nature, and hence on behalf of artistic freedom. But Rembrandt's assault on the classical rules of art was also a means of understanding them. Out of that understanding grew the *Danaë* in St Petersburg (Fig. 3), Rembrandt's nearest approach to a traditional classical nude. But by the standards of Titian or Raphael even this is imperfect; the head and hands are too large, the facial expression is too eager and one breast is pressed awkwardly out of shape by its position against the left hand. After these early experiments, Rembrandt's confrontation with classicism was never so direct or so highly charged; he never came so close either to accepting it, as in the *Danaë*, or to rejecting it completely, as in the *Ganymede*. In his later work, his attitude towards it is subtle, unexpected and oblique.

Freedom is the keynote of Rembrandt's relationship not only to the classical ideal but to other styles and traditions of art as well. What has just been said about his attitude to the Antique and the theory of ideal art could also be applied to his artistic relationships with Dürer, Leonardo and Titian (who is perhaps the artist with whom his affinity is closest, although the resemblances between his late work and that of the Venetian may be due to coincidence). Moving nearer to Rembrandt's own country and time, there are similar analogies to be found with the work of Elsheimer, Rubens and Seghers. Rembrandt's use of all these, and other, sources was selective and flexible. We have seen one example of the way in which his flexibility showed itself: his treatment of the classical nude. But his freedom of approach had many more consequences than this. He could paint 'high' subject-matter in a 'low' style (thus breaking the classical rule of decorum). He could combine the beautiful and the ugly, the majestic and the ordinary and, most important of all, the supernatural and the real. While accepting the obligation enjoined by classical art-theory to represent emotion in his figures, he succeeded in evolving a new, naturalistic method of doing it. It was a method quite different from that originally devised by Italian Renaissance artists, which elsewhere in Europe during his lifetime was hardening into a formula. As will be seen later, Rembrandt's method was in effect no method, but an apparently direct depiction of the feelings experienced by a figure, a result which he achieved as much by relying on the surrounding context and by means of the

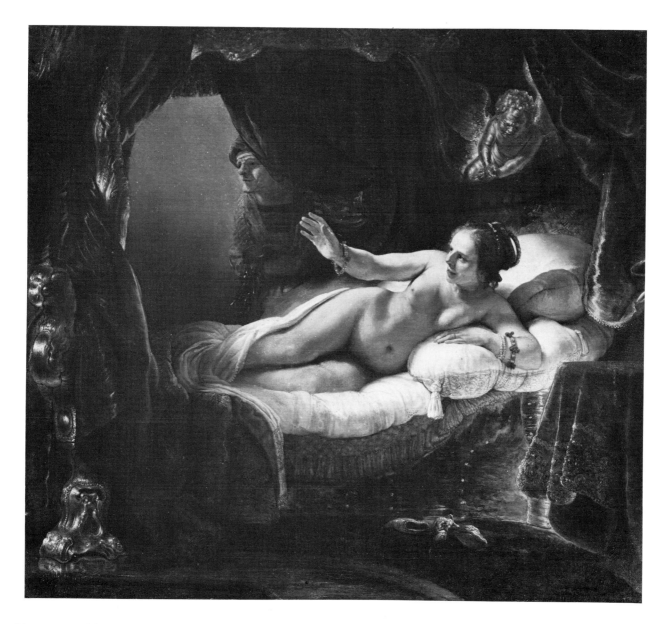

chiaroscuro and brushwork as by using movements of the facial muscles or gestures with the hands.

Furthermore, Rembrandt (though in this he was like several other Dutch artists) ignored the convention, which was inherent in the theory of ideal art, according to which the different categories of painting should be kept distinct from one another. With him, religious subjects may be treated like genre scenes (see Plate 1); portraits may merge in one direction into paintings of saints or mythological characters (Plate 10), in another direction into studies of anonymous models (Plate 31). However, there was one distinction which Rembrandt did maintain: that between subjects appropriate to paintings and those he regarded as suitable only for drawings (his etchings characteristically occupy a middle position between these two). Whereas his drawings include many genre scenes (Fig. 23), genre figures (Fig. 20) and landscapes studied from nature (Figs. 6 and 24), his paintings on the whole do not. As a painter, Rembrandt was concerned with men and women as human and spiritual beings, and to have shown them in his paintings in the passing context of their day-to-day environment and activities, as he did in his drawings, would have detracted from that concern. Thus, after a few early experiments, he abandoned the painting of genre scenes and transferred the element of genre into the representation of domestic scenes from the Old and New Testaments. Nor was this merely a nominal transposition, for the whole character of the subject is subtly altered, not just its outward details. In these paintings, a common Dutch pictorial form – the genre scene – and a deeply rooted social

Fig. 3
Danaë
Signed 'Rembrandt
f.16(3)6'. (reworked later,
before 1643.) Canvas,
185 x 203 cm.
Hermitage, St Petersburg

preoccupation – the home – are given a heightened poetic significance by their treatment as a religious subject.

It would be possible to see this characteristic in Rembrandt as a kind of idealism, and hence as the expression of an attitude similar to that which underlay the theory of ideal art. Nor would this necessarily be wrong, and Rembrandt's perception of everyday people, objects and events in a quasi-religious or moral light would have been in keeping with the Protestant sensibility of The Netherlands at the time. Moreover, this attitude is reflected not only in Rembrandt's assimilation of everyday subject-matter to religious art, but also in his treatment of the painted single figure which was neither a portrait nor a character from the Bible or classical mythology. It is customary in catalogues and convenient for purposes of discussion to classify these figures as 'genre studies'. But this is precisely what they are not, for they lack that distinguishing feature of genre, namely the element of anecdote and the hint, however slight, of activity. Rembrandt's single figures do nothing but think. To call such figures as *A Girl leaning on a Stone Pedestal* (Plate 21) or the *Two Africans* (Plate 40) genre studies is to diminish their significance.

There is also something else. Just as these paintings have a more profound content than other Dutch paintings of single figures, so they have a less explicit *subject*. It is impossible to attach an allegorical label to them, like one of the Five Senses or *Vanitas*, any more than they can be called figures drinking, playing music, reading a letter or trying on a pearl necklace, for they do none of these things. Their lack of subject in the ordinary meaning of the term may be reflected in Sandrart's report that Rembrandt painted subjects 'that are ordinary and without significance, subjects that pleased him and were picturesque (schilderachtig), as the people of The Netherlands say.' As a critical comment this is misleading, as it implies that Rembrandt was motivated by that idle curiosity which produces genre, yet the absence of an identifiable subject in these paintings was sufficiently remarkable for Sandrart to think it worth recording. It may even be the case that some of Rembrandt's paintings in which the figure is dressed in an exotic costume may belong to this category. These figures are usually interpreted nowadays as characters from the Bible, but Rembrandt may not have intended anything so specific, at least when he conceived the figure, although he may have attached a name to it afterwards. Perhaps even the famous and mysterious *Polish Rider* (Plate 33), over which modern scholars have speculated endlessly in an attempt to find a title that would fit it, is a painting of this type. Be that as it may, Rembrandt's development of the single-figure study with no explicit subject as a serious independent art form was not the least of his contributions to the future of European painting.

The Subject Pictures

The term 'subject pictures' here covers paintings, whether of religious or mythological themes, in which a situation or story is represented. In this section we shall be concerned with the way Rembrandt developed his style and technique in these pictures, which of their nature usually contain two or more figures. The problems of the single figure, which have already been touched on, will be discussed further in the next section, under portraits.

Rembrandt's earliest subject pictures (Plates 1 and 2) are small, crowded and highly finished. They are designed to be examined minutely at close range. In style and often in subject they depend on his teacher, Lastman (Fig. 4); they also contain echoes, transmitted through Lastman, of the intense, exotic art of Elsheimer. Their subjects tend to be taken from some minor episode in the Bible or from ancient history, which lent itself to the narrative treatment characteristic of other contemporary Dutch artists. As paintings they are primitive and awkward. Their forms are lumpy, their poses complicated, and each figure seems to have been studied on its own, to be joined to the others afterwards. Hands gesticulate, eyes are beady and mouths drawn down. The flesh even of quite young figures appears to be shrivelled up like a wizened apple. There is often a figure in the foreground in shadow seen from the back. It is evident that, like many young artists,

Fig. 4
Pieter Lastman:
Tobit and Tobias
kneeling before the
Angel
Signed 'P. Lastman
f. 1618'. Panel, 63 x 92 cm.
Statens Museum for
Kunst, Copenhagen

Rembrandt was keeping a close eye on the art around him and, knowing he would be judged by its standards, trying to outdo it. We can sense him hoping to win through by a display of skill. He would expect each figure to be admired in turn. At the same time, he was bolder than Lastman, who seems by comparison frightened of disobeying the classical rules. He avoids Lastman's generalized forms and draperies; from the start Rembrandt is concerned with the particular. An individual vein of appealing sentiment informs the *Anna and Tobit* (Plate 1), and there is an intriguing ambiguity about the figures in the *Two Scholars disputing* (Plate 2). Who are they? Are they real scholars? Named Greek philosophers? Old Testament prophets or New Testament saints? It has recently been suggested that they are the apostles Peter and Paul (though they lack the traditional attributes of those saints, the key and the sword). These things strike a new, arresting note.

About 1630 Rembrandt steps back a pace or two from the subject and places the figures in the second plane in a high vaulted space. Perhaps attracted by indirect knowledge of Caravaggio, he makes the observation of a pool of light surrounded by darkness the visual motive of the picture. Where there is only one figure, this figure is often represented in contemplation or asleep, so that the shadowy atmospheric space above appears as an emanation of thought or dreams. Visually it is as if Rembrandt were standing at a distance watching the light as it fell from a high window in a dim Gothic interior. Similar but not identical means are used for the depiction in this setting of a lonely scholar seated by a window and *The Presentation of Jesus in the Temple* (Plate 6). The difference is that, whereas in the secular scene the light has a visible source, in the latter the natural light is fused with a supernatural radiance emanating from the figure group. Yet this is done so subtly that we are only subconsciously aware of it and the way the light falls strikes us at first glance as natural. Rembrandt was to use this device again and again in his religious pictures in the future.

The composition of *The Presentation* is absolutely calm. No one moves or speaks but everyone looks. It is a picture about looking, about understanding through the eyes. In the central group, gazes are fastened on Simeon holding the Christ-Child; he returns them in the direction of the tall robed figure, whose profile is lost in shadow. Other figures – grave Rabbis seated in the foreground, a more excited crowd dimly visible on the steps to the right – watch from a distance. Two old men from the crowd have come forward to join the central group, peering over Mary's shoulder. We recognize in them the many pen and ink studies of beggars which Rembrandt made from life during this period. Thus is reality blended with sacred history. The solemn mood leaves us in no doubt that we, like the onlookers in the painting, are witnesses to a divine revelation.

Within the scheme of light and shade, the composition is defined by lines: verticals in the figures and architecture, horizontals and receding diagonals along the steps and the divisions in the pavement. The vertical emphasis, which rises to a climax in the pillar to the right of centre, above the Infant

Christ, rests on a firm base. The figures too are lineally conceived, but the lines fall as much within the forms, following the folds in the drapery, as they do along their contours. We are again reminded of Rembrandt's drawings of this period, in which he used long looping strokes, hardly lifting his chalk from the paper. The colours are cool and close to one another in the spectrum; the brushwork is delicate and the surface smooth and luminous like deeply polished wood, echoing the wooden panel on which the picture is painted.

The Presentation in the Temple, executed in 1631 shortly before Rembrandt left Leyden for Amsterdam, is one of his first masterpieces on a small scale. But, regarding his career as a whole, we must take account not only of the intimate, closed, spiritual Rembrandt; there is also the open, monumental, baroque Rembrandt to be remembered. Perhaps initially the decision to work on a large scale was the desire to emulate Rubens, who deeply affected Rembrandt's art in the early 1630s and was, after Lastman, the most important single influence in his career. Rubens's richly plastic modelling, though not his composition, is already reflected in the heads of *The Anatomy Lesson of Dr Tulp* (1632; Plate 7), with which Rembrandt made his reputation on his arrival in Amsterdam. Like most of Rembrandt's group portraits this is partly a subject picture, since it contains an action and figures responding to it. The painting shows the chief anatomist and principal lecturer of the Surgeons' Guild, Dr Nicolaes Tulp, demonstrating the function of the muscles and tendons in the forearm in causing the fingers to curl, an effect which he echoes with his own left hand. Nevertheless, the composition is as much that of a group portrait as of a documentary record, and the action, in addition to being basically true to life, is a device for unifying the picture. What contemporaries would have admired is Rembrandt's virtuosity as an artist: his invention, the vividness of the expressions, his smooth brushwork and the skilful foreshortening of the naked corpse. In Amsterdam in 1632 this was what painting was believed to be about.

Belshazzar's Feast (Plate 11), another large work of this decade which exhibits similar qualities, is still more ambitious. Whether it is equally successful is another question. Rembrandt, here unhampered by real life, gives his imagination free rein. It is a painting designed to impress. It displays difficult technical problems chosen and overcome: not only expression but lighting, movement, and the treatment of exotic still-life accessories and costumes. Much is made of the play of both direct and reflected light on surfaces. This is especially true at the left, where the woman seated in the foreground seems literally bathed in phosphorescence. Softer, partly reflected light glances over the two figures facing Belshazzar, while another figure almost lost in shadow hovers dimly in the background. On the right a swaying, foreshortened figure reflects the influence of Venetian painting both in pose and in the painting of the red velvet sleeve. The composition is defined by powerful baroque diagonals anchored at the centre by the massive body of Belshazzar and focused on the great jewelled clasp of his cloak. The impasto is very thick and heavily worked in this area, as if mimicking the substance it is representing. The cloak, turban and trinkets would have been modelled on the bizarre costumes and curios with which Rembrandt stuffed his studio wardrobe.

This is perhaps Rembrandt's most purely theatrical painting. Everything in it is emphatic, exotic and astounding. Yet for most modern critics it is a failure. It seems to be too lacking in other qualities. The dramatic event which touches off the action – 'the Writing on the Wall' – is sensational enough to justify the rhetoric but we feel that Rembrandt is trying too hard. Wine spilling not just from one but from two goblets is too much. The expressions are overdone and the painting of Belshazzar's face and hands is ugly and grotesque. But it is at least – with some of the early self-portraits – a corrective to any sentimental view of Rembrandt. Only he could have carried off such a monstrous performance.

After this, Rembrandt progressively diminishes the area in which rich costumes and precious metals appear, yet until the last decade there is usually a hint of material richness somewhere in the picture, of brocades or burnished metals glowing like fire. Rhetoric also dies away and, from the early 1640s onwards, out-flung arms and grimacing features – the outward, baroque means

of conveying emotion – are replaced by subtle hints of feeling in the eyes, set of the head and pose.

The transition to a new kind of art was effected by Rembrandt in a number of tranquil scenes painted during the 1640s, the common theme of which is domestic piety. We find this epitomized in scenes from the Old Testament (*The Departure of the Shunamite Woman*; *Tobit and Anna*) as well as in the New (*The Holy Family*, Plates 22 and 23, and *The Adoration of the Shepherds*). No mythological subjects were painted during this decade, even among the single figures. The most typical single figure is an impoverished, bearded old man, hatless or wearing a simple cap, seen head and shoulders only, and a young servant girl leaning on a pedestal (Plate 21). Whether this withdrawal into a more intimate kind of art was occasioned by reaction (Rembrandt's, not his contemporaries') against the bombast of *The Night Watch* (1642; Plates 17 and 18), by grief at the death of his wife, or by factors in his own interior life, is uncertain. Rembrandt's own thoughts and feelings, as distinct from their manifestations in his appearance (as seen in his self-portraits) lie outside our knowledge.

Perhaps the most significant development – it is even more important than the subject-matter and composition – consists in the technique. A simple way of putting this is to say that the brushwork becomes broader, but there is more to it than that. The change affects the whole treatment of form. An alternative explanation might be to suggest that the top layers of paint have been left off and that the surface now visible is what would previously have been the under-painting or a sketch; in other words, one might describe the paintings, as the early critics described them, as unfinished. In fact they are not unfinished, nor did Rembrandt simply substitute sketches for finished pictures. On the whole he did not make preparatory sketches in oil except for some of his early etchings. Nevertheless, the analogy with the sketch and the first stages of a painting is one way of understanding the process by which the new technique was achieved. A glance at the early monochrome sketch of *The Entombment of Christ* (Plate 12) will illustrate this, as it shows what happens at its simplest and most extreme. Not only are the surfaces of the forms left out but the transitions between tones are omitted as well. A stroke of paint is used simultaneously to indicate the tone of a form and its approximate shape. Dissimilar tones are placed side by side instead of being blended into one another. This brushwork is a kind of 'note form'. It is functional and without embellishments; it does not suggest movement or texture; it denotes rather than describes.

It could not be more different from the highly finished parts of early paintings such as *The Presentation in the Temple*. There the brushwork follows the contours and internal modelling of the forms, describing their surfaces minutely. The tones are blended, the stroke is soft and linear. This even applies to more vigorously handled works of the late 1630s, such as *The Risen Christ appearing to the Magdalene* (Plate 13). It is only in subsidiary parts of these paintings, which are not meant to attract the eye particularly and where the forms are slightly indistinct, that the simplified brushwork of the 1640s is anticipated. (Contrary to what might be expected, it does not seem to be anticipated in Rembrandt's most personal, and therefore most freely handled, early paintings, such as his portraits of himself and his wife; the brushwork in these is looser but its descriptive character is the same as that of other works of the same period.)

However, in the 1640s there are differences as well as similarities in technique between Rembrandt's finished paintings and his sketches. For one thing, speed is of the essence in a sketch, and Rembrandt was not interested in speed; Baldinucci records that he was a slow worker, going over passages again and again, waiting for each layer to dry, until he was satisfied with the result. More important, the brushstrokes in the finished paintings of this period (e.g. *The Holy Family with Angels*, Plate 22) are very refined and their shapes are carefully calculated. Each touch is unobtrusive yet of the utmost significance. It conveys simultaneously form, colour, texture and tone. To some extent the last three could be adjusted later by means of glazes but the form had to be exactly right from the first; its shape had to be defined exactly by the mark made by the brush. In some of the figures in smaller works, a complete head or hand may be represented by a single brushstroke, without modulations of tone. No more than three or four strokes were required for the headcloth of the

Madonna in *The Holy Family with Angels*; another single broad stroke sufficed for the piece of this cloth which comes over her right shoulder (a similar economy of means is to be found in Rembrandt's drawings). In still later works (see the hands in the portrait of *Jan Six*, Fig. 29), proportionately fewer strokes are used for more complex forms. The main tonal variations are expressed by juxtaposition, not by blending. The slight changes which suggest the play of light and atmosphere over the forms are obtained by glazes. One advantage of this broader yet very precise method of handling was that Rembrandt could make larger, seemingly 'empty' areas visually interesting. He could avoid the fussiness which characterizes many of his paintings of the previous decade, such as *The Risen Christ appearing to the Magdalene* (Plate 13). What earlier or contemporary painter could have made so commonplace an object as a child's wicker cradle seem so fascinating to the eye? The paint has a beauty in itself, over and above its representational function.

The brushwork also had another purpose: to represent emotion. By the 1640s, Rembrandt was no longer interested in conveying expression by exaggerated facial movements, that is to say, by movements which he could describe by tracing their outlines with the brush. He knew that human emotions are often expressed by only very slight changes in the facial muscles – perhaps only around the eyes and at the corners of the mouth – changes which the observer in real life is able to pick up but which are too subtle to be represented by conventional methods of pictorial expression. By placing the brushstroke just 'so', in the cheek below the eye or along the eyelid, Rembrandt was able to record these tiny movements and hence to imply the expression in the eye itself. This gave him, further, the power to convey a whole range of emotions that were outside the capacity of previous artists. This applies particularly to the inward or contemplative emotions of love, compassion and apprehension, as distinct from the outgoing and active ones of terror and rage. In his middle and later years Rembrandt hardly ever represented figures in violent states of feeling. Moreover, his mastery of expression was not confined to the treatment of faces; it is also evident in his painting of hands and indeed the whole body. No painter has made so much of the touching of one figure by another with a hand: the husband laying a hand on his wife's shoulder in *Jupiter and Mercury visiting Philemon and Baucis* (Plate 37); *Jacob blessing the Sons of Joseph* (Plate 34); Mary reaching out a hand to lift the cloth from the Child's cradle without waking Him (Plate 22).

The technical characteristics which have just been described are epitomized in this last, most beautiful and most central painting of Rembrandt's middle years. To study it is to realize that what can be described as technique is not a dry mechanical dexterity but the counterpart of imaginative and spiritual qualities. Here is the familiar theme of the Madonna and Child represented in the costumes and setting of a genre scene (Goethe's 'Dutch Peasant Woman') but made sacred, not just by the presence of angels, but by the colour, expressions and brushwork. By keeping the colours and lighting very pure and by a slight emphasis on the regularity of certain forms – the line of Mary's shoulder, the oval of her face, the smoothness of her brow – Rembrandt invests the figure with a sweetness which proclaims that this is no ordinary mother but the Mother of God.

In Rembrandt's late art this sweetness is avoided. It is an art largely dominated by men: the Madonna hardly reappears; the characteristic female figure is the virtuous Roman matron, Lucretia, who stabbed herself in shame after being raped (Plate 48). Many of these paintings are large. The figures are almost all life-size and are usually shown in three-quarter length. The conception of the pictures is monumental and austere, although it may encompass moods both of great tenderness (*The Jewish Bride*, Plate 47) and bitter humiliation (*The Disgrace of Haman* in St Petersburg). The sentiment in the second of these paintings is conveyed entirely through facial expression and is not even fully apparent to a spectator ignorant of the story. Equally, the late pictures may include a strain of vivid realism, as in the *Two Africans* (Plate 40); or they may summon up ghosts. What apparitions are they, what survivors of some unknown Northern mythology, that gather round the table to swear the oath in *The Conspiracy of Julius Civilis* (Plate 42)?

However, we are more conscious of what unites the late works than of what divides them. The trend is away from realism and narrative, and towards essence rather than existence. Even the expressions are often mute or inscrutable; the figures think and feel but no longer communicate as before. They embody a kind of super-real presence which is all the more intense for being without corresponding form or rational cause. The observation of light and shade is less illusionistic than before. The brushwork also almost ceases to have a representational function and to become, instead, an independent medium. We often cannot tell the material of which the costumes are made. The paint, applied in square overlapping patches, layer upon layer, scratched with the handle of the brush, scraped off and reapplied, has its own extraordinary character, its own vitality. The marks scarcely define the shape of forms; like the penstrokes in the late drawings or the drypoint lines in the late etchings, they lie outside or within, not along, the contours. Blocked in with straight edges, they serve as lines of force, indicating direction.

The forms, though massive in area, are insubstantial and flattened, and limbs that would normally be seen in foreshortening are sometimes distorted in order to bring them into a plane parallel with the picture surface. The integrity of the picture surface is all. What we see is a tapestry of colours and tones into which figures and faces are dimly yet palpably woven. A greater number of different tones and different shades of the same or related colours, each distinct yet harmonized with the others, is visible than in the work of any other artist, even the late Titian. The effect is at once dream-like and intensely vivid; subtle and overpoweringly impressive. Like the late work of many other great artists, Rembrandt's is essentially tragic. As the mind contemplates it, it is purged of the emotions of pity and terror and brought to a state of peace.

The Portraits

In discussing Rembrandt's portraits it is difficult not to begin with the cliché that he was the greatest portrait painter of all time. This statement does not take us very far; and if true, it imposes an obligation on the critic to explain why it should be the case. At all events, it will generally be agreed that Rembrandt embodies most of our ideas of what a great portrait painter should be. Nowadays we think more highly of that type of portraiture which reveals character rather than mere likeness. We expect a portrait to uncover 'the real person', to show him or her warts and all, and to disclose the private weaknesses behind the public face. We would rather that the painter were the critic than the flatterer of his sitters. Further, we ask that a portrait should tell us as much about the artist as about the person portrayed; that it should be the product of a collaboration between the two, the end in view being the creation of a work of art.

Now, these are democratic expectations, which previous ages for the most part did not share. It happens that Rembrandt – in a sense – satisfies them; the fact that he does so is one reason for his popularity today. But Rembrandt fulfils the modern requirements of portraiture to both a greater and lesser extent than might be supposed. As usual, his method is not reducible to a formula; nor is it easy to group his portraits and single figures into categories for purposes of discussion. Although they all have some things in common, each turns out on examination to be a unique achievement.

The painting of a portrait poses two main artistic problems. The first, which applies to all representations of the single figure, is how to avoid monotony. It is one failing of the second-rate portrait painter that all his sitters, apart from their features and sometimes clothing, tend to look alike. Even the very good portrait painter of the second rank, such as Frans Hals, may, by emphasizing the pose and introducing gestures and movement, achieve only a superficial variety, since if these factors are overstressed they appear contrived. Rembrandt generally keeps the poses of his sitters quiet and unassuming, although they are never dull, and he rarely uses gesture or movement. Except in his earliest self-portraits the expressions are also restrained, and this becomes increasingly true in his later work; there is always something withheld from, as well as given to, the observer. Rembrandt's principal means of

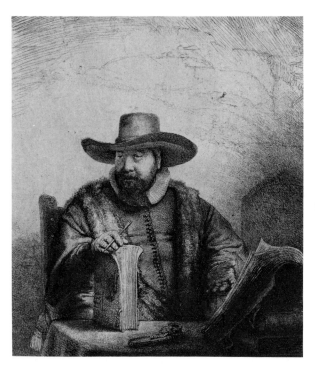

Fig. 5
Portrait of the
Preacher, Cornelisz.
Claesz. Anslo
Signed 'Rembrandt
f.1641'. Etching,
18.6 x 15.7 cm.
Kupferstichkabinett,
Berlin

gaining variety are firstly, the use of costumes and attitudes which show the sitter adopting a role (this is not confined to portraits of himself and his family although it is most clearly evident there); and secondly, the creation of a mood of introspection or internal drama, into which the observer finds him or herself drawn. This mood stimulates curiosity and produces a suggestion of 'content' which is like that of subject paintings, not just of portraits, and hence is capable of similar pictorial variations. By concentrating on the sitter's psychology, sometimes emphasizing one side of his personality by showing him acting a role, Rembrandt achieves a more genuine variety than he would have done if he had used more superficial means.

The second problem of portraiture is that of representing character. Ever since the Renaissance, it has been understood that the portrait painter has a duty to reveal the character of his sitters and not merely to copy their likeness. Until comparatively recently this did not mean probing the sitter's inner psychology; it was sufficient if his or her more salient virtues were displayed. The task presented no theoretical problem, since it was generally believed – following the basic premise of that popular intellectual game of the period, physiognomics – that 'the face is the index to the mind'. In practice, however, the achievement of this aim was very difficult, not so much because of the inherent limitations of the visual medium of painting, although these were serious enough, but because of a fallacy in the theory. Briefly, this fallacy was the assumption that it is possible to deduce a person's character from a painted image of his or her features, whereas in fact character can only be *recognized* by this means; in other words, the face only reveals the qualities of a person's character to those who are aware of them already. To friends and contemporaries of the sitter, his portrait may reveal him 'to the life', but its doing so depends on their knowing him in life and being able to read into the portrait his typical expression, aspects of his character and so on, which are already familiar to them. To take a specialized case – one of the few recorded contemporary comments on Rembrandt as a portrait painter: the poet Vondel exhorted Rembrandt, when portraying Cornelisz. Claesz. Anslo (Fig. 5), who was a famous preacher in Amsterdam, 'to paint Cornelisz's voice'. Whether Vondel was satisfied with the result is not known, but Rembrandt's presumed success, even in the metaphorical sense in which Vondel meant it, is inevitably lost on us as we have no means of comparing the painting with the living model. It follows from this that a portrait can convey character to posterity to something like the extent it did to contemporaries only if the sitter is historically very well known; that is to say, if we possess written information about him or her which we can read into the portrait in the same way that contemporaries were able to apply their knowledge of the person gained from life. Unfortunately none of Rembrandt's sitters is sufficiently well known for this to be the case.

It does not seem that the significance of this aspect of the problem of portraying character found a place in Renaissance and seventeenth-century art theory. Nevertheless, painters appear to have grasped it intuitively from an early date and to have attempted to convey certain elements of a sitter's character by means which posterity and those unacquainted with him or her in the flesh could discern (this is particularly evident in portraits of rulers, where the monarch's or prince's authority and virtues had to be clearly conveyed to his or her subjects and to foreign powers). One favourite method was to include symbolic attributes of the sitter's accomplishments or profession; another was the use of emblems; a third was idealization of the sitter's features and body, to emphasize his position in society and distinction of mind. Rembrandt, as might be expected, had a deeper understanding of the problem than any other painter, yet he hardly used any of the usual, mostly external, devices. His means were principally inward-looking and subjective – above all, the chiaroscuro. He used chiaroscuro to create an appropriate mood or a revealing play of emotions in the sitter's features. Alternatively, he would emphasize some features at the expense of others; thus in some of his self-portraits he adjusts the shadow down one side of his face to hide the bulbousness of his nose. In this type of self-portrait he presents himself as refined and relaxed, quietly confident of his powers; in other types the thickness of his features is unsparingly revealed and he appears aggressive when young or anguished when old. A further means of expressing character, as it is of achieving variety,

is also common in Rembrandt's portraits. This is the casting of the figure in some guise or role by the use of costumes, by means of the pose and, occasionally, through associations of style. At one extreme this takes the form of dressing up or play-acting, as in *Saskia as Flora* (Plate 10 and Fig. 13). At the other extreme it may appear as a subtle emphasis on one side of a sitter's personality at the expense of others: thus, slight adjustments to the composition and chiaroscuro in the portrait of *Jacob Trip* (Plate 41) tend, without detracting from his individuality, to build him up into 'the man of authority'. In the same way, Rembrandt presents himself in his self-portraits now as 'the artist' (Plate 44), now as 'the gentleman' (Plate 15), and so on.

From all this it is evident that Rembrandt's depiction of character is far from being the total disclosure that it is sometimes made out to be (though it is significant that those who hold this view tend to be reticent as to the precise characteristics disclosed). What Rembrandt achieves is all that a painter can achieve, namely to show, by artistic means, certain qualities of a sitter's character that we might be able to recognize in his face if we knew him in life. It is in the nature of things that we cannot specify or label these qualities very exactly and that our understanding of them is subjective; yet, such is Rembrandt's skill, they can be identified up to a point. Beyond that point, Rembrandt gives us 'character' in a more general sense, as we say in the phrase 'this figure is full of character', or that person is 'a man of character'. He does this by making his figures look within themselves as well as out towards us, and by presenting them in a context of introspection and thought. These qualities will be discussed again in a moment but at this stage it will be convenient to look at some examples of Rembrandt's portraiture in slightly more detail. They will be taken in approximate chronological order but the differences between them can be found at all stages of his career and only partly reflect a development in his approach.

The first is the enchanting *Saskia as Flora* in St Petersburg of 1634 (Plate 10). This is a costume piece like the well-known painting of the same subject in London, but the two are not identical in treatment. In the London *Saskia* (Fig. 13), we are very much aware of the contrast between the sitter and her costume, although this contrast is itself revealing and not merely awkward. It is a portrait of Saskia unaccustomed to this fancy dress. In the St Petersburg painting the sitter, though still clearly recognizable as Saskia, has been more fully assimilated to the idea of a classical goddess. The metamorphosis is not complete and is all the more touching for that, but Saskia's face is sweetened and she steps into her pastoral role with a grace that owes something to Titian and Rubens as well as to contemporary Dutch conventions of pastoral painting. Her pregnancy adds the idea of fertility to the traditional conception of the classical goddess of spring. The handling is smooth and the colours unusually clear and decorative for Rembrandt. Flowers appear in the background as well as in Saskia's hair and wound round her staff. The gesture of holding something lightly in the hand, as so often in Rembrandt, is an indication of informality; for example, Jan Six drawing on his gloves (Plate 29) or Titus puzzling over his homework (Plate 32). The picture sustains, fused and in perfect balance, a number of contrasting associations: those of reality, mythology and the stage. Is the figure Saskia dressed up as Flora, or an allegorical painting of Flora for which Saskia sat as a model? That the answer is in doubt is an index of the painting's position on the borderline between portraiture and mythology. It is at once a personal record of Rembrandt's affection for his wife – and hence it tells us something about one side of her personality – and a commentary on the pastoral convention of spring.

The portrait probably of *Pieter Six* (Plate 27), datable to about 1650, is in many ways simpler and more straightforward. It is a regular commissioned portrait, showing the sitter wearing the plain white collar with tassel, black doublet and black cassock typical of a Dutch bourgeois in the mid-seventeenth century. Six (assuming it is he) stands with his arm resting on the back of a chair and is represented, rather unusually for Rembrandt, with a landscape behind him. With his large dark eyes, long blond hair and fair, almost white, moustache and eyebrows, he looks refined yet shy and retiring. A dense atmosphere, giving a sensation of extraordinary stillness, pervades the picture. The figure makes a striking contrast to the painting of Pieter Six's younger brother,

Jan Six (Plate 29), depicted in 1654 in one of Rembrandt's most famous single portraits. The treatment there is bold and colourful and the brushwork exceptionally broad. The strong-featured Jan Six is brought forward almost to the picture plane and his expression and pose are instinct with alertness. The captivating portrait of *Catrina Hooghsaet* (Plate 36) of 1657, is bold, too, though the handling is smoother and the lighting clearer, giving a harder edge to the contour than was usual with Rembrandt at this date. A superior smile plays about Catrina Hooghsaet's face as she sits confidently, turned sharply away from the observer in a pose reminiscent of Van Dyck. With the *Gérard de Lairesse* (Plate 45) of 1665, on the other hand, Rembrandt reverts to a softer and more relaxed treatment, with the difference that the brushwork has the rough texture typical of the artist's final years. In this case, the strong chiaroscuro blurs the sitter's somewhat unfortunate features (Lairesse had no bridge to his nose) and lends distinction to what would otherwise be a plain and simple presentation.

The portrait of *Jacob Trip* (Plate 41) also makes creative use of chiaroscuro. Here, however, every stroke proclaims the idea of authority – parallel verticals of the stick and the chair, the severely upright pose, the look in the heavy-lidded eyes, and the shadows which fall in such a way as apparently to lengthen the face. It happens that several portraits of Trip by other artists are known, from which it can be deduced that Rembrandt's is a good likeness. But the comparison also shows that it is very much more than a likeness. The versions by Cuyp and Maes tell us little more than that the sitter was an old man with a thin face and hooked nose. Rembrandt depicts the aged armaments manufacturer as a symbol of iron will-power. No Old Testament prophet or mythological sage elsewhere in his oeuvre is as gaunt as this formidable ancient figure, who is both sinister and wise, a merchant patriarch of the new, Protestant Jerusalem which was Amsterdam. Even if the sitter's whole personality cannot be understood, if the presentation is one-sided, and though any interpretation is bound to be subjective, there is no doubt that this is an image of 'character'. And it is achieved by stylistic means: by the low viewpoint and imposing breadth of the lower part of the figure, by the massive cloak and archaic, throne-like chair, and, most subtly, by the chiaroscuro. This elongates the face and figure, widens the forehead and enlarges the eyes.

Contemplation or introspection is the leitmotif of Rembrandt's mature and late portraits. Sunk in reverie or gazing towards the observer, the figures seem to exist in an atmosphere of their own. They are watchful yet withdrawn, and behind the eyes the mind is preoccupied by thought. Rembrandt began treating portraits and studies of old people in this way very early in his career, then applied the same method to his self-portraits, and finally extended it to all his portraits in varying degrees after 1640. As a conception of portraiture this was not without precedents: the *Mona Lisa* is one famous example and there are others of a slightly different kind in the work of Titian. But Rembrandt developed this type of portrait further than anyone else and used it for a far wider range of sitters. Although its most typical representatives are men accustomed to thought rather than action – doctors, preachers and artists – it is not confined to them. Rembrandt's principal means is once more the chiaroscuro. The face normally receives the strongest light, which gives it the prominence which its importance in the portrait leads one to expect. At the same time the face is criss-crossed by shadows which both lend it interest and character and enmesh it, as it were, in the background. Shadows collect in and around the eyes and the hollows of the cheeks, down one side of the nose and round the mouth. Sometimes the eyes are heavily shaded by a hat. The edges where one tone meets another are softened, and it is frequently the side of the face turned towards the observer which is illuminated, thereby avoiding a sharply silhouetted cheek-line on the other side. The effect of all this is to divert attention from the face as a unit and transfer it to the features. The features, especially the eyes, thus become all the more telling as indicators of mood and character. Yet for all their rich expressiveness they remain partly inscrutable, for two reasons. The first reason is that the eyes are defined by the shadows, not by the light, which gives them a far-away look, as if there were some invisible force uniting them with the background (it is remarkable how much more aggressive – and less interesting – the faces in Rembrandt's portraits appear if they are

looked at with the backgrounds masked off). The second reason is that the expressions are not superficially animated. Rembrandt's sitters may watch the observer intently; they do not communicate with him. Their eyes are steady and their mouths closed. Animation lies in the technique – the fluid *impasto*, the delicate and varied glazing, the play of atmosphere and light and shade over the features; it does not lie in the features themselves.

This is a conception of portraiture that belongs at the opposite pole from arrested movement; the impression is rather one of immobility and timelessness. It follows that Rembrandt's portraits stand not just for the likeness and characterization of individuals. Nor do they add up to 'the portrait of an epoch'; they are not social documents. While each portrait is unique and each records the lineaments of a particular person, it carries overtones which make the individual the representative of humanity. At bottom what Rembrandt portrays is the human predicament. And he saw that predicament as both tragic and watched over by a mysterious spiritual force. It is not for nothing that critics have seen a resemblance between Rembrandt's paintings and the philosophical ideas of his fellow resident of Amsterdam, Spinoza (although the latter was too young to have influenced him). Both men were steeped in the Jewish scriptures, and Rembrandt would have shared Spinoza's doctrine of the integration of spirit and matter. The mystery which permeates Rembrandt's shadows is ultimately a metaphor for the immanence of God.

There is one further characteristic of Rembrandt's portraiture: the intensity of the relationship between the sitter and the observer. Although in one sense Rembrandt's sitters are remote from us, in another sense they are vividly real. They are vulnerable to scrutiny and, wearing no social mask, they draw us into their world. The experience of looking at them is essentially private; it excludes the presence of a third person and exposes the observer to his own thoughts and feelings as much as it reveals those of the person portrayed (contrast Frans Hals, whose sitters often seem to be looking over the observer's shoulder at someone else). There is some reason to believe that Rembrandt always wanted his paintings to be contemplated very intimately. He interposed first the background, then the frame, as a barrier between the painted image and the outside word – this was the reverse of the baroque principle of extending the created world of the painting into the observer's space. In two cases, not portraits (one is *The Anatomy Lesson of Doctor Joan Deyman*; Plate 35), Rembrandt indicated the type of frame he would like: it was a kind of tabernacle, with pilasters either side, a base and a curved or pedimented top. In a third example, *The Holy Family with a Cat* (Plate 23), such a frame, together with a curtain half drawn in front of the scene, actually forms part of the picture.

To be exact, the contemplation of Rembrandt's portraits usually involves three people: the sitter, the observer and the artist. But there was one category in which this number was reduced to two: the self-portraits. Perhaps it is not altogether fanciful to see this factor as an additional, aesthetic reason, over and above the commercial and autobiographical ones, for the quantity of self-portraits in Rembrandt's oeuvre. In the self-portrait he was able to address the observer directly, without the distraction of another personality. If a portrait becomes a work of art as the result of a collaboration between the sitter and the artist, that collaboration is most effective when sitter and artist are one. When painting himself, Rembrandt was freer to vary his interpretation by adopting a wider range of poses, costumes and lighting effects than he could use in his commissioned portraits; he could treat himself as either sitter or model, that is, he could depict himself either more or less formally; and, knowing himself better than he knew anyone else, he could make the self-portrait a more effective vehicle of character. He was sufficiently self-absorbed to represent his own features at least once a year during his early and later periods (though less often, for some unknown reason, during his middle years), and he did so for the most part not in the casual or experimental media of drawings and oil sketches but in finished paintings and, to a lesser extent, etchings. Some of these painted self-portraits are as highly wrought as any portraits in his *oeuvre*. It is evident that there was a market for them (significantly, not one is listed in the inventory of his possessions drawn up in 1656, although some of his less formal self-portraits may appear there disguised as *tronies*, or 'heads'). If Rembrandt's

Fig. 6
A View on the Amstel
c.1650-5. Reed pen and
brown ink wash, with
some white heightening
on reddish-brown
prepared paper,
14.5 x 21.2 cm.
British Museum, London

self-portraits constitute a diary, as in a sense they do, it was a diary at least partly intended for publication.

Nevertheless, his self-absorption was accompanied by a remarkable objectivity. In his youth he was bold enough not to disguise his conceit; in his maturity and old age he became his own severest critic. To call Rembrandt's self-portraits his greatest achievement would be to fall into the trap of sentimentalizing him. It would also be incorrect. But they are in some ways the purest expression of his approach to portraiture.

A Note on the Landscapes

As we have seen, Rembrandt was not a genre painter, although he made many drawings of scenes from everyday life. It would be impossible to deny that he was a landscape painter, but the same distinction applies; that is, he made numerous landscape *drawings* from nature but very few naturalistic landscape *paintings*. Those exceptions apart, all his landscape paintings were imaginary, and they were all executed, including the naturalistic ones (Plate 24), during his middle period, between about 1636 and 1655. As with his treatment of everyday life, the gap between his drawings and paintings was bridged by his etchings, which are partly naturalistic and partly imaginary.

Objectively it is hard to understand the gulf between the two categories. As a landscape draughtsman from nature (Fig 6), Rembrandt was one of the most brilliant and inventive of all artists; light and air vibrate between every stroke of his rapid sketches of the open Dutch countryside. Rembrandt's paintings, on the other hand, are motionless and claustrophobic, despite their romantic intensity (Plate 19). To a greater extent than any of Rembrandt's other works they fall into a category of their own in the history of art. Whereas his subject pictures, painted figure studies and portraits entered the mainstream of later European painting, his landscape paintings have had only an occasional influence (for example, on English art around 1800). Rembrandt's landscapes seem to deny one of the basic principles of the genre: interest in the mutually supporting roles of space, light and air. Instead, these elements tend to contradict one another in his work. While the arbitrary relationship between the light and shade pattern and the composition is an effective source of visual surprise, it prevents the landscape from expanding outwards to the sides or backwards into depth as far as the horizon. The exceptions to this tendency prove the rule, for they occur not in his imaginary landscapes proper but in the background of a figure painting – *The Risen Christ appearing to the Magdalene* (Plate 13) – and in the naturalistic *Winter Landscape* (Plate 24). Here, at least, the rendering of nature is beautifully fresh.

Yet Rembrandt's landscape paintings may become more intelligible if they are seen in the context of his own aesthetic attitudes. Like his ideas of architecture and costume, he evolved his conception of landscape independently of the classical tradition, that is, independently of the conventions of ideal landscape painting. Rembrandt's antiquity is an imaginary Hebraic antiquity, developed as an alternative to the Greek and Roman antiquity of Italian and Italianizing artists, such as Claude Lorrain. Almost the only thing his landscapes have in common with ideal landscapes is that they are not naturalistic. But unlike ideal landscapes, and unlike the landscapes of that other great Northern inventor of imaginary scenes – Rubens – Rembrandt's landscape paintings have no real basis in the study of nature. Nor, unlike his drawings, are they Dutch in topography, although they show some Dutch stylistic influences. As was the case with his treatment of genre scenes, he transposed the subject-matter of his landscapes – nature – on to the plane of religious art. They have that brooding, numinous quality which informs so much of his work. They confirm once more, if only negatively, that the true subject of Rembrandt's art is human beings.

Outline Biography

1606 Rembrandt Harmensz van Rijn born on 15 July at Leyden, the son of Harmen Gerritsz. van Rijn, miller, and Neeltgen Willemsdochter van Suytbrouck, daughter of a baker; he was the ninth of ten children, of whom seven survived into adulthood.

1620 20 May: Rembrandt enrolled at Leyden University. His short stay there was preceded by about six years spent in the Latin School at Leyden.

1620-4 Period of apprenticeship: three years with Jacob Isaaksz. van Swanenburgh in Leyden, followed by six months with Pieter Lastman in Amsterdam (1624).

1624-5 Rembrandt returns to Leyden and sets up as an independent painter, working closely with another former pupil of Lastman, Jan Lievens (1607-74).

1628 February: Gerrit Dou (1613-75) becomes Rembrandt's first pupil, remaining with him until 1631/2.

1629 Constantijn Huygens visits Rembrandt and Lievens in Leyden and admires their work.

1630 Death of Rembrandt's father.

1631-2 Between 8 March 1631 and 26 July 1632, Rembrandt settles permanently in Amsterdam, lodging first with the dealer, Hendrik van Uylenburgh, in the Sint-Anthonisbreestraat.

1633 5 or 6 June: Betrothal to Saskia van Uylenburgh (1612–42), the daughter of a former burgomaster of Leeuwarden and a cousin of Hendrik van Uylenburgh.

1634 22 June: Marriage to Saskia at Sint-Annaparochie, near Leeuwarden. In this year, Rembrandt joins the Guild of St Luke (the painters' guild) in Amsterdam.

1635 Rembrandt rents a house of his own in the Nieuwe Doelenstraat, where his and Saskia's first child, Rumbartus, who survived only two months, is born in December.

1637 Rembrandt is recorded as living in the 'Sugar Refinery' on the Binnen-Amstel, where Ferdinand Bol (1616-80), among others, became his pupil.

1638 22 July: baptism of a second child, Cornelia, called Cornelia I, who lived less than a month.

1639 1 May: Rembrandt moves into a grand house, for which he is unable to pay in full, in the Sint-Anthonisbreestraat. This is now the Rembrandt House in the Jodenbreestraat.

1640 29 July: baptism of a third child, called Cornelia II, who dies in August. On 14 September, Rembrandt's mother is buried in St Peter's Church, Leyden.

1641 22 September: baptism of Rembrandt's and Saskia's fourth and only surviving child, Titus.

1642 14 June: death of Saskia. In this year, Geertje Dircks is employed as a nurse for Titus and begins a liaison with Rembrandt.

1647 At about this time, Hendrickje Stoffels (1625/27-1663) joins Rembrandt's household as a maidservant. She later becomes his mistress.

1649 Geertje Dircks sues Rembrandt for breach of promise, as a result of which he is required to pay her a yearly maintenance allowance of 200 guilders. In the following year, he has her detained at his own expense in the women's house of correction in Gouda.

1654 30 October: baptism of Rembrandt's and Hendrickje's illegimate child, Cornelia.
On 10 December Rembrandt is compelled to pay the balance owing on his house in the Sint-Anthonisbreestraat, for which purpose he takes out a mortgage.

1656 17 May: Rembrandt transfers the legal ownership of his house to Titus.
25 and 26 July: inventory of the contents of his house in the Sint-Anthonisbreestraat drawn up by the Court of Insolvency. His appeal for the liquidation of his property, to avoid being declared a bankrupt and run the risk of being thrown into the debtors' prison, had been agreed shortly before.

1657 December: first sale of Rembrandt's possessions.

1658 1 February: the house in the Sint-Anthonisbreestraat auctioned for 11,218 guilders (nearly 2,000 guilders less than its price in 1639)
14 February: further sale of his possessions authorized.
24 September: final sale authorized of the remaining

prints and drawings in Rembrandt's collection, including many of his own (total, 600 guilders).
By 1 May he had left Sint-Anthonisbreestraat and moved into a smaller house on the Rozengracht.

1660 15 December: Titus and Hendrickje form a company for dealing in works of art, with Rembrandt as their employee.

1663 24 July: burial of Hendrickje Stoffels in a rented grave in the Westerkerk, Amsterdam.

1668 10 February: marriage of Titus to Magdalena van Loo.
On 7 September Titus is buried in the Westerkerk.

1669 22 March: baptism of Titus's and Magdalena's daughter, Titia.

1669 4 October: Rembrandt dies in his house in the Rozengracht. He is buried in an unknown rented grave in the Westerkerk, Amsterdam, on 8 October.

Select Bibliography

Catalogues

K. Bauch, *Rembrandt: Gemälde*, Berlin, 1966

O. Benesch, *The Drawings of Rembrandt*, 6 vols., London, 1954-7 (abbr: Ben.)

H. Bevers, P. Schatborn and B. Welzel, *Rembrandt: the Master and his Workshop – Drawings and Etchings* (exh. cat., Berlin-Amsterdam-London), London, 1991

D. Bomford, C. Brown and A. Roy, *Art in the Making: Rembrandt* (exh. cat., National Gallery), London, 1988

A. Bredius, *Rembrandt: The Complete Edition of the Paintings*, revised by H. Gerson, London, 1969 (abbr: Br.)

C. Brown, J. Kelch and P. van Thiel, *Rembrandt: the Master and his Workshop – Paintings* (exh. cat., Berlin-Amsterdam-London), London, 1991

J. Bruyn and others, *A Corpus of Rembrandt Paintings*, The Hague and London: Vol.I (1625-31), 1982; Vol.II (1631-34), 1986; Vol.III (1635-42), 1989. Further volumes to follow

N. MacLaren, *National Gallery Catalogues: The Dutch School*, revised and expanded by C. Brown, London, 1991

L. Münz, *Rembrandt's Etchings*, 2 vols., London, 1952 (abbr: M.)

P. Schatborn, *Tekeningen van Rembrandt, zijn onbekende leerlingen en navolgers* (catalogue of the drawings in the Rijksmuseum, Amsterdam), The Hague, 1985

C. White and K. G. Boon, *Rembrandt's Etchings*, 2 vols., Amsterdam, 1969

M. Royalton–Kisch, *Drawings by Rembrant and his Circle in the British Museum*, London, 1992

Books

S. Alpers, *Rembrandt's Enterprise*, Chicago and London, 1988

W. von Bode, *Great Masters of Dutch and Flemish Painting*, London, 1909

K. Clark, *Rembrandt and the Italian Renaissance*, London, 1966

J. Emmens, *Rembrandt en de Regels van de Kunst*, Utrecht, 1968

H. Focillon and L. Goldscheider, *Rembrandt*, London, 1960 (contains English translations of the three earliest biographies of Rembrandt)

H. Gerson, *Seven Letters by Rembrandt*, The Hague, 1961

B. Haak, *Rembrandt: his Life, his Work, his Time*, New York, 1969

J. Held, *Rembrandt Studies*, Princeton, 1991

J. Rosenberg, *Rembrandt: Life and Work*, 1948; 2nd edition reprinted Oxford, 1980

G. Schwartz, *Rembrandt: his Life, his Paintings*, New York, 1985

S. Slive, *Rembrandt and his Critics, 1630-1730*, The Hague, 1953

W. L. Strauss and M. van der Meulen, *The Rembrandt Documents*, New York, 1979

H. van de Waal, *Steps towards Rembrandt*, Amsterdam and London, 1974

C. White, *Rembrandt as an Etcher*, 2 vols., London, 1969

List of Illustrations

Colour Plates

1. Anna accused by Tobit of stealing the Kid
 Signed 'RH 1626'. Panel, 39.5 x 30 cm.
 Rijksmuseum, Amsterdam

2. Two Scholars disputing (St Peter and St Paul in Conversation?)
 Formerly signed 'RH.1628'. Panel, 72.4 x 59.7 cm.
 National Gallery of Victoria, Melbourne

3. The Artist in his Studio
 c.1629. Panel, 25 x 31.5 cm.
 Museum of Fine Arts, Boston

4. Self-Portrait
 1630-1. Panel, 69.7 x 57 cm.
 Walker Art Gallery, Liverpool

5. An Old Woman reading
 Signed 'RHL 1631'. Panel, 59.8 x 47.7 cm.
 Rijksmuseum, Amsterdam

6. The Presentation of Jesus in the Temple
 Signed 'RHL 1631'. Panel, 61 x 48 cm.
 Mauritshuis, The Hague

7. The Anatomy Lesson of Doctor Tulp
 Signed 'Rembrandt f:1632'. Canvas,
 169 x 216.5 cm. Mauritshuis, The Hague

8. Portrait of the Artist Jacques de Gheyn
 Signed 'RH Van Ryn 1632'. Panel, 29.9 x 24.9 cm.
 Dulwich Picture Gallery, London

9. Portrait of a Young Woman holding a Fan
 Signed 'Rembrand f 1633'. Canvas,
 126.2 x 100.5 cm.
 Metropolitan Museum of Art, New York

10. Saskia as Flora
 Signed 'Rembrandt f.1634'. Canvas, 125 x 101 cm.
 Hermitage, St Petersburg

11. Belshazzar's Feast: The Writing on the Wall
 Signed 'Rembrand. f.163'. Canvas, 167 x 209 cm.
 National Gallery, London

12. The Entombment of Christ
 c.1635. Panel, 32 x 40.5 cm. Hunterian Art Gallery,
 University of Glasgow

13. The Risen Christ appearing to the Magdalene ('Noli me tangere')
 Signed 'Rembrandt ft 1638'. Panel, 61 x 49.5 cm.
 Buckingham Palace, London (reproduced by gracious permission of Her Majesty The Queen)

14. A Man in Oriental Costume (King Uzziah?)
 Signed (falsely?) 'Rembran f.1639'.
 Panel, 102.8 x 78.8 cm. The Duke of Devonshire,
 Chatsworth (Derbyshire)

15. Self-Portrait
 Signed 'Rembrandt f.1640'. Canvas, 102 x 80 cm.
 National Gallery, London

16. Portrait of Agatha Bas
 Signed 'Rembrandt f.1641'. Canvas, 104 x 82 cm.
 Buckingham Palace, London (reproduced by gracious permission of Her Majesty The Queen)

17. The Militia Company of Captain Frans Banning Cocq ('The Night Watch')
 Signed 'Rembrandt f.1642'. Canvas, 359 x 438 cm.
 Rijksmuseum, Amsterdam.

18. Detail from 'The Militia Company of Captain Frans Banning Cocq' ('The Nightwatch')

19. Landscape with Buildings
 1642-6. Panel, 44.5 x 70 cm.
 Louvre, Paris

20. Christ and the Woman taken in Adultery
 Signed 'Rembrandt. f.1644'. Panel, 83.8 x 65.4 cm.
 National Gallery, London

21. A Girl leaning on a Stone Pedestal
 Signed 'Rembrandt ft.1645'.
 Canvas, 82.6 x 66 cm.
 Dulwich Picture Gallery, London

22. The Holy Family with Angels
 Signed 'Rembrandt f.1645'. Canvas, 117 x 91 cm.
 Hermitage, St Petersburg

23. The Holy Family with a Cat
 Signed 'Rembrandt ft 1646'. Panel, 46.5 x 68.5 cm.
 Schloss Wilhelmshöhe, Cassel

24. Winter Landscape
 Signed 'Rembrandt f.1646'. Panel, 17 x 23 cm.
 Schloss Wilhelmshöhe, Cassel

25. Susanna surprised by the Elders
 Signed 'Rembrandt f.1647'. Panel, 76.6 x 92.8 cm.
 Gemäldegalerie, Berlin

26. Christ and the Two Disciples at Emmaus
 Signed 'Rembrandt f.1648'. Panel, 68 x 65 cm.
 Louvre, Paris

Text Figures

6. A View on the Amstel
c.1650-5. Reed pen and brown ink wash, with some white heightening, on reddish-brown prepared paper, 14.5 x 21.2 cm.
British Museum, London

Comparative Figures

7. Gerrit Dou: Rembrandt in his Studio
c.1630. Panel, 53 x 64.5 cm.
Private collection

8. Saskia wearing a Straw Hat
Silverpoint on whitened vellum, 18.5 x 10.7 cm.
Later inscribed by Rembrandt (in Dutch): 'This is a drawing of my wife, made when she was 21 years old, the third day of our bethrothal – 8th June 1633'. Kupferstichkabinett, Berlin

9. A seated Old Man
Signed with initial and dated 1630.
Red chalk, 15.7 x 14.7 cm.
Private collection

10. A Beggar standing with a Stick
Signed (?) 'R' lower right. 1629-30.
Black chalk, 29 x 17 cm.
Rijksmuseum, Amsterdam

11. Portrait of Maurits Huygens
Signed 'RH Van Ry[n] 1632'. Panel, 31.1 x 24.5 cm.
Kunsthalle, Hamburg

12. Sir Anthony van Dyck: Portrait of Marie de Raet, Wife of Philippe le Roy
1631. Canvas, 215 x 123 cm.
Wallace Collection, London

13. Saskia as Flora
Signed (falsely) 'Rem...1635'.
Canvas, 123.5 x 97.5 cm.
National Gallery, London

14. The Entombment of Christ
1636-9. Canvas, 92.5 x 70 cm.
Alte Pinakothek, Munich

15. Detail from 'The Risen Christ appearing to the Magdalene' ('Noli me tangere')

16. Study for the etching, 'The Great Jewish Bride'
c.1635. Pen and brown ink wash, 24.1 x 19.3 cm.
Nationalmuseum, Stockholm

17. Titian: Portrait of a Man
c.1510-15. Canvas, 81.2 x 66.3 cm.
National Gallery, London

18. Portrait of Nicolaes van Bambeeck, Husband of Agatha Bas
Signed 'Rembrandt f.1641'.
Canvas, 108.8 x 83.3 cm.
Musée Royal des Beaux-Arts, Brussels

19. Annibale Carracci: Landscape with the Flight into Egypt
c.1604. Canvas, 122 x 230 cm.
Galleria Doria-Pamphili, Rome

20. Sheet of Studies of Women and Children
c.1636. Pen and brown ink, 13.4 x 12.8 cm.
Private collection, Boston

21. Studies of the Nude, with a Woman and Baby lightly etched in the Background
c.1646. Etching, 19.4 x 22.8 cm.
British Museum, London

22. The Holy Family with Angels (by Rembrandt or a pupil)
c.1645. Pen and brown ink, 16.1 x 15.8 cm.
Musée Bonnat, Bayonne

23. Saskia's Lying-In Room
c.1640. Pen and brown ink with brown and grey washes, 14.3 x 17.6 cm.
Institut Néerlandais (Fondation Custodia), Paris

24. Farm Buildings by a River
c.1652-3. Pen and brown ink with wash, 14.9 x 24.8 cm. The Art Institute of Chicago

25. The Goldweigher's Field
Signed 'Rembrandt 1651'.
Etching, 12 x 31.9 cm.
British Museum, London

26. Study for 'Susanna surprised by the Elders'
c.1647. Black chalk, 20.3 x 16.4 cm.
Kupferstichkabinett, Berlin

27. Christ and the Two Disciples at Emmaus
c.1628. Paper on panel, 39 x 42 cm.
Musée Jacquemart-André, Paris

28. Portrait of the Physician, Ephraim Bonus
Signed 'Rembrandt f.1647'.
Etching, 24 x 17.7 cm.
British Museum, London

29. Detail from the 'Portrait of Jan Six'

30. Self-Portrait in Studio Attire
c.1655. Pen and brown ink, 20.3 x 13.4 cm.
Rembrandt-Huis, Amsterdam

31. Bathsheba holding King David's Letter
Signed 'Rembrandt ft.1654'.
Canvas, 142 x 142 cm. Louvre, Paris

1
Anna accused by Tobit of stealing the Kid

Signed 'RH 1626'. Panel, 39.5 x 30 cm. Rijksmuseum, Amsterdam

The subject is taken from the Apocryphal Book of Tobit, Chapter II, vv, 11-14. Tobit was a wealthy, God-fearing Jew, strict in his observance of the Mosaic law, who had lost all his money and been blinded in an accident. To keep them from starving, his wife Anna took in sewing and washing. One day, hearing the bleating of a kid which Anna had been given to supplement her earnings, Tobit falsely accuses her of having stolen it. In return, she upbraids him for his self-righteousness which has brought them to their present plight (this is the scene represented in the picture). Later, however, the couple's fortunes are restored by their son, Tobias, who goes to find the money his father has lost and to marry a rich wife. On the way he meets the Angel Raphael, who instructs him when they come to a river to catch a large fish, the entrails of which are afterwards applied to Tobit's eyes to cure his blindness.

Rembrandt's lifelong fascination with old people is already evident in this painting, which dates from shortly after he had set up as an independent artist in Leyden in 1625. He was attracted by the lines in their faces and hands and by the very lack of elegance in their bodies, qualities which gave him the opportunity to display his mastery of detail and his skill with the brush. The brushstrokes are so smooth as hardly to be separately visible. Every surface and every drapery fold is carefully modelled in light and shade and, in contrast to his work of only a few years later, no contour line is lost. The colours are warm, pale and bright and the lighting is relatively even. The space depicted is confined but packed with domestic detail: onions hanging up by the window, a basket on the wall, cooking utensils on the shelves, part of Anna's sewing apparatus glimpsed between the two figures, and, in the foreground, Tobit's stick, his dog and a modest fire.

Such meticulously painted still-life detail had been a characteristic of Netherlandish art since the time of Jan van Eyck, if not earlier. However, in contrast to so many examples of its use up to and including the seventeenth century, it appears here to be without ulterior symbolic meaning. Like the expressions on the faces of the two figures and the gestures of their hands, its purpose is to give the maximum reality to the events of the story.

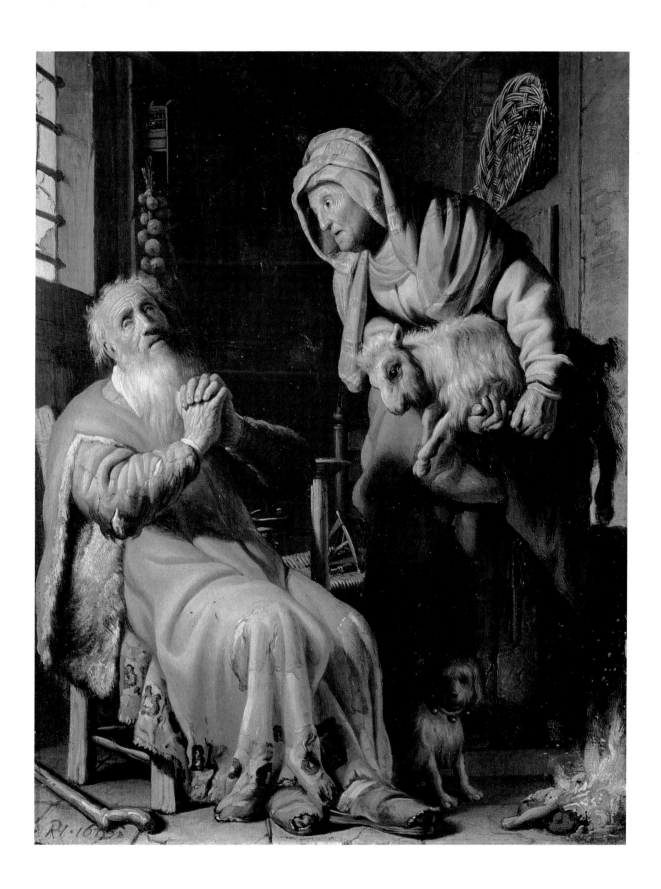

2 Two Scholars disputing (St Peter and St Paul in Conversation?)

Formerly signed 'RH.1628'. Panel, 72.4 x 59.7 cm. National Gallery of Victoria, Melbourne

This is another typical small-scale work of Rembrandt's Leyden period, though now, two years after *Anna accused by Tobit of stealing the Kid* (Plate 1), the tone contrasts have become stronger and the forms more fluent and powerful. The composition is defined by lines which move into the depth of the picture as well as forming a pattern on the surface, and it may not be an accident that 1628 is the first year from which drawings by Rembrandt survive in significant numbers; a spirited chalk study exists for the man in 'lost profile' on the left (Ben.7).

The picture is probably that listed in an inventory, dated 1641, of the possessions of Rembrandt's patron and fellow artist, Jacob de Gheyn III (see Plate 8), where it is described as 'Two old men disputing ... there comes the sunlight in'. The fact that it was not given a more specific title is not unusual and does not mean that Rembrandt had no specific subject in mind.

Assuming that he intended the painting to be more than merely a genre scene, the most likely explanation is that it represents *St Peter and St Paul in Conversation*, as was first suggested by Christian Tümpel ('Studien zur Ikonographie der Historien Rembrandts', *Nederlands Kunsthistorisch Jaarboek*, XX, 1969, pp. 107-98). Tümpel demonstrated that there were several earlier representations of this theme in art (including one in particular by Lucas van Leyden) which show the two apostles as bearded scholars seated together, with one expounding a passage in a sacred book which the other holds on his knee. (The allusion is to St Peter's instruction of St Paul after the latter's conversion, mentioned in Galatians, Chapter I,v.18: 'Then after three years I went up to Jerusalem to see Peter, and abode with him fifteen days.')

It is true that Rembrandt omits the attributes - the key for St Peter, and the sword and the book for St Paul - by which the two apostles were traditionally identified. He relies only on their physical characteristics, as established by artistic precedent, and on what they are seen to be doing, that is earnestly discussing a text which the one (St Peter) is explaining to the other. Could this mean that Rembrandt was merely borrowing the pictorial motif and not taking over the biblical subject? Probably not, in fact, and there are many other instances among his paintings, together with still more among his drawings, in which he disdains the use of obvious - and artificial - recognition signs and represents the religious or mythological scene 'as it might really have happened'.

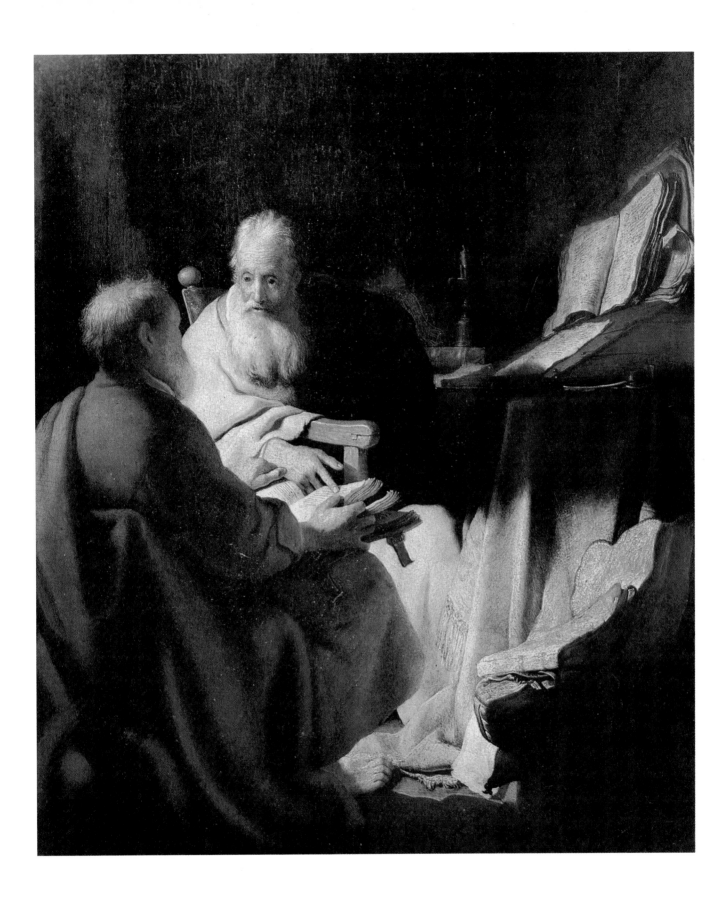

The Artist in his Studio

c.1629. Panel, 25 x 31.5 cm. Museum of Fine Arts, Boston

Fig. 7
Gerrit Dou:
Rembrandt in his
Studio

c.1630. Panel,
53 x 64.5 cm.
Private collection

The theme of the artist in his studio was a popular one in seventeenth-century Dutch art, and Rembrandt returned to it several times in his drawings and etchings, though not again in his paintings (apart from his self-portraits holding palette and brushes, such as Plate 44). On each occasion he did something original with it. Even in this early example, datable to about 1629, the image is very striking. In contrast to most Dutch artists who made of the theme a sumptuous, or at least cluttered, genre scene, Rembrandt depicts a bare room with the plaster cracked and peeling from its walls and with a large panel on the easel, its back evocatively turned towards the spectator. Several feet away from this, the tiny artist stands muffled in a long winter coat and wearing a hat, as if literally posing for his picture.

It is interesting to compare this painting with an almost contemporary representation of a similar, or perhaps even the same, scene by Gerrit Dou, who joined Rembrandt as his first pupil at the age of fourteen in February, 1628 (Fig. 7). So small is the artist in the Boston picture that it has been supposed that it is Dou, not Rembrandt, who is represented. Yet a comparison of the features with those of Rembrandt's early self-portraits, particularly a drawing in the British Museum (Ben.53), shows that the figure is indeed that of the older artist. Moreover, the only other authentic full-length self-portrait by Rembrandt, a drawing made when he was about fifty (Fig. 30), indicates that he was a short, stocky man.

Dou's painting, which dates from about 1630, also depicts Rembrandt, though very differently. There he appears as serious, elegant and almost deferential, and, as if to point the contrast, on the wall there is a typically aggressive *Self-Portrait* - not corresponding exactly to any of the known ones but similar to those in Stockholm and Liverpool (Plate 4). On the easel, this time facing the spectator, is an unidentified biblical scene, also lost, similar to the *Judas returning the Thirty Pieces of Silver* (English private collection; Br.539A), which Huygens admired on his visit to Rembrandt in 1629. Various studio props, among them a bow, a parasol, a globe and a shield and helmet (the last two of which re-appear in other paintings by both Rembrandt and Dou), are disposed about the room, and a visitor comes in at the door. In short, this is a 'public' picture of the artist, whereas Rembrandt's is a more private one. Perhaps neither painter recorded the studio exactly as it was, and the truth may have lain somewhere between the two.

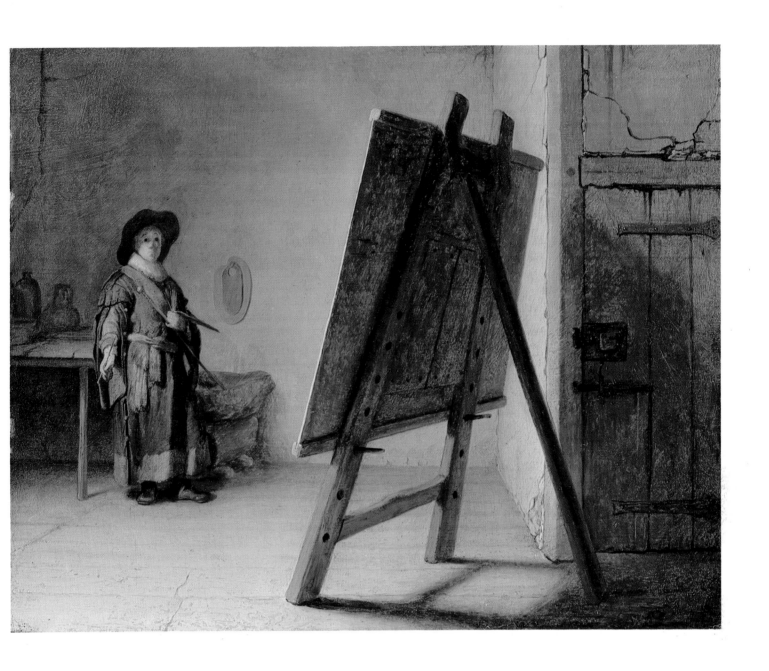

Self-Portrait

1630-31. Panel, 69.7 x 57 cm. Walker Art Gallery, Liverpool

Fig. 8
**Saskia wearing a
Straw Hat**

Silverpoint on whitened
vellum, 18.5 x 10.7 cm.
Later inscribed by
Rembrandt (in Dutch):
'This is a drawing of my
wife, made when she was
21 years old, the third day
of our bethrothal -
8th June 1633'.
Kupferstichkabinett,
Berlin

Rembrandt began making paintings, drawings and etchings of himself in or about 1628, thereby inaugurating a career as a self-portraitist which is unique in the history of art. Those produced up to about 1631, when he moved to Amsterdam, form a distinct group from the rest. The majority - about fifteen - are etchings. Most, like the etching (Fig. 1) reproduced at the front of this book, and to some extent the painting opposite, are not finished self-portraits in the normal sense but studies in expression. Moreover, by comparison with the self-portraits of other artists and with some of Rembrandt's own later ones, they are unusually direct in approach, sketch-like in handling and small in size. In part, Rembrandt was using them for practice, to discover for himself the range of expressions of which the human face is capable; he needed this information for the portrayal of emotion in his subject pictures. In part, however, he was making use of a picture-type - the head-and-shoulders figure marked by a strong facial expression (the seventeenth-century Dutch term is *tronie*) - for which there was a lively market in The Netherlands in the 1620s. With most artists these pictures were of genre subjects: small boys, tramps, drinkers, musicians and so on. Where Rembrandt was original was in using his own features for the purpose.

Gradually, however, he discovered that more normal portraits of himself were marketable. The Liverpool *Self-Portrait* reproduced here dates from towards the end of his Leyden period and is transitional between a study of expression, a *tronie*, and a conventional head-and-shoulders 'portrait of the artist'. The rather sly, wide-eyed look and twisted mouth proclaim the study of expression, while the relatively smooth brushwork, neat black cap, coat with fur collar and gold chain denote the self-portrait. Shortly after it was painted, this picture, together with two others probably from the circle of Rembrandt, found its way into the hands of Robert Ker, Earl of Ancram, who then gave all three to King Charles I. The *Self-Portrait* was almost certainly the earliest painting by Rembrandt to leave The Netherlands and was the first to arrive in Britain.

By contrast, the charming silverpoint portrait of Saskia (Fig. 8), drawn by Rembrandt two days after their engagement, is a genuinely private work, not one made as an artistic exercise or for sale.

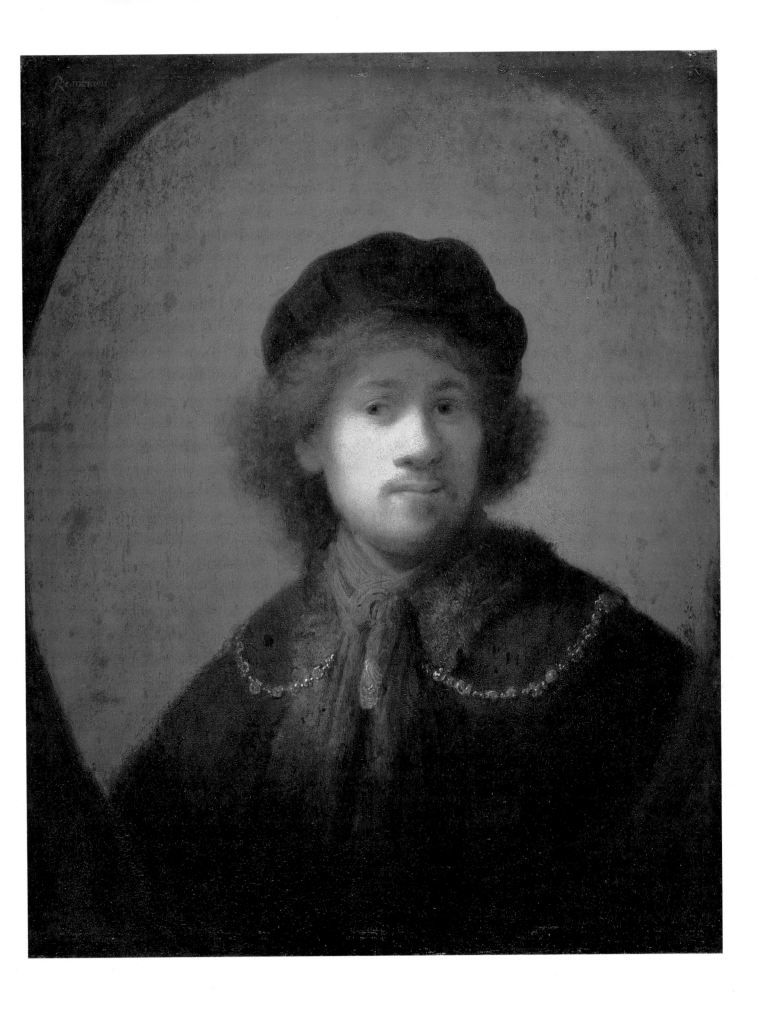

5 An Old Woman reading

Signed 'RHL 1631'. Panel, 59.8 x 47.7 cm. Rijksmuseum, Amsterdam

Fig. 9
A seated Old Man

Signed with initial and
dated 1630. Red chalk,
15.7 x 14.7 cm.
Private collection

The thoughtful portrayal of old people of both sexes is a conspicuous feature of Rembrandt's work, especially in his Leyden years. Plates 1 and 2 of this book are examples of this in his subject pictures. He also often represented old people singly. The models in these paintings are sometimes represented in their own persons, but more often they are dressed in one or more of the exotic costumes which Rembrandt accumulated and kept in his studio wardrobe.

One elderly male and one elderly female model recur repeatedly in his work throughout the Leyden period - and not only in Rembrandt's work but also in that of his associates at this time, Gerrit Dou and Jan Lievens. In the past, these two figures were often identified as Rembrandt's father and mother. The red chalk drawing illustrated here (Fig. 9) is an example of the 'father', but it is now known from another drawing (Ashmolean Museum, Oxford; Ben.56), inscribed 'Harman Gerrits van Rijn', that the artist's father, who died in 1630 aged seventy, looked very different. The question concerning his mother is more difficult, and scholars are still reluctant to let go of the possibility that the figure depicted opposite as *An Old Woman reading* may be Rembrandt's mother, Neeltge van Suydtbrouck. She appears in at least three other paintings by him, including *Anna accused by Tobit of stealing the Kid* (Plate 1) and the first, Hamburg version of *The Presentation of Jesus in the Temple* (Br.535), where she is the Prophetess Anna. The same woman is also represented in five etchings by Rembrandt between 1628 and 1633. The inventory of the estate of the print-dealer, Clement de Jonghe, in 1679 lists an etching by Rembrandt as 'Rembrandt's mother', though without specifying which etching. However, even if we did know which etching was meant, it would be no guarantee that the identification was correct, since dealers often attached fancy titles to Rembrandt's etchings. A further problem is that the woman in these paintings and etchings seems to be a least eighty, whereas in 1630 Rembrandt's mother was only sixty-two (she died in 1640).

It has also been supposed, with more reason, that the woman in this picture represents the Prophetess Anna reading a sacred book. The letters appear to be Hebrew, although they cannot be read as a text. For Anna's role in the story of the Presentation in the Temple, see note to Plate 6.

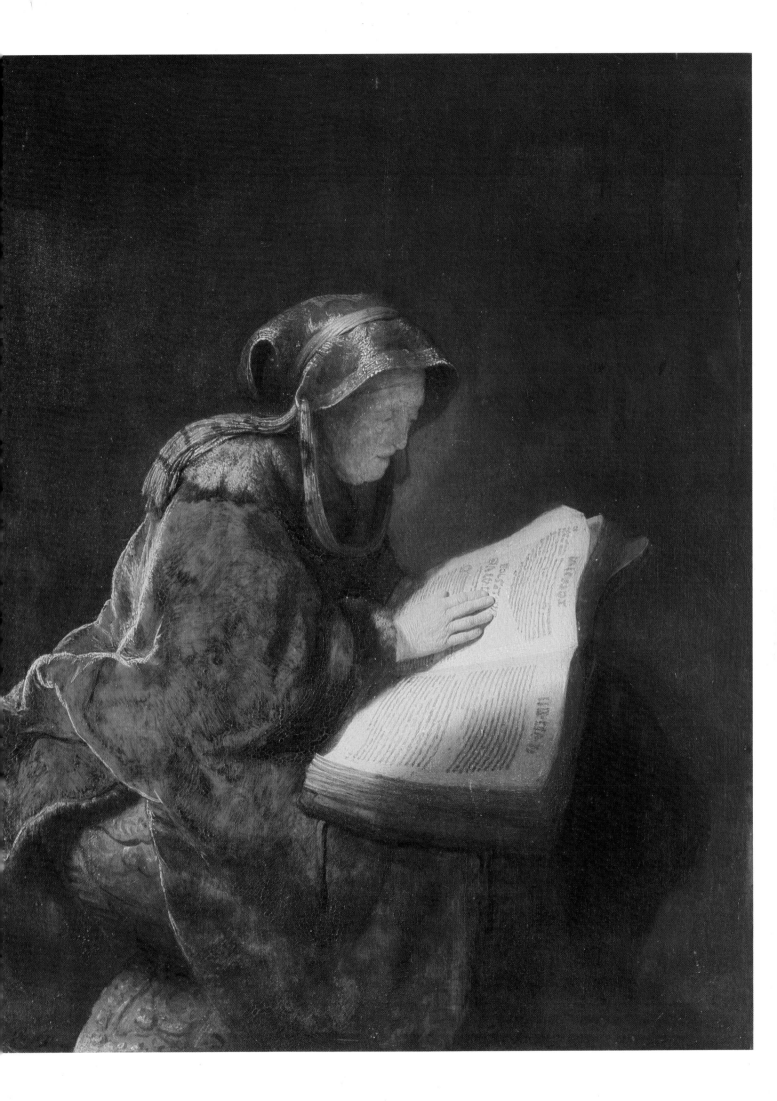

The Presentation of Jesus in the Temple

Signed 'RHL 1631'. Panel, 61 x 48 cm. Mauritshuis, The Hague

Fig. 10
A Beggar standing
with a Stick

Signed (?) 'R' lower right.
1629-30. Black chalk,
29 x 17 cm. Rijksmuseum,
Amsterdam

The story is told in St Luke's Gospel, Chapter II, vv.23-38. In accordance with Jewish law, Mary and Joseph bring the infant Jesus into the temple at Jerusalem to be presented to the Lord. While there, they meet Simeon, an elderly devout man who had been promised that he would not die until he had seen Christ. He takes the child in his arms and speaks the words later adopted for use at Evensong by the Christian Church:

> Lord, now lettest thou thy servant depart in peace,
> according to thy word:
> For mine eyes have seen thy salvation,
> Which thou hast prepared before the face of all people;
> To be a light to lighten the Gentiles,
> and to be the glory of thy people Israel.

The tall robed figure standing with back turned to the spectator is likely to be the Prophetess Anna, who was also present on the occasion.

The painting is a major work dating from the end of Rembrandt's Leyden period. A feature of his style at this time (1630-31) is a liking for elongated figures, diagonal compositional lines and mysterious, cavernous spaces. A little while before, he had represented *The Presentation of Jesus in the Temple* in another painting (now in Hamburg; Br.535) and in an etching (M.191), in both of which he had treated the subject more like a genre scene than he does here; the figures were more animated, Anna faced the spectator, and the space was shallower. Here, on the other hand, there is a sense of grandeur, the mood is immensely solemn and the execution is highly refined. As has been noted in the Introduction to this book, this 'is a picture about looking, about understanding through the eyes'. It marks a 'still' moment in Rembrandt's development preceding the surge of baroque turbulence which appeared in his work a few years later.

A useful insight into his conception of form at this stage can be gained from the drawing of *A Beggar standing with a Stick* (Fig. 10). Rembrandt models the figure with long, vertical strokes, which give a sense of fluidity to the forms as well as a sense of height. Single figures of beggars are a common subject also of Rembrandt's etchings in this period, and two similar beggars peer at the Child from behind the sacred group in *The Presentation of Jesus in the Temple*.

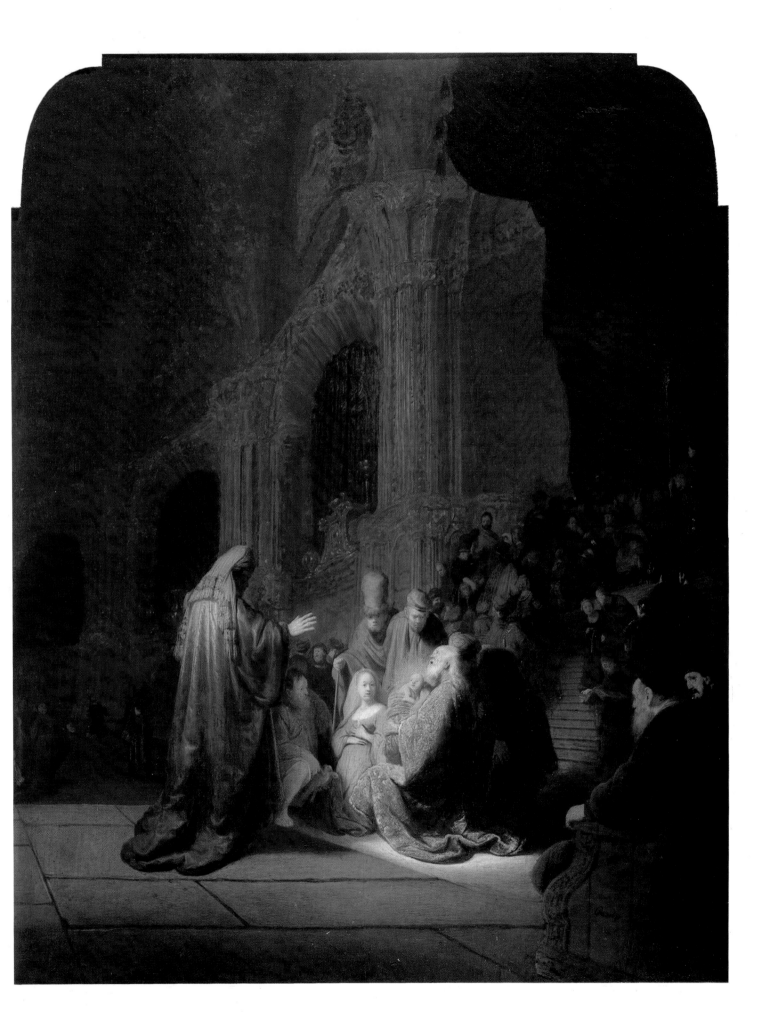

Signed 'Rembrandt f:1632'. Canvas, 169 x 216.5 cm. Mauritshuis, The Hague

The Anatomy Lesson of Doctor Tulp probably hung in the Guild-Room of the Amsterdam Surgeons' Hall in the Nieumarkt from the time it was painted until 1828, when it was bought for the Mauritshuis by King William I. It was Rembrandt's first large picture and was the work with which he consolidated his reputation on moving from Leyden to Amsterdam in 1631-2.

As Riegl first pointed out in his classic study, *Das holländische Gruppenporträt* (Vienna, 1902), the painting marked a turning point both in Rembrandt's stylistic development and in the evolution of the Dutch corporation, or guild, portrait. For the first time, the figures were unified not merely by token gestures and glances but by their common interest in an event taking place within the composition. By 1600, the surgical dissection of corpses in The Netherlands had been made into official, though not frequent, occasions, with fixed procedures controlled by the guild. It was forbidden to hold a dissection, either in public or private, without the guild's permission, and the corpse had to be that of an executed criminal. The only dissection known to have taken place in Amsterdam in 1632 was on 31 January, when the criminal was Adriaen Adriaensz. Dr Nicolaes Tulp (1593-1674) was chief anatomist and lecturer of the Surgeons' Guild of Amsterdam from 1629 to 1653.

Like most Dutch corporation portraits, this painting was not collectively commissioned by the guild but privately commissioned by Tulp and the other persons represented in it; their names are on the paper held by one of them. Moreover, the scene depicted is not an actual dissection – at which there would have been many more people present and the operation would have begun with the opening of the stomach, as in *The Anatomy Lesson of Doctor Deyman* (Plate 35). It is, rather, an imaginary construction, in which the grouping of the figures was dictated by pictorial considerations.

The main action shows Dr Tulp lifting the muscles of the dissected arm to make the fingers curl; he himself echoes this movement with the fingers of his own left hand while he explains what is happening. As W. Shupbach has demonstrated (*The Paradox of Rembrandt's 'Anatomy of Dr Tulp'*, Supplement No. 2 to *Medical History*, London, The Wellcome Institute, 1982), Tulp belonged to a religio-medical tradition which regarded the hand as the supreme mobile instrument bestowed by God on the human body. This was allied to the notion that, since the body was God's creation, the art of anatomy was a pathway to the knowledge of God.

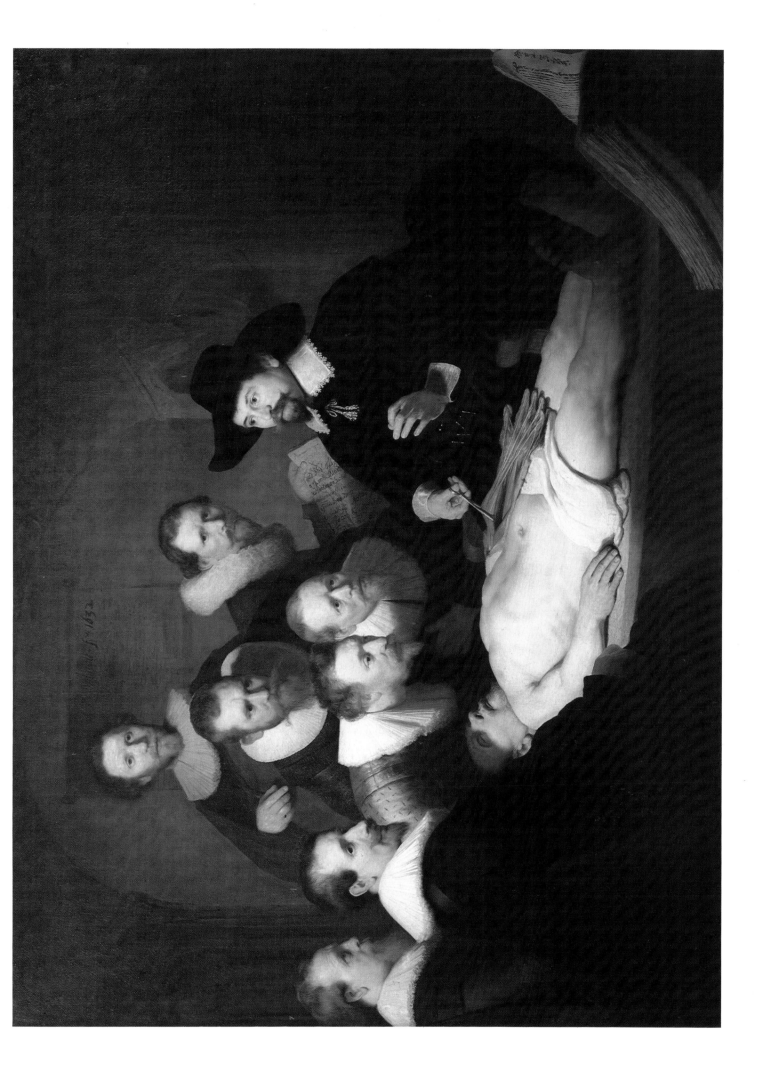

Signed 'RH Van Ryn 1632'. Panel, 29.9 x 24.9 cm. Dulwich Picture Gallery, London

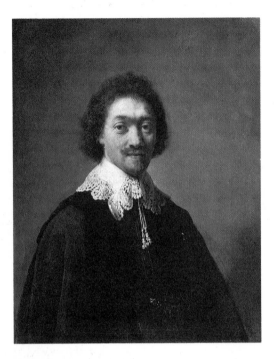

Fig. 11
Portrait of Maurits Huygens

Signed 'RH Van Ry[n]
1632'. Panel,
31.1 x 24.5 cm.
Kunsthalle, Hamburg

Immediately following his arrival in Amsterdam and the beginning of his association with the art dealer Hendrick van Uylenburgh, Rembrandt established for himself a busy portrait practice - an activity with which he had hardly, if at all, concerned himself while in Leyden. A few portraits of Amsterdam citizens were painted even before he had completed *The Anatomy Lesson of Doctor Tulp*. Many more were to follow during the next ten years. Some were half or threequarter-length figures, like the *Young Woman holding a Fan* (Plate 9), a few whole-length, and a considerable number head-and-shoulders only.

The portrait of *Jacques de Gheyn* (1596-1641), known as de Gheyn III because he was the son and grandson of artists of the same name, was painted as a near-companion piece to one of *Maurits Huygens* (1595-1642; Fig. 11), now in Hamburg. The two men were close friends living in The Hague, where Huygens was Secretary to the Council of State, an administrative body under the States-General of the Republic. De Gheyn, like his father and grandfather, was a painter and draughtsman, though not a very prolific one, apparently because he had inherited wealth. The two portraits were almost certainly painted by Rembrandt during a visit to The Hague, and it is likely that Rembrandt was already acquainted with the sitters (de Gheyn was the first owner of the *Two Scholars disputing*, Plate 2). A still more important member of the circle for Rembrandt was Huygens' younger brother, Constantijn Huygens (1596-1687), Secretary to the Stadholder Prince Frederick-Henry; he was a lover of the arts and literature and had warmly praised Rembrandt's work on a visit to his Leyden studio in 1629. Later he was to secure for the artist one of his most prestigious commissions (see Plate 12). When Jacques de Gheyn died in 1641, he bequeathed Rembrandt's portrait of him to Maurits Huygens, as an affectionate inscription on the back of the panel testifies.

The two portraits are unusual in Rembrandt's work in being under lifesize. That of Jacques de Gheyn in particular is painted in a smooth, meticulous manner reminiscent of Rembrandt's Leyden period. The soft chiaroscuro gives plasticity to the forms. According to Constantijn Huygens, who wrote a number of epigrams on it, the portrait was not a good likeness of the sitter.

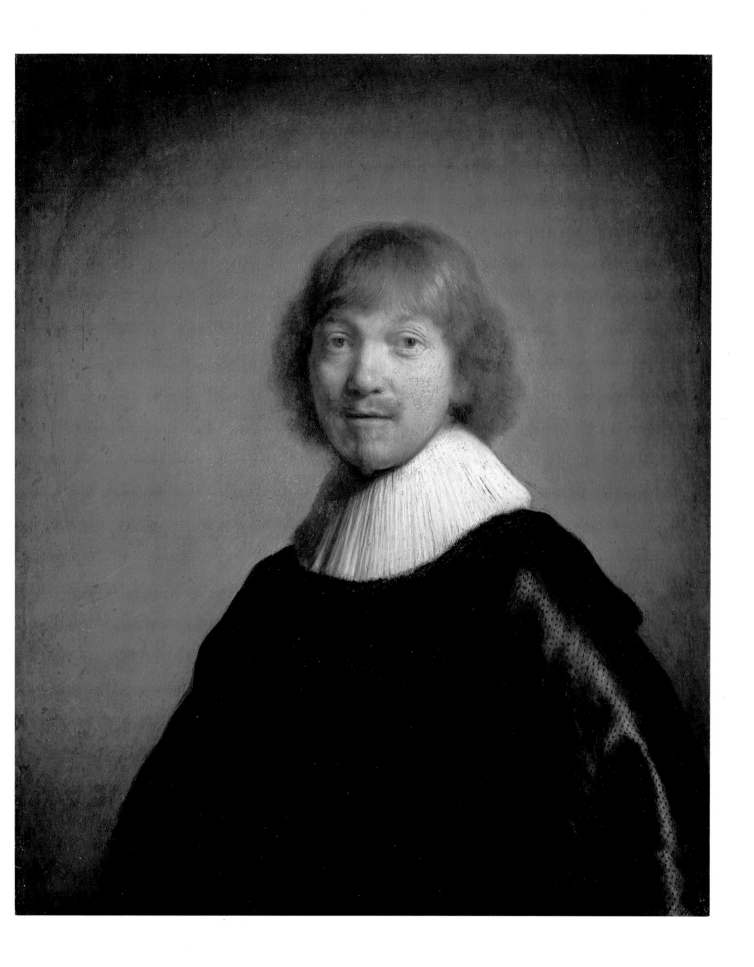

Signed 'Rembrand f 1633'. Canvas, 126.2 x 100.5 cm. Metropolitan Museum of Art, New York

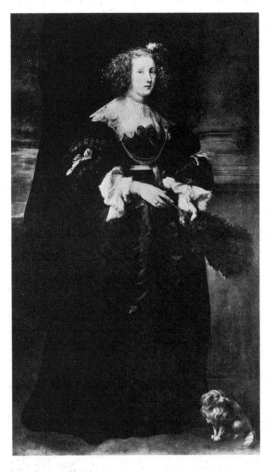

Fig. 12
Sir Anthony
van Dyck:
Portrait of Marie
de Raet, Wife
of Philippe le Roy

1631. Canvas,
215 x 123 cm. Wallace
Collection, London

This confident young woman, represented life-size, is more typical of Rembrandt's portraits of the Dutch upper classes in the 1630s than is that of Jacques de Gheyn. She gazes directly at the observer, her body slightly tilted, and her silhouette almost filling the picture frame. The somewhat awkward rendering of the table at the lower right is apparently accounted for by the fact that it was originally painted as the arm of a chair. Then Rembrandt decided, for pictorial reasons, to raise the right arm of the chair (our left) but was unable to do the same with the other arm as it would have meant re-painting the woman's hand. Accordingly he turned the chair-arm into the corner of a table which he shows covered, as was the Dutch fashion, with a heavy oriental carpet.

It is interesting to compare this portrait with one by Van Dyck dating from his second Antwerp period (Fig. 12). Van Dyck visited The Hague from Antwerp both in 1628 and 1631-2 and was much in demand there at the court of the Stadholder, Frederick-Henry. Among his admirers at this court was the Secretary, Constantijn Huygens, who, as we have seen, was also an admirer of Rembrandt. (It is tempting to think that Van Dyck and Rembrandt might have met when the latter went to The Hague in 1632 to paint the portraits of *Maurits Huygens* and *Jacques de Gheyn* – see note to Plate 8 - though there is no evidence that they did so.) Van Dyck's manner of portraiture was a great deal more elegant, sophisticated and flattering than anything seen previously at The Hague, just as it was to be in London, and his influence swept through Dutch portraiture for a decade.

In the Metropolitan *Young Woman holding a Fan*, Rembrandt takes over from Van Dyck the confident pose, full modelling of the black satin dress, and the hint of movement in the figure. However, the head and hands form a less compact, less conventionally elegant unit than they do in Van Dyck's portrait of Marie de Raet. By spreading out the woman's hands and positioning her shoulders parallel to the picture plane, Rembrandt introduces that element of pictorial surprise which is so characteristic of him. The companion portrait of the woman's husband (Br.172), now in Cincinnati, which shows him rising from his chair and extending his hand in a gesture of welcome, is even more startling.

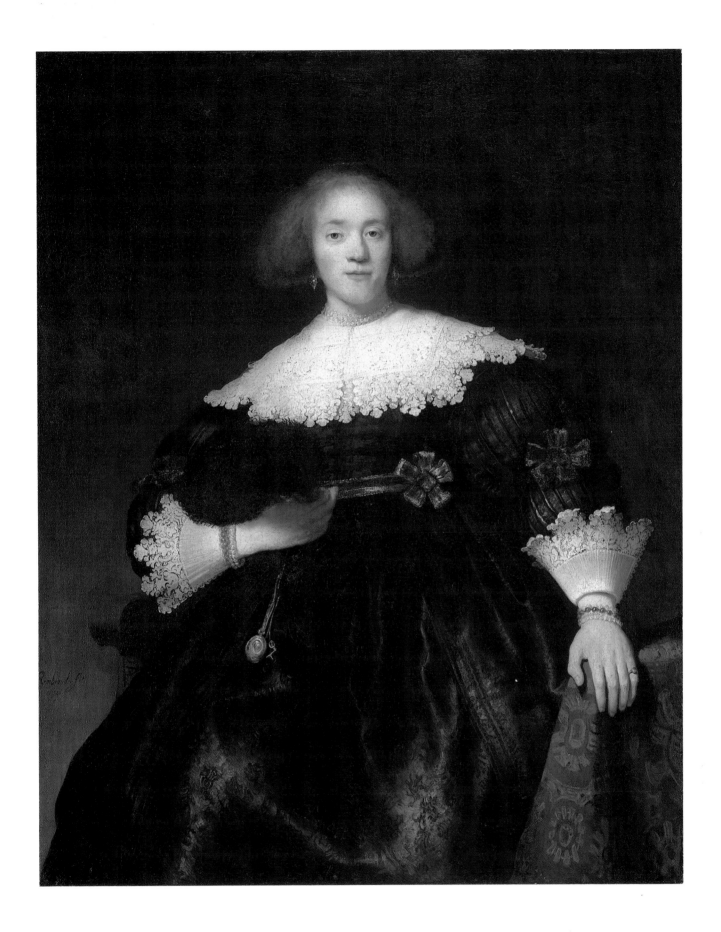

Signed 'Rembrandt f.1634'. Canvas, 125 x 101 cm. Hermitage, St Petersburg

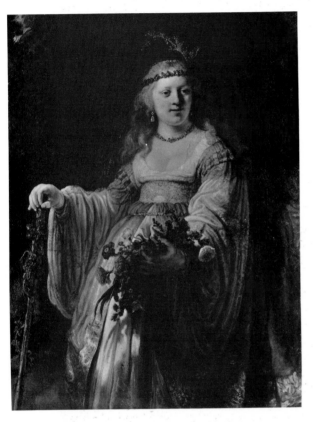

Fig. 13
Saskia as Flora

Signed (falsely)
'Rem...1635'.
Canvas, 123.5 x 97.5 cm.
National Gallery, London

Rembrandt represented Saskia as Flora, the classical goddess of Spring, on at least two occasions: in this picture and in one executed the following year (Fig. 13), now in the National Gallery, London. The identification both of the model as Saskia and of the subject as Flora has, it is true, been challenged. As to the model's identity, the authors of *A Corpus of Rembrandt Paintings* (Vol. II, 1986, A93 and 112) are unpersuaded by the evidence usually cited in favour of its being Saskia, namely Rembrandt's drawing of her made two or three days after their engagement in 1633 (Fig. 8). However, when allowance is made for the fact that the three works were executed in different media and in successive years, it is hard to see how the facial resemblance could be closer.

As regards the subject, it has been thought (see N. MacLaren, *National Gallery Catalogues: The Dutch School*, 1960, p. 334) that Rembrandt was 'merely essaying the current Arcadian fashion', and not depicting Flora. That he was influenced by the contemporary vogue among painters of the Utrecht School for dressing figures up in Arcadian, or pastoral, costumes need not be in doubt, but the theme of both the Hermitage and National Gallery pictures is primarily flowers. Flowers are held in the figure's hand and are entwined in her hair, and no other pastoral accessory, such as a shepherdess's crook or farm animals, is present. The identification of the subject as Flora is, in fact, accepted by *A Corpus of Rembrandt Paintings*, while in the latest edition of the National Gallery *Dutch School* catalogue (by N. MacLaren, revised and expanded by C. Brown, 1991, No. 4930), the model is named as Saskia. What has also been discovered by means of X-rays is that Rembrandt originally intended the National Gallery picture to represent the Old Testament heroine, Judith. In the figure's right hand there was a sword and in her left, where the flowers now are, she held the severed head of Holofernes, which a maidservant was inserting into a large bag. To accommodate this servant, Rembrandt at first used a canvas that was a good deal wider on the right. Later he cut it down, obliterated the signs appropriate to Judith, and painted in the flowers and staff we see now.

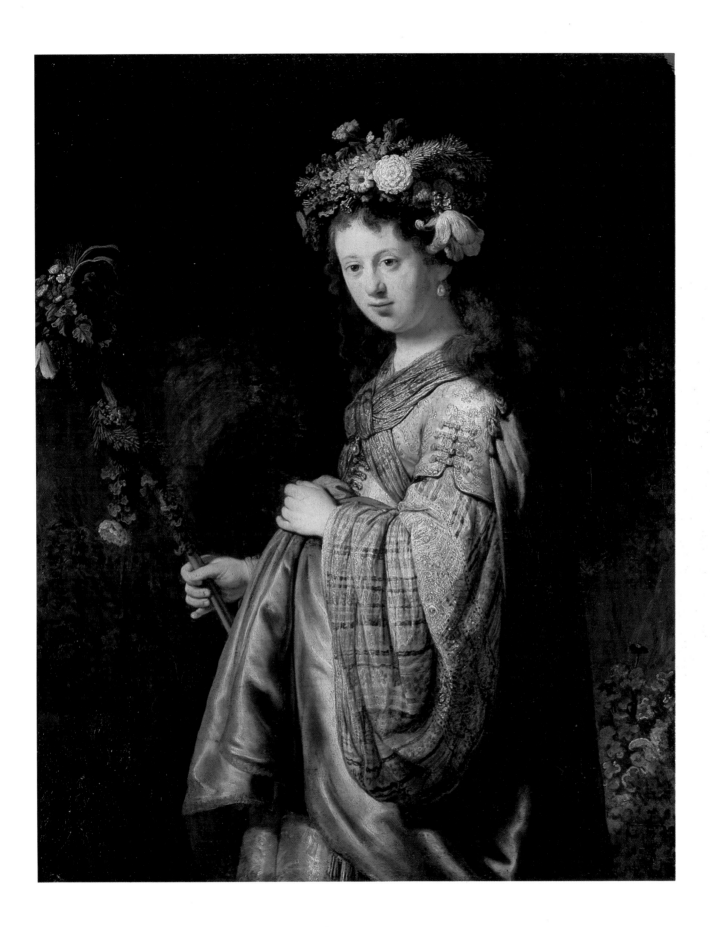

Signed 'Rembrand. F.163'. Canvas, 167 x 209 cm. National Gallery, London

The subject is taken from the Book of Daniel, Chapter V. The Babylonian King, Belshazzar, feasting with a thousand of his lords, wives and concubines, commands the gold and silver vessels, which his father, Nebuchadnezzar, had looted from the temple at Jerusalem, to be brought in and filled with wine. At this, a mysterious hand appears and writes on the wall: MENE, MENE, TEKEL, UPHARSIN. Belshazzar, terrified, sends for soothsayers to decipher the writing but they all fail, and eventually the Jewish captive, Daniel, is summoned. He explains that the words mean that, because of his sacrilege, Belshazzar's days are numbered and his kingdom will be divided. That very night, Belshazzar is slain.

Rembrandt, contrary to western pictorial tradition, depicts the words in Hebrew script. They read vertically downwards, beginning at the top right, and follow a form sometimes found in Jewish literature. Specifically, they are very close to the version printed in *De termino vitae* by the Jewish author, Menasseh ben Israel, published in Amsterdam in 1639, and this has led some critics to suppose that the picture must have been painted in or after that year. However, it is now generally agreed that this is too late on stylistic grounds, and a date of around 1636 is favoured. It is pointed out that Rembrandt lived across the street from Menasseh ben Israel and etched his portrait in 1636 (M.56); thus he could have had access to Menasseh's manuscript in advance of publication or to his research. The resemblance in the lettering is too close for coincidence.

The composition is vaguely reminiscent of a painting by Lastman of *The Fury of Ahasuerus*, now in Warsaw, as was first observed by Keith Roberts (*Connoisseur Year Book*, 1965, pp.65-70), and Rembrandt may also have had in mind Lievens's early *Feast of Esther*, in Raleigh, North Carolina. The figure at the lower right bending back and presenting the top of her head to the spectator is perhaps the first sign of Venetian influence in Rembrandt's art. But whatever the precedents, this is a spectacular example of Rembrandt's baroque style at its most vigorous. The powerful figure of Belshazzar constitutes a tilting axis, to either side of which subsidiary figures cower in fear.

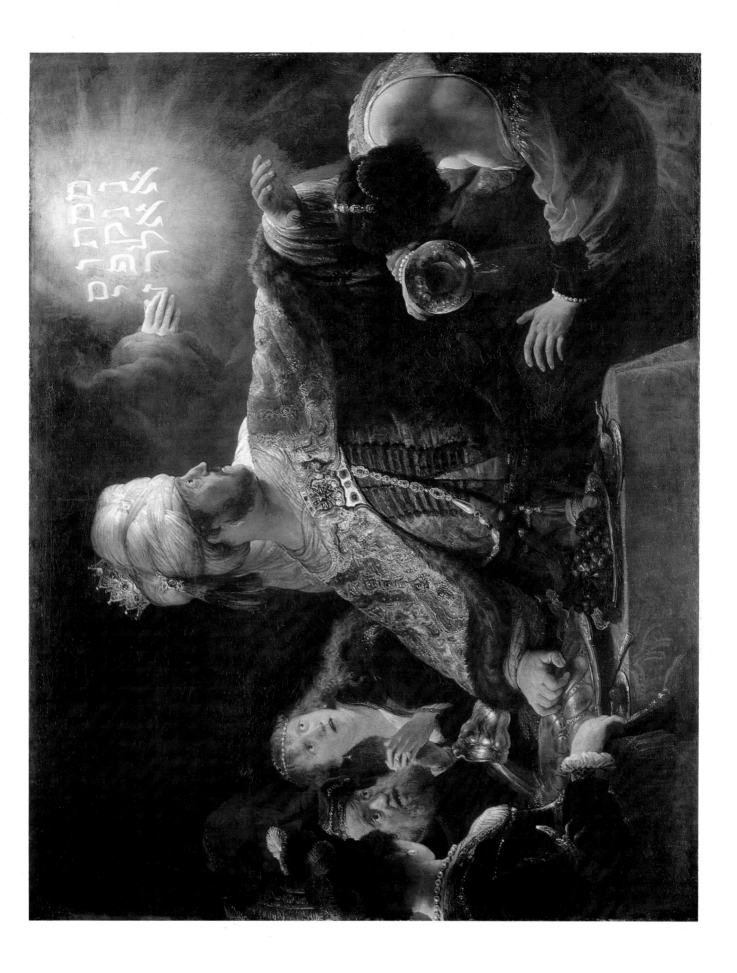

The Entombment of Christ

c.1635. Panel, 32 x 40.5 cm. Hunterian Art Gallery, University of Glasgow

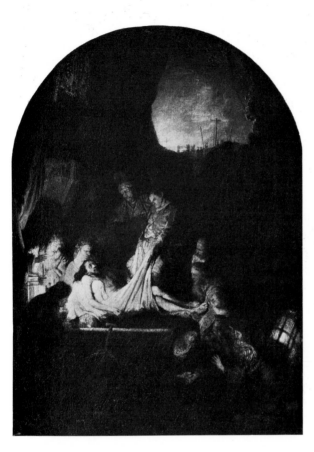

Fig. 14
The Entombment
of Christ

1636-9. Canvas,
92.5 x 70 cm. Alte
Pinakothek, Munich

This monochrome sketch in oils is fairly closely related to the painting of the same subject (Fig. 14) which Rembrandt completed in 1639 as part of a series on the Life of Christ for the Stadholder, Prince Frederick-Henry of Orange (1584-1647). This series, which is now in Munich, comprises six paintings and originally included a seventh, now lost, the *Circumcision*. Frederick-Henry's interest was doubtless first kindled by his Secretary, Constantijn Huygens (1596-87), whom we have already met several times in this book as an admirer of Rembrandt. The commission was not executed in biblical order and may well have been given by stages beginning with the *Descent from the Cross* in 1632-3. It was finally completed only in 1646, with the *Adoration of the Shepherds* and the *Circumcision*.

Some of the events connected with the execution of the series are referred to in seven letters written by Rembrandt to Constantijn Huygens between 1636 and 1639. These are the only letters by the artist to survive and are mainly about money. They show that Rembrandt demanded the large sum of 1,200 guilders for each picture, though he only received that amount for the last two. (The whole history of the commission, so far as it is known, is well summarized by P.van Thiel in the catalogue of the exhibition, *Rembrandt: the Master and his Workshop - Paintings*, Berlin, Amsterdam, London, 1991-2, under No. 13; Rembrandt's letters were published in full, both in the original Dutch and in English translation, by H. Gerson, The Hague, 1961.)

According to Rembrandt's letters, the *Entombment* and *Resurrection* were 'more than half done' at the beginning of 1636 and were finished in January 1639. He said that he had expressed in these two paintings 'the greatest and most natural movement' (for the significance of this phrase, see the Introduction to this book), 'which is also the principal reason why they have been so long in the making'. A date of 1635 for the Glasgow sketch illustrated here, coinciding with the time when Rembrandt presumably began working on the *Entombment*, is acceptable on stylistic grounds. However, he normally used drawings rather than oil sketches as preparatory studies for his paintings, and some scholars have therefore concluded that the Glasgow sketch was originally made for an etching, which was not in the event executed. This sketch is remarkably free in handling and is in some ways technically closer to Rembrandt's drawings and etchings than to his paintings.

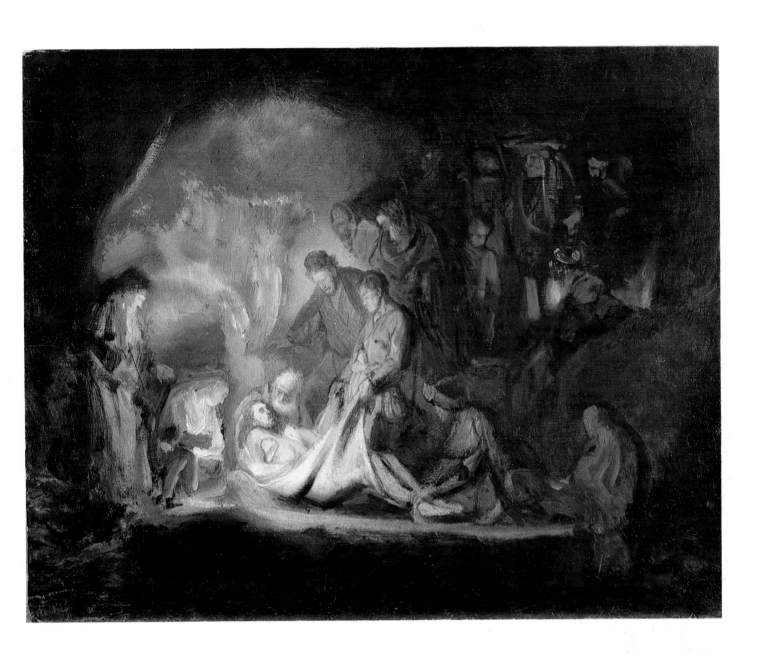

13 The Risen Christ appearing to the Magdalene ('Noli me tangere')

Signed 'Rembrandt ft 1638'. Panel, 61 x 49.5 cm. Buckingham Palace, London (reproduced by gracious permission of Her Majesty The Queen)

The subject is taken from St John's Gospel, Chapter XX, vv.11-17. Christ carries a spade and wears a broad straw hat, the traditional allusion in art to the Magdalene's mistaking him for the gardener. The landscape (detail, Fig. 15) is particularly fresh and beautiful. On the back of the panel is a transcript of a poem in Dutch by Rembrandt's friend, Jeremias de Dekker (1609/10-1666); this was first published in 1660 in *De Hollantsche Parnas*, a poetry anthology which contained several references to Rembrandt:

> As I read the story told to us by Saint John
> And there beside it see the picture, then I think:
> When has the pen ever been so faithfully followed by the brush
> Or lifeless paint been so nearly brought to life?
> Christ seems to say: Mary, be not afraid,
> It is I, and death no longer has any part in thy Lord:
> She, as yet only half believing this,
> Seems to hover between joy and sorrow, hope and fear.
> The rock of the grave rises by art high into the air
> And, rich with shadows, gives a majesty
> To the whole work. Your masterly strokes,
> Friend Rembrandt, have I seen first pass over the panel,
> Therefore shall my pen write a poem to your gifted brush
> And my ink spread the fame of your paint.

The third and fourth lines from the end seem to imply that de Dekker had actually seen Rembrandt at work on the picture. It was painted for, or later owned by, a mutual friend of Rembrandt and de Dekker, H.F. Waterloos.

Fig. 15
Detail from
'The Risen Christ
appearing to
the Magdalene'
('Noli me tangere')

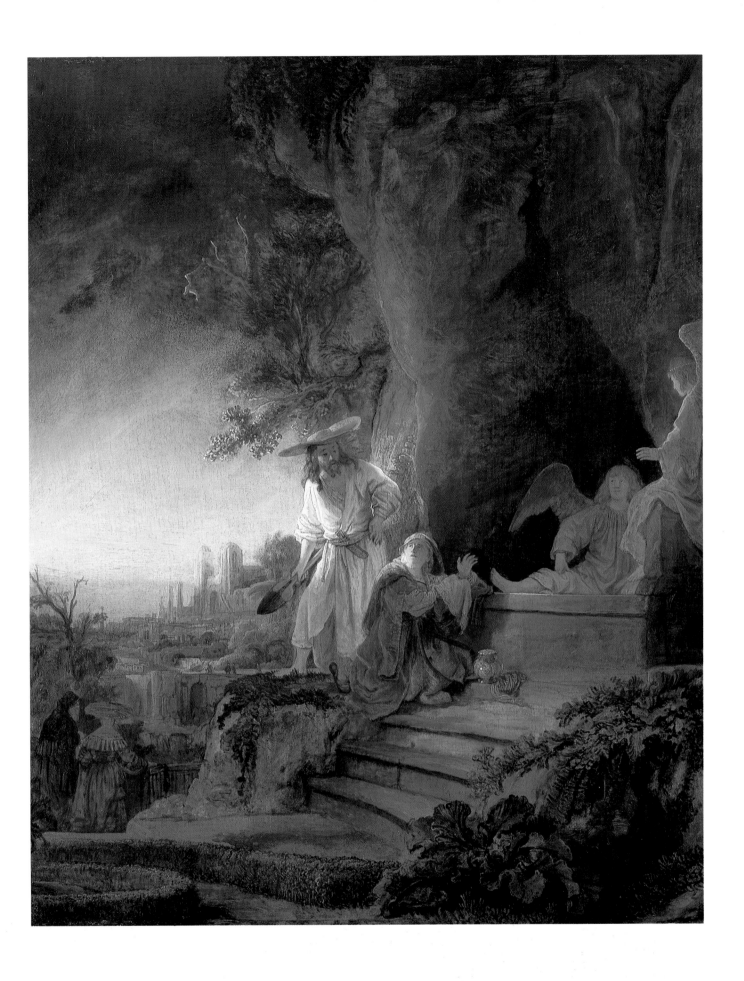

Signed (falsely?) 'Rembran f.1639'. Panel, 102.8 x 78.8 cm. The Duke of Devonshire, Chatsworth (Derbyshire)

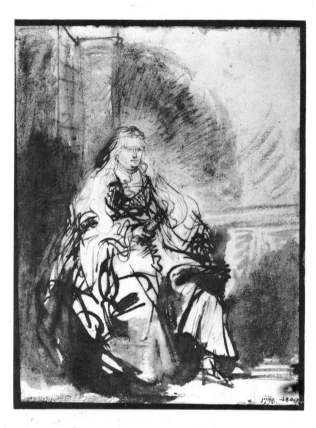

Fig. 16
Study for the etching, 'The Great Jewish Bride'

c.1635. Pen and brown ink wash, 24.1 x 19.3 cm. Nationalmuseum, Stockholm

'Uzziah stricken with leprosy', related in 2 Chronicles, Chapter XXVI, vv. 18-19, is one possible suggestion for the subject of this painting. The story is also told in greater detail by Flavius Josephus in his *Jewish Antiquities*, Book IX, paragraph 222, and Rembrandt may have used that as his source. King Uzziah of Judah, who brought great prosperity to his realm, became so puffed up with pride that he entered the temple of Jerusalem and tried to burn incense at the altar, which only priests were permitted to do. As a punishment for his presumption he was struck down with leprosy. The problem with this interpretation is that it takes no account of the peculiar gold-coloured column, surmounted by a lion's head between two globes and entwined by a snake, which stands on a pedestal on a round table in the right background of the painting. These objects, which also include a chair and a purse hanging from the back wall, ought to have some bearing on the iconography of the scene, but no-one has yet found a convincing explanation for them; they do not easily fit the story of Uzziah. On the other hand, in contrast to most unidentified single figures in Rembrandt's oeuvre, the facial expression is not one of contemplation or repose - quite the contrary. The face is tense with rage or fear, which would be suitable for Uzziah or some other Old Testament figure. Moreover, the face is blotched with greyish-white flecks, which are not due to discolouration of the paint, and can hardly be anything other than the marks of leprosy.

In type, the figure is similar to a number of others dating from the mid and late 1630s in Rembrandt's work, among whom Belshazzar in *Belshazzar's Feast* (Plate 11) is conspicuous; other examples occur among the etchings. The characteristics of this type are a massive square head and body, a thick beard, a broad cap or turban, and very heavy clothes. The study reproduced here (Fig. 16) for the etching, *The Great Jewish Bride* (M.90 - though there is no compelling reason to think that she is Jewish) shows the female equivalent of this figure. The stylistic approach in all of them is strongly baroque, that is, the forms are very fully, not to say aggressively, modelled and the face is richly animated.

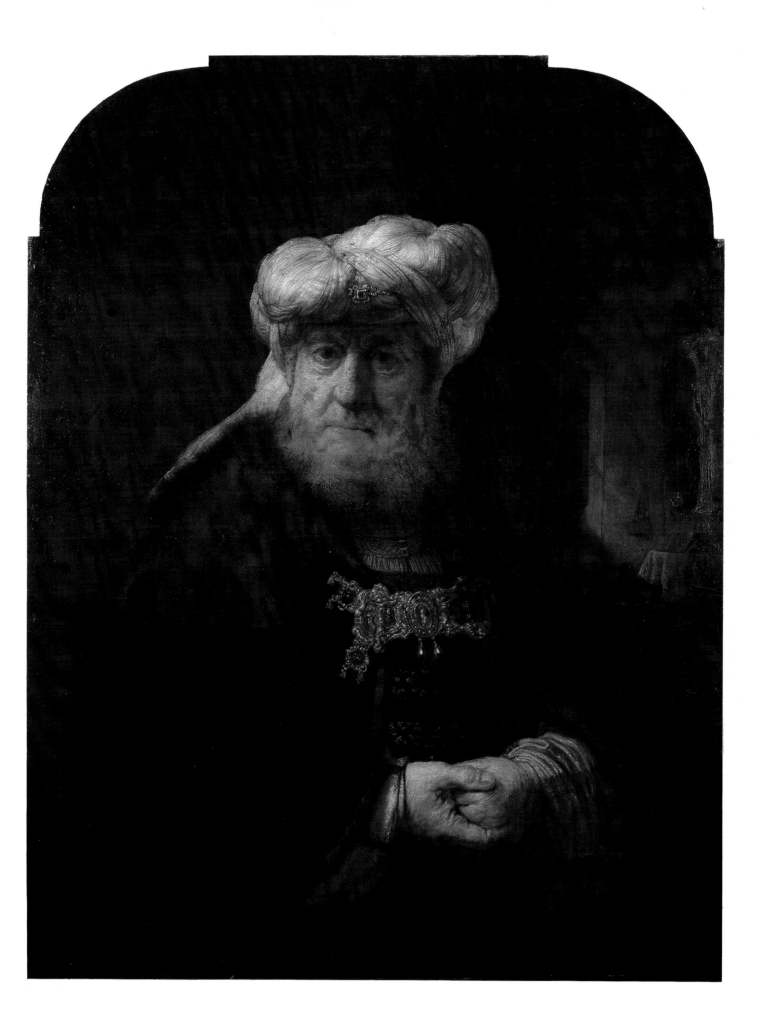

Signed 'Rembrandt f.1640'. Canvas, 102 x 80 cm. National Gallery, London

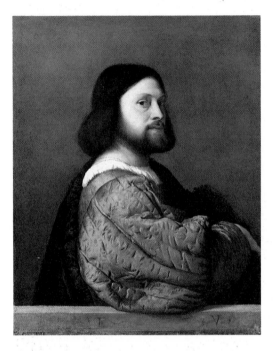

Fig. 17
Titian:
Portrait of a Man

c.1510-15. Canvas,
81.2 x 66.3 cm.
National Gallery, London

Although Rembrandt's habitual method of presenting himself in his self-portraits was as a forceful working artist and social misfit, there were occasions, especially during the first half of his career, when he appeared as a man anxious to conform. In those portraits of which this is true, he is seen as elegantly dressed, with his hair neatly brushed, his moustache and beard trimmed, and with the lighting in the picture so arranged as to make his features more regular and his skin smoother than they probably were in reality. What is more, the handling of the paint is carried to a higher degree of finish than usual, recalling the brushwork used in his commissioned portraits of the Amsterdam bourgeoisie.

The National Gallery *Self-Portrait* is the supreme example of this type. It dates from 1640, the year after Rembrandt moved into his grand house in the Sint-Anthonisbreestraat, and the portrait may be said to mark this. Moreover, at around this time Rembrandt's style generally became more restrained and introspective. One sign of this is that he began studying Italian Renaissance art, the influence of which is evident in the classical poise which characterizes this and other paintings during these years. His sources were chiefly copies and engravings, but in 1639 he saw and sketched Raphael's famous *Portrait of Baldassare Castiglione* (now in the Louvre) when it was put up for sale in Amsterdam. Both this sketch and a *Self-Portrait* etching (M.24) based on it, which was made the same year, were used as partial models for the National Gallery *Self-Portrait*. But an even more important source for the latter was Titian's *Portrait of a Man* (Fig. 17), also now in the National Gallery, which was then believed to represent the poet, Ariosto. It was owned by Alfonso López, a Portuguese-Jewish merchant resident in Amsterdam from 1636 to 1641, who also bought the Raphael. For his *Self-Portrait*, Rembrandt uses a similar type of composition, that is, a stable pyramid, with the head turned towards the spectator, one arm resting on a ledge, and the shoulders and upper part of the body shown in three-quarter view.

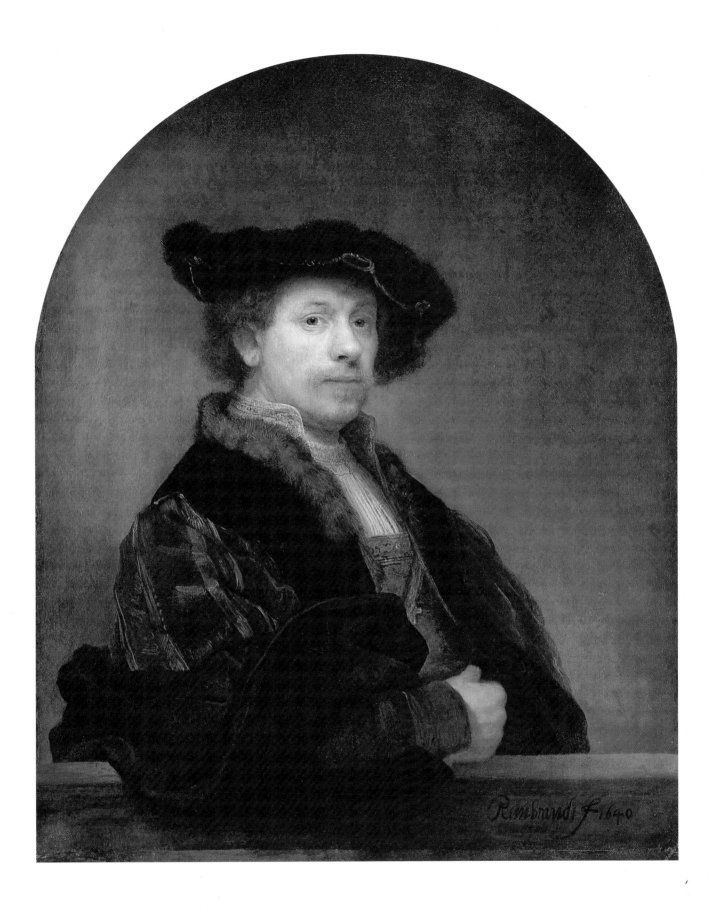

Signed 'Rembrandt f.1641'. Canvas, 104 x 82 cm. Buckingham Palace, London
(reproduced by gracious permission of Her Majesty The Queen)

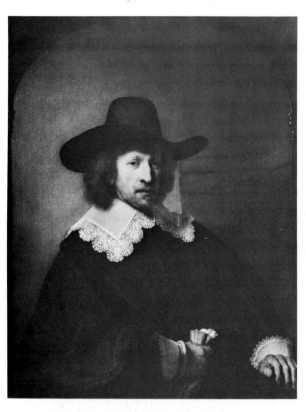

Fig. 18
Portrait of Nicolaes
van Bambeeck,
Husband of Agatha
Bas

Signed 'Rembrandt
f.1641'. Canvas,
108.8 x 83.3 cm.
Musée Royal des Beaux-
Arts, Brussels

The companion portrait of the sitter's husband (Fig. 18; Br.218), also dated 1641, is in the Musée Royal des Beaux-Arts, Brussels; the two paintings remained together until 1814. The identification of the sitters as the wealthy Amsterdam merchant, Nicolaes van Bambeeck, and his wife, Agatha Bas, is due to I.H. van Eeghen (*Een Amsterdamse Burgemeestersdochter van Rembrandt in Buckingham Palace*, 1958). Respectively aged 44 and 29 at the time the portraits were painted, as inscriptions on the canvases testify, the Van Bambeecks lived in the same street as Rembrandt. They were typical members of the high merchant and diplomatic class which sat to Rembrandt in fairly large numbers in the 1630s and early 1640s. However, by this stage the artist's approach was becoming more personal and his interpretation more penetrating than in the previous decade (though the wife's portrait is more remarkable from these points of view than that of the husband). In fact, both portraits belong to a phase (which includes *The Night Watch*) during which Rembrandt seems to have been more than usually interested in illusionistic effects. The figures are placed in painted openings, which give the impression of being windows, though in form they are closer to picture frames. Part of the hand in each case overlaps this frame, as does the womans's fan, which serves to create the illusion that the figures are physically present; in addition, the husband seems to lean slightly out towards the spectator. Apart from his left arm and hand, the composition of his portrait is similar to that of Rembrandt's *Self-Portrait* of 1640 (Plate 15; this also once showed the left hand, until the artist painted it out). With Agatha Bas's portrait, the interest lies not so much in the composition as in the intentness of the sitter's gaze and the brilliant painting of the white lace, the embroidered bodice and the fan.

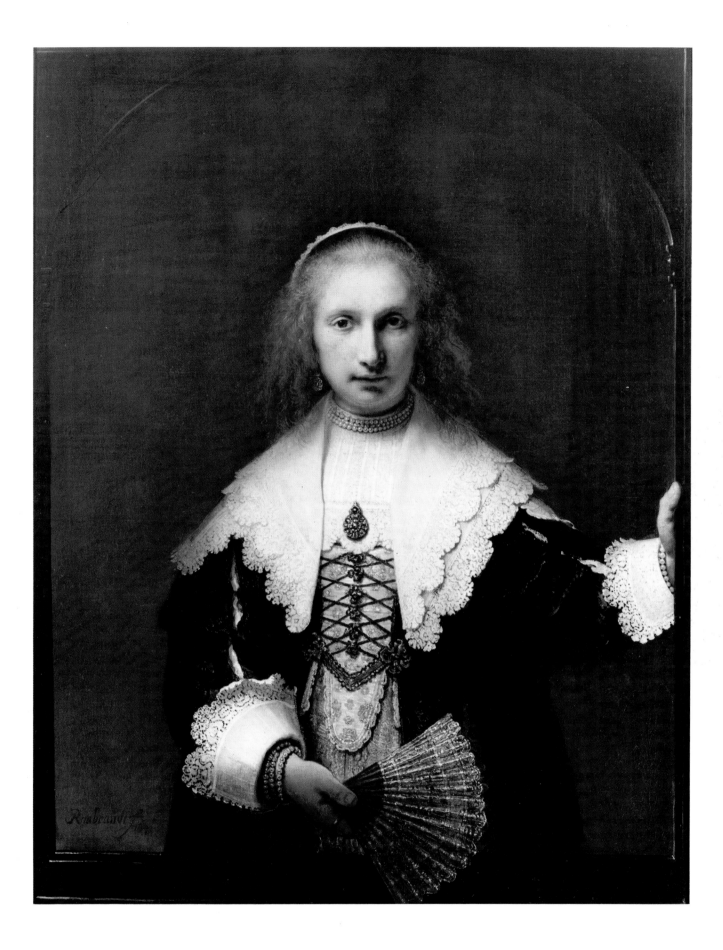

The Militia Company of Captain Frans Banning Cocq ('The Night Watch')

Signed 'Rembrandt f.1642'. Canvas, 359 x 438 cm. Rijksmuseum, Amsterdam.

This painting hung in the Great Room of the Kloveniersdoelen (the Musketeers' Assembly Hall) in Amsterdam until 1715, when it was moved to the Town Hall; it was transferred to the Rijksmuseum in 1808.

So famous a picture, which in the past has been almost as much abused as praised, has not surprisingly given rise to an immense literature. No more than a few selected points from this can be mentioned here. As is shown by early copies, the canvas has been cut, probably when it was moved to the Town Hall in 1715; some 60 cm., incorporating two background figures and a baby, have been removed from the left side, and lesser amounts from the other three sides. This unbalances the composition (the arch in the background was originally nearer the centre) and compresses the figures into too confined a space. In all, twenty-six figures are now fully or partly visible, including three children (or dwarfs?), and small parts of five more figures can just be discerned in the background. (For these and other particulars, see E. Haverkamp Begemann, *Rembrandt: The Night Watch*, Princeton, 1982). To the right of the arch there is a shield, added later, bearing the names of eighteen of the persons portrayed. According to two of them who gave evidence on Rembrandt's behalf during the investigation into his financial affairs in 1658/9, he was paid a total of 1,600 guilders; the sitters contributed an average of 100 guilders each, the sum varying with their prominence in the picture.

A reference in the family album of the captain, Frans Banning Cocq (1605-55), states that the painting shows him directing his lieutenant, Willem van Ruytenburch, to order the company to march out; the captain is in black with a red sash, the lieutenant in pale yellow carrying a ceremonial lance. At least since the cleaning of the picture in 1946/7, it has been evident that the scene takes place in daylight, with the sun streaming down from the top left. A further cleaning completed in 1980 shows that the tones are predominantly cool. The traditional title, *The Night Watch*, which dates from the late eighteenth century, is therefore erroneous but it would be absurdly pedantic to suggest changing it now.

continued overleaf

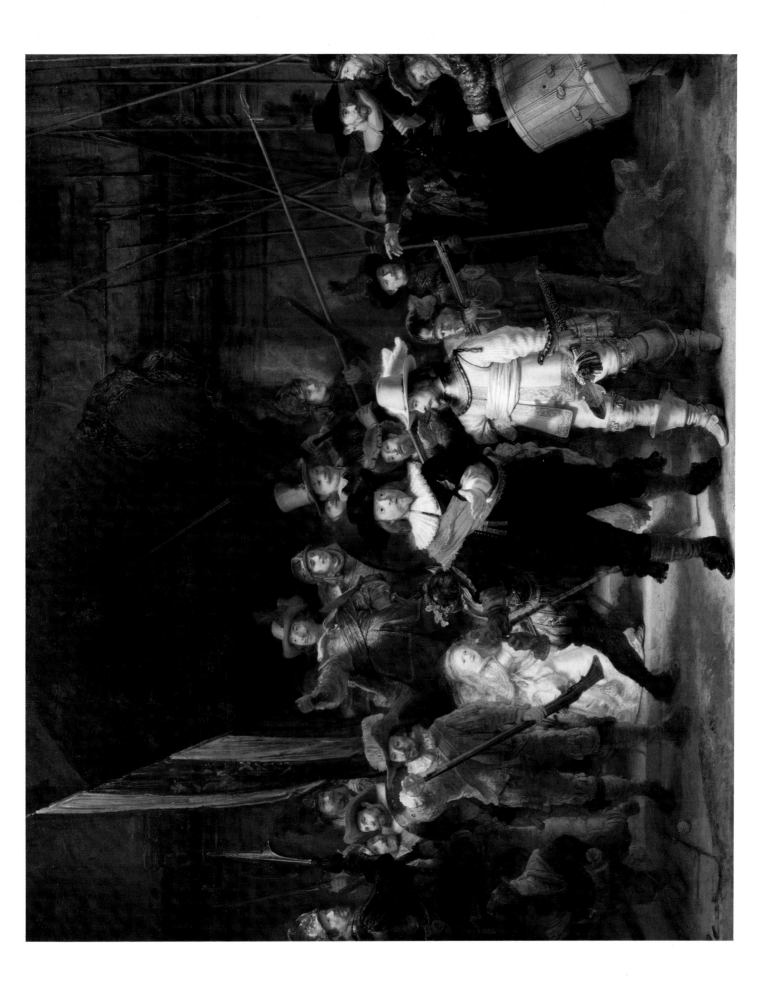

Detail from 'The Militia Company of Captain Frans Banning Cocq' ('The Nightwatch')

Continued

Local militia companies were raised in the sixteenth century during the Dutch war of independence to protect the cities from invasion by the Spanish armies active in Flanders, but by Rembrandt's time they were no longer needed in a military capacity except on the frontier and were kept in being for symbolic reasons. It has been presumed that the company in Rembrandt's painting is marching out to take part in a shooting match. The girl to the left of and behind Banning Cocq carries at her girdle a dead fowl, the prominent claw of which is an emblem of the Musketeers. This bird may also be intended as a punning reference to the Captain's name. Several figures are shown handling their weapons. One pours powder down the barrel of his musket; another, to the right of and behind the lieutenant, is attending to the priming pan; a third – the small figure in a helmet directly behind Banning Cocq – appears to be firing his musket into the air. Various other interpretations of the picture, involving allusions to past and contemporary historical events, have also been put forward, but they are all now discredited. The meaning of the painting is likely to be purely that of a role portrait, the theme of which is the 'citizen in arms'.

Visually, *The Night Watch* is also unlike any other group portrait. Some characters are represented much more distinctly than others, and the eighteen who subscribed are supplemented by almost as many subordinate figures, included by Rembrandt for pictorial effect. The group portrait is here transformed into an action picture: a work of dazzling inventiveness and splendour or, as some nineteenth-century critics maintained, a wildly over-inflated account of a very ordinary event. It marked at once a revolution in, and the swan-song of, the militia company portrait for, shortly afterwards, the demand for these portraits ceased and artists turned to the quieter, more humdrum themes of the guild portrait and the portrait of the board of hospital governors. Moreover, Rembrandt himself was never to paint such a flamboyant or such a fully baroque picture again. However, one thing is certain: *The Night Watch* was a success at the time. The story that it was disliked by those portrayed and that it was the cause of the decline in Rembrandt's contemporary reputation (which did occur to some extent in the later 1640s and 1650s) is a romantic fiction invented in the nineteenth century. Indeed, it is a wonder how this fiction arose, since there is abundant evidence to show that for more than a hundred years after it was painted *The Night Watch* was widely regarded as Rembrandt's most celebrated work.

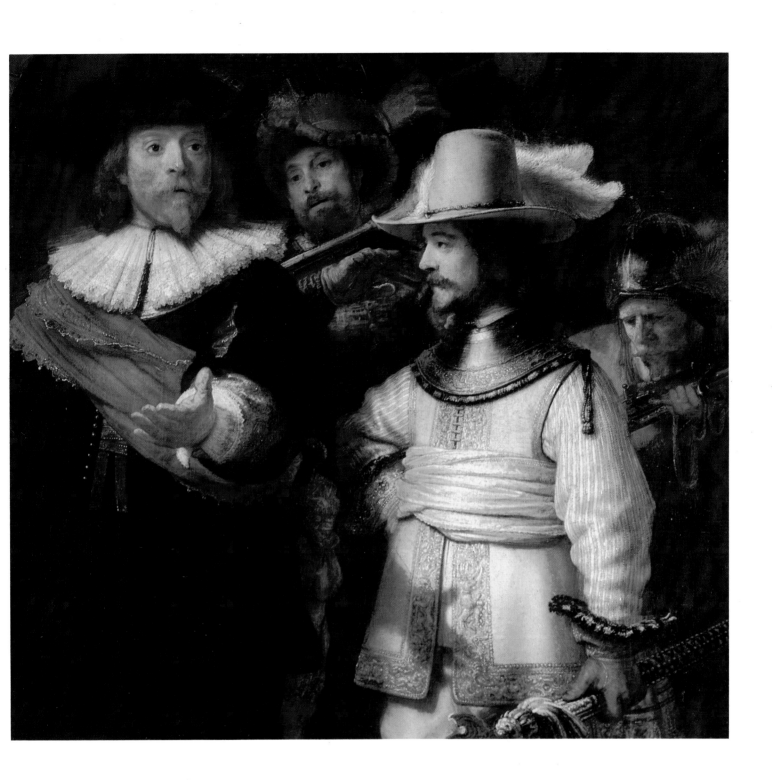

1642-6. Panel, 44.5 x 70 cm. Louvre, Paris

Although Rembrandt used extensive landscape settings in several of his early biblical and, more particularly, mythological pictures, he only took up landscape painting proper for the first time in the late 1630s. (By this term is meant paintings in which the landscape is the main subject, not necessarily paintings without figures.) He probably produced fewer than a dozen landscapes in oils altogether and seems to have given up the practice after 1650. In drawings and etchings, his landscapes formed a higher proportion of the total but these too were confined to the middle twenty years of his career.

The *Landscape with Buildings* illustrated here is the most monumental of Rembrandt's landscape paintings, even though it is not physically large. It is also the most classical, and may be compared with Annibale Carracci's *Landscape with the Flight into Egypt* (Fig. 19), painted in Rome about 1604, which Rembrandt might have known in a copy (the picture does not seem to have been engraved). In both paintings, the skyline is dominated by a mixed group of buildings, seen partly in sunshine and partly in shadow. These buildings are so fully integrated with the landscape that they seem almost like extensions of it, as if they were outgrowths of rock rising out of the hillside. The foreground is occupied by a placid river, which in the case of Rembrandt's picture is crossed by a low classical bridge. Rembrandt may, in fact, have left the Louvre painting unfinished and perhaps would have included figures, though whether they would have represented the *Flight into Egypt* is impossible to say.

Fig. 19
Annibale Carracci:
Landscape with
the Flight into
Egypt

c.1604. Canvas,
122 x 230 cm. Galleria
Doria - Pamphili, Rome

Signed 'Rembrandt. f.1644'. Panel, 83.8 x 65.4 cm. National Gallery, London

Fig. 20
**Sheet of Studies
of Women and
Children**

c.1636. Pen and brown
ink, 13.4 x 12.8 cm.
Private collection, Boston

The subject is taken from St John's Gospel, Chapter VIII, vv. 2-11. A woman found committing adultery was brought before Jesus in the temple by the scribes and pharisees to see whether he would uphold the Mosaic law, which demanded that she be stoned to death. He replied by stooping down and writing with his finger on the ground: 'He that is without sin among you, let him cast the first stone.' One by one the woman's accusers stole away and she was pardoned.

The painting is probably that mentioned in the inventory, dated 1657, of the Amsterdam art dealer, Johannes de Renialme, where it is described (in Dutch) as 'A picture of the woman taken in adultery by Rembrandt van Rhyn'; it was valued at 1,500 guilders, half as much again as any other painting in his collection and only slightly less than the artist received for *The Night Watch*. *The Woman taken in Adultery* continued to fetch high prices down to the early nineteenth century, when it was bought by J.J. Angerstein, with whose collection it was acquired at the foundation of the National Gallery in 1824.

The painting was thus probably always a 'collector's piece' and is the kind of relatively early, highly finished Rembrandt which appealed to the taste of the seventeenth, eighteenth and early nineteenth centuries. Indeed it looks as if the artist deliberately painted the central group in an earlier, more finished style than was usual for him at this date (1644), no doubt to please the patron. The sketchier background figures are in the manner of the drawings from nature (Fig. 20) which Rembrandt had been making for the past decade. The bright colours and meticulous brushwork used for the central group are in the manner of *The Presentation of Jesus in the Temple* of 1631 (Plate 6); the composition is also reminiscent of that painting. However, the surrounding figures are handled more broadly and the receding diagonals of the earlier work have been rearranged so as to form a pattern more nearly parallel to the picture surface. The fiery golds and reds of the throne at the upper right form an area glowing with colour and touched with the mystery typical of Rembrandt's paintings in his middle period.

A Girl leaning on a Stone Pedestal

Signed 'Rembrandt ft.1645'. Canvas, 82.6 x 66 cm. Dulwich Picture Gallery, London

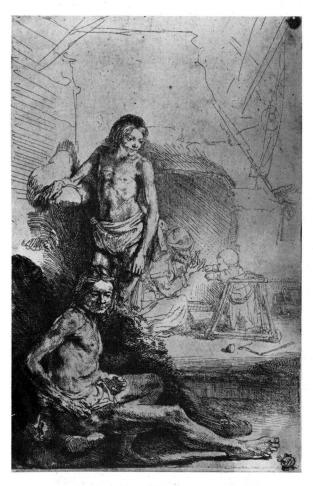

Fig. 21
Studies of
the Nude, with
a Woman and Baby
lightly etched in
the Background

c.1646. Etching,
19.4 x 22.8 cm.
British Museum, London

This painting of a young girl exhibits a freedom from tension rare in Rembrandt's work; not even his portraits of Saskia show a similar unself-consciousness more than once or twice (for example, the silver-point drawing reproduced as Fig. 8). In the Dulwich picture he portrays, in a moment of ease, fresh-faced girlhood without ulterior motives. The same feeling transferred to a religious context is expressed in the paintings of the Holy Family illustrated in the next two Plates. This is Rembrandt, in mid-career, revealing himself at his most relaxed and most beguiling.

Underlying his approach here is a new objectivity in his attitude to the human figure. He does not seek to dramatize it, caricature it or make it appear in motion, but is content to represent it for its own sake. One is more aware in this picture than usual of the existence of the studio, of the daily work of drawing and painting the posed model. The same may be said of the etching of a boy shown in Fig. 21 (it is the same boy etched twice). The figure exists simply to be represented - which is not to say that Rembrandt is interested only in pure form without emotional expression. He made a preliminary sketch of the girl in black chalk (now in the Princes Gate Collection, The Courtauld Institute; Ben.700); in this her arms are posed differently and her hair is untidier. However, the existence of the sketch does not mean that the picture was not painted from the life. Perhaps, as in the drawing, the girl was leaning on a small table or desk, which Rembrandt translated in the painting into a medieval stone pedestal abutting a wall with an opening in the centre behind the girl's head. (Previously the picture was thought to show the figure leaning out of a window, but this is incorrect; see C.J. White in the exhibition catalogue, *Collection for a King: Old Master Paintings from the Dulwich Picture Gallery*, Washington, DC, and Los Angeles, 1985.)

The figure is as richly modelled in three dimensions as any in the artist's earlier work, but the handling is now broader and the treatment as a whole more atmospheric.

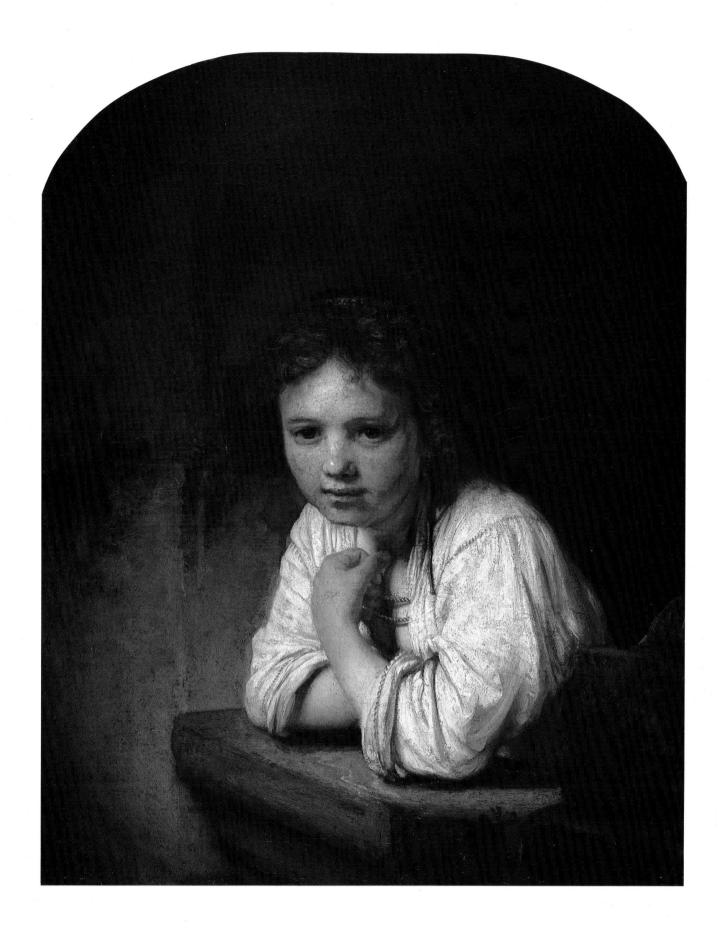

The Holy Family with Angels

Signed 'Rembrandt f.1645'. Canvas, 117 x 91 cm. Hermitage, St Petersburg

Fig. 22
The Holy Family
with Angels
(by Rembrandt
or a pupil)

c.1645. Pen and brown
ink, 16.1 x 15.8 cm.
Musée Bonnat, Bayonne

During the 1640s, Rembrandt turned more often than at any other time in his career to the theme of Christ's birth and infancy; he depicted repeatedly, in paintings, drawings and etchings, the Adoration of the Shepherds, the Flight into Egypt and, above all, the Holy Family. The painting of this last subject now in the Hermitage is surely the most tender, the most perfect and the most poetic of them all, and indeed it is one of the most poetic Holy Families anywhere in art. Unusually for Rembrandt, angels enter the room: not a swarm of ecstatic grown-up angels, as in Italian baroque art, but a few small boys, at least one of whom, with his wings and arms outstretched, hovers over the cradle with an expression of considerable surprise. In the background Joseph works away, unconcerned, at his carpentry.

Mary, meanwhile, with a book in her hand, looks up from her reading and turns towards the Child, raising the cover that shields him from the firelight, to gaze at him or perhaps just to make sure he is all right. It is - one cannot avoid the expression - an intensely human scene. But no artist in history was more adept than Rembrandt at rendering the spiritual in human terms.

As has been explained in the Introduction, Mary is depicted almost but not quite as an ordinary Dutch peasant girl; not quite, for her features are a little more regular, her face more perfectly oval, than any actual girl's would be, and she wears clothes which hint at the traditional idealized garments of the Madonna as represented in Italian art. The baby and the cradle are in a way more surprising as they are genuinely realistic. The cradle is the handsomest object in the room. The baby, its face as plain as any human baby's, is sound asleep. We rely on Mary, the angels and the overall mood of the picture to tell us that this is a religious scene.

There is, in Bayonne, a brilliant pen and ink sketch connected with the painting (Fig. 22; Ben.567), showing how Rembrandt conceived the composition in almost geometrical terms; in this drawing, to quote Benesch, 'not only solids but rays of light turn into tracks of energetic line'. However, doubts have recently been felt about the authenticity of this sheet, which may be by a pupil who would have sketched the painting as an exercise, possibly while Rembrandt was still working on it.

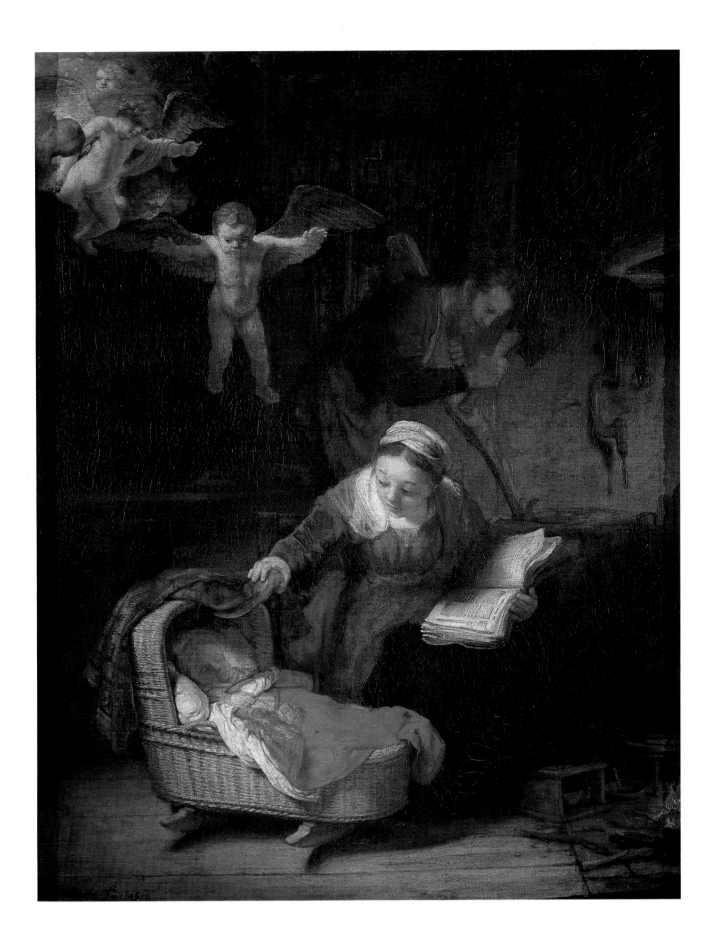

The Holy Family with a Cat

Signed 'Rembrandt ft 1646'. Panel, 46.5 x 68.5 cm. Schloss Wilhelmshöhe, Cassel

Fig. 23
Saskia's Lying-In Room

c.1640. Pen and brown ink
with brown and grey
washes, 14.3 x 17.6 cm.
Institut Néerlandais
(Fondation Custodia),
Paris

The remarks in the note to Plate 22 about the importance of the theme of the Holy Family to Rembrandt in the 1640s also apply to this picture. As might be expected, *The Holy Family with a Cat* is far from being a mere repetition. For one thing, it is more obviously domestic, not to say bourgeois, in mood. The Holy Family is set in just such an interior as Rembrandt himself might have inhabited - and indeed did inhabit, as the drawing of Saskia's lying-in room (Fig. 23) shows. This is not to say that he literally reproduced his own surroundings or that the Madonna and Child are to be understood as portraits of Saskia and one of her children (Saskia had been dead for four years in any case). The painting is not autobiographical in that way. What it shows is how narrow the gap was in Rembrandt's art - never more so than at this stage of his career - between the real and the spiritual: narrow, that is, but also profound. For him, the materials were all there in his drawings from the life of women and children, beggars, artisans, room interiors and furnishings. Yet when put together in his paintings, sweetened and enveloped in light and shade, these materials were transformed into the elements of a religious scene.

The other distinctive feature of this picture is the elaborately designed imitation frame and the curtain. How often Rembrandt's paintings were in fact framed in this manner is hard to say; to judge from contemporary inventories, probably rather seldom. Plain or perhaps lightly carved black ebony frames seem to have been the rule. Yet on two or three occasions, Rembrandt sketched an architectural frame round a drawing of the composition, indicating that this was how he would like the painting to be displayed. It added dignity to the work, gave an extra sense of depth to the pictorial space, and gave the picture something of the character of an altarpiece or shrine. The curtain is also a substitute for a real one. In the seventeenth century, curtains were sometimes hung in front of pictures, partly to protect them from dust but chiefly, it seems, to enhance the effect of surprise. When the curtain was drawn back, the 'marvel' of the work of art seemed all the greater.

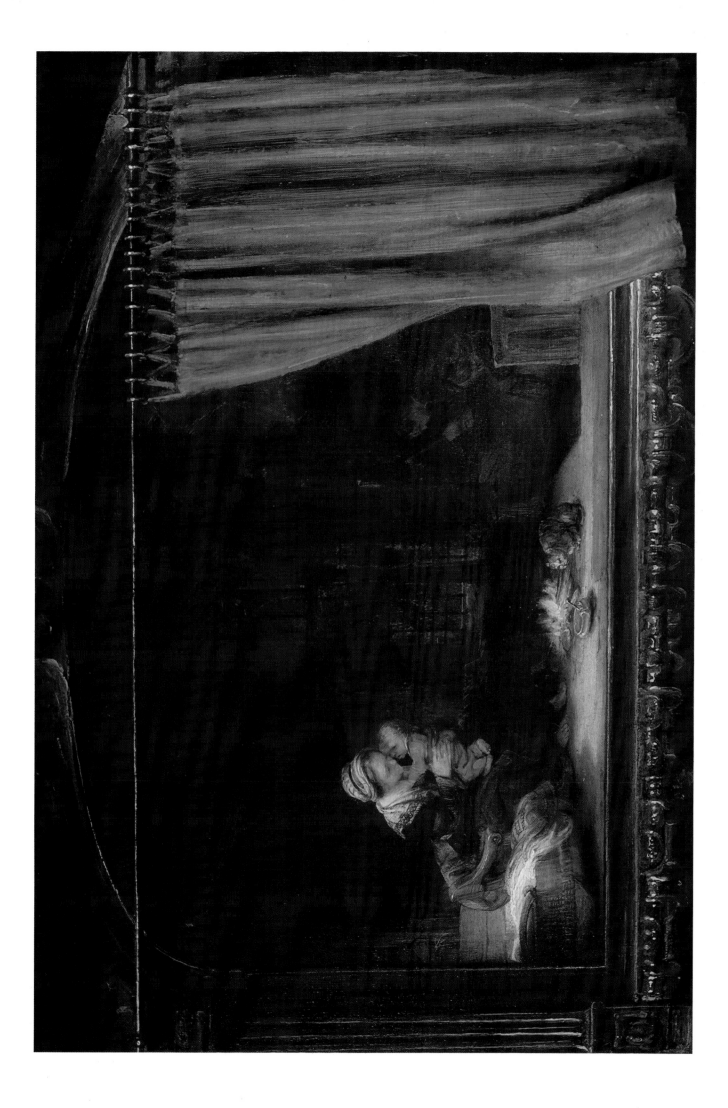

Signed 'Rembrandt f.1646'. Panel, 17 x 23 cm. Schloss Wilhelmshöhe, Cassel

Fig. 24
Farm Buildings by a River

c.1652-3. Pen and
brown ink with wash,
14.9 x 24.8 cm. The Art
Institute of Chicago

Fig. 25
The Goldweigher's Field

Signed 'Rembrandt 1651'.
Etching, 12 x 31.9 cm.
British Museum, London

For the most part, Rembrandt reserved his direct responses to the flat, open countryside of his native land for his drawings and etchings (Figs. 24 and 25). Very few of his painted landscapes show the same naturalism of approach and, of those that do, the *Winter Landscape* is the only one not to be partly veiled in shadow; though to judge from his inventory of 1656, there may once have been more, for several 'small landscapes' by Rembrandt are listed in it, and one is even described as having been painted from nature. The *Winter Landscape* would not have been painted in this way, as artists did not work out of doors at that time of year, but its small size and broad handling suggest that it was a sketch. It is less decorative than other Dutch *Winter Landscapes* of the period, and the depiction of the weather is startlingly realistic.

However, if a feeling for the open air is the exception in Rembrandt's paintings, it is precisely this quality which is conveyed by his drawings and many of his etchings. In the former especially, Rembrandt's method of composition was very simple and direct. Instead of framing the landscape with trees on one or both sides and opening out a vista in the centre, as was usual at the time, he normally placed the principal subject in the centre middle distance and led the eye to it across an almost empty foreground. Any view into the far distance would occur at the sides. The flatness of the ground is emphasized by a horizontal line across the width of the composition and the subject is set in a plane strictly parallel to the picture surface. (This also applies to the painted *Winter Landscape*.) The subject itself is usually a church, a windmill or farm-buildings with trees. No other visual source, surely, yields so much or such reliable information about the economy of the Dutch countryside in the seventeenth century as Rembrandt's drawings and etchings (see also Fig. 6).

Although some of his landscape etchings are mere finished translations of his drawings into a different medium, others, like *The Goldweigher's Field* (Fig. 25), are more complex. In etching, he was able to take advantage of the fine line produced by the needle, a line considerably finer than any pen-stroke, to render both a greater quantity of detail and a wider effect of space.

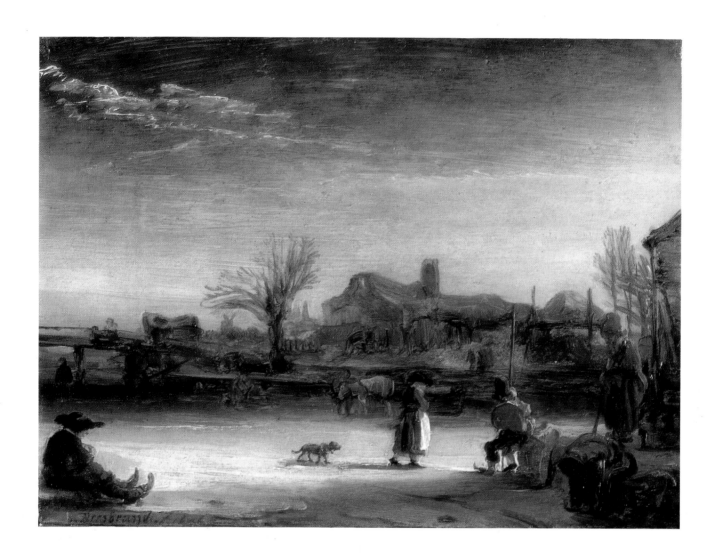

Signed 'Rembrandt f.1647'. Panel, 76.6 x 92.8 cm. Gemäldegalerie, Berlin

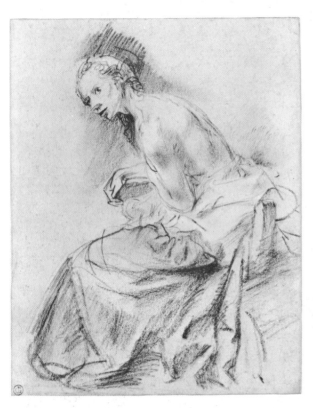

Fig. 26
Study for 'Susanna
surprised by the
Elders'

c.1647. Black chalk,
20.3 x 16.4 cm.
Kupferstichkabinett,
Berlin

The subject is taken from the Apocryphal History of Susanna. Two Jewish Elders, hidden in the garden, threaten Susanna that they will publicly accuse her of committing adultery with a young man unless she gives herself to them. In contrast to most representations of this theme in art, Rembrandt's painting is not a scene of violence. Susanna's awareness of her dilemma is apparent in her expression as she attempts to cover her nakedness: 'Then Susanna sighed and said, I am straightened on every side: for if I do this thing it is death to me: and if I do it not I cannot escape your hands.' She is eventually exonerated by the wise judge, Daniel, and the Elders are punished.

The subject, like that of Bathsheba, clearly had a considerable fascination for Rembrandt and is evidence (of which there is plenty more elsewhere in his work) that he was a man of strong sensuality. He made numerous drawings of Susanna (such as Fig. 26) and at least one other painting, now in The Hague (Br.505). That picture executed in 1636 was, in fact, used as the starting point for the present one, which appears to have been begun shortly afterwards, i.e. ten years before it was completed in the form we see it now. As X-rays show, the Berlin painting consists of three layers, the first of which reveals the agitated type of composition characteristic of Rembrandt's style of the 1630s. When he re-painted the picture in 1647, he revised the design throughout, changing it into something much calmer. It is now the handling which is lively, not the composition. The figure style, the lighting, the colour and even the relationship of the figures to the landscape setting are all typical of the mid-1640s. For the composition, Rembrandt used a painting of the same subject by Lastman, also now in Berlin, which he copied in a drawing. For all the lack of movement, the narrative and psychological elements of the story are conveyed with the utmost clarity. Rembrandt no longer needed the heightened dramatic language of the Baroque to express emotion at this period of his life.

'A picture of Susanna', presumably the present one, was sold by Rembrandt for 500 guilders in 1647 to the merchant Adriaen Banck. In the eighteenth century it was owned by Sir Joshua Reynolds.

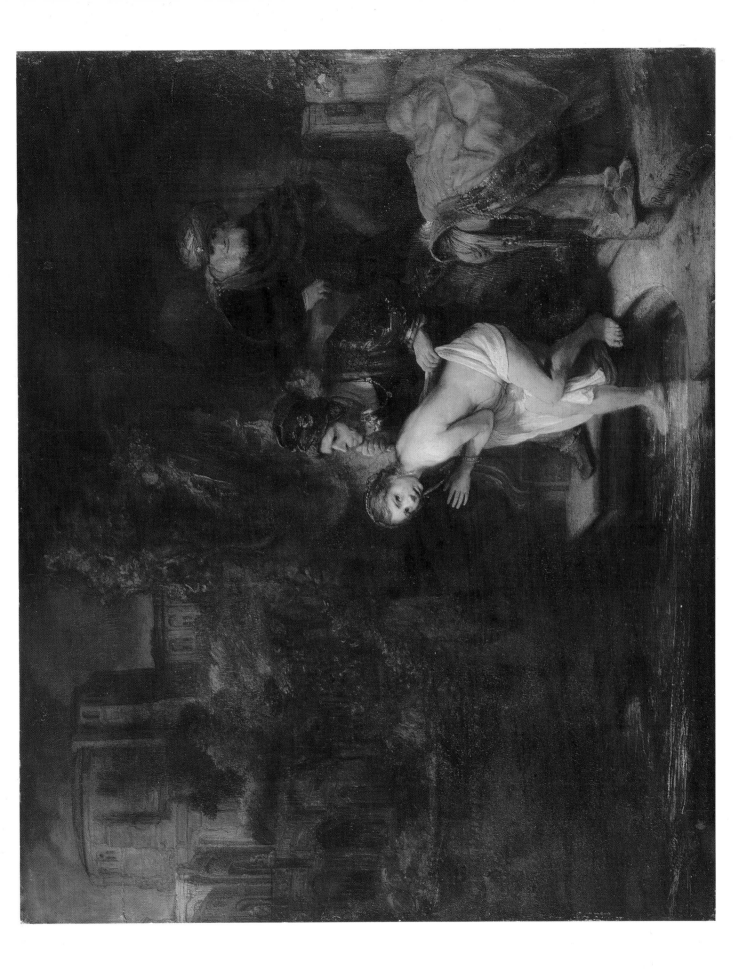

26 Christ and the Two Disciples at Emmaus

Signed 'Rembrandt f.1648'. Panel, 68 x 65 cm. Louvre, Paris

In or about 1629 Rembrandt, painted a striking first version of this theme (Fig. 27). Christ starts back in his chair, dramatically silhouetted against a blinding light as he makes himself known by the breaking of bread to the two disciples; in the next instant he will vanish out of their sight (St. Luke, Chapter XXIV, vv. 30-31). One disciple recoils in alarm, while the other, either terrified out of his mind or overcome with adoration, bows down at Christ's feet; this figure, whose back is below the level of the table, is so deeply immersed in shadow as to be scarcely visible in reproductions of the painting. The composition is asymmetrical and turbulent, like others by Rembrandt during his years in Leyden.

By contrast, his painting of the subject executed in 1648 is calm and introspective. The revelation depicted is experienced inwardly, not externalized through physical action. In composing the picture, the artist here follows the Italian tradition of placing Christ in the centre with the disciples on either side of him and the servant waiting at table. The pose and expression of Christ are reminiscent of the Christ in Leonardo da Vinci's *Last Supper*, which Rembrandt knew in engravings and copies. In the present painting, the divinity and humanity of Christ are fused in a way that is both indebted to Leonardo and highly characteristic of Rembrandt's work of the 1640s. The intimacy and domesticity of the scene may also be compared with his Nativities and Holy Families of that period.

Fig. 27
Christ and the Two Disciples at Emmaus

c.1629. Paper on panel,
39 x 42 cm.
Musée Jacquemart-André,
Paris

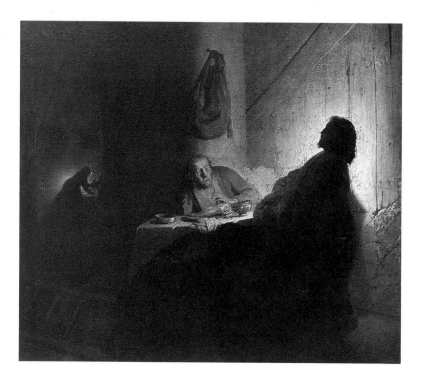

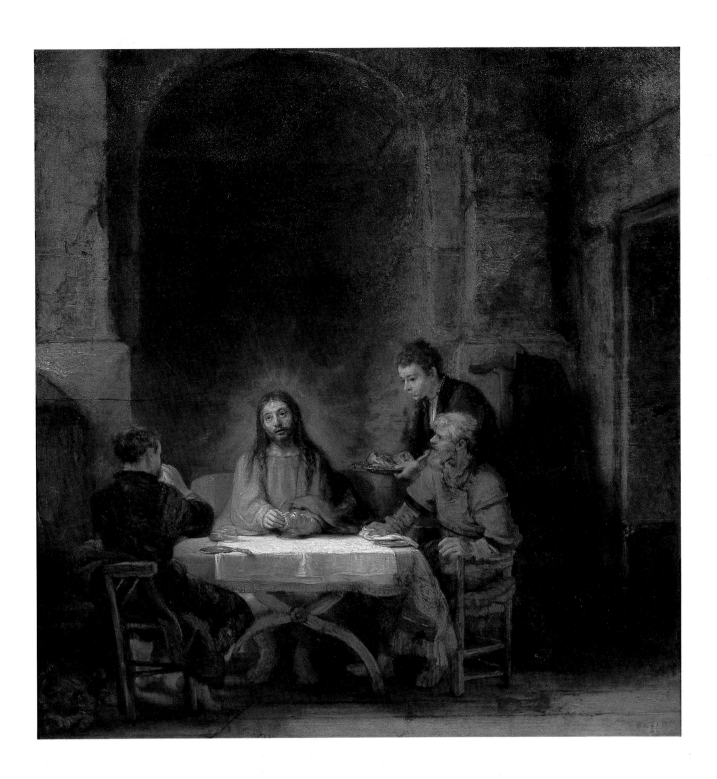

Portrait of a Man, probably Pieter Six

Signed 'Rembrandt f'. c.1650. Canvas, 94 x 75 cm. The Faringdon Collection Trust

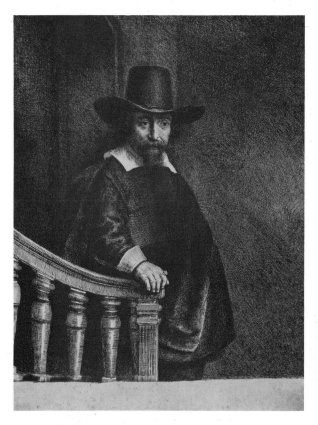

Fig. 28
Portrait of
the Physician,
Ephraim Bonus

Signed 'Rembrandt
f.1647'.
Etching, 24 x 17.7 cm.
British Museum, London

In the mid-1640s, the spate of portrait commissions that Rembrandt had received from the wealthy burghers of Amsterdam since his arrival in the city subsided, and only started again in earnest in the late 1650s. What seems to have happened in the intervening period is that a smoother and more elegant portrait style than Rembrandt's – a style influenced by Van Dyck and practised chiefly by Bartholomaeus van der Helst (1613-70; see Fig. 42) – captured the market, though the possibility should not be overlooked that Rembrandt himself decided not to compete in that market for the time being. Those clients who now sat to him for their portraits were drawn not so much from high society as from a circle of doctors, preachers and fellow artists whom he probably knew personally. Most of these portraits, such as Fig. 28, were, moreover, etchings, not oil paintings.

A partial exception is the *Portrait of a Man* in the Faringdon Collection, recently identified as probably a portrait of Pieter Six (1612-80), the elder brother of Jan Six, on whom see the note to Plate 29. The identification of the sitter as Pieter Six was first proposed by Gary Schwartz in the Dutch edition, 1984, of his book published in English in 1985 as *Rembrandt: His Life, His Paintings*. In this latter edition, however, he seems to withdraw the proposal. The identification was reaffirmed in 1987 by J.R. Voûte in *De Kroniek van het Rembrandthuis* on the basis of a comparison with a drawing supposed to be of Pieter Six in the Six family collection. The Sixes were rich Amsterdam merchants, and Rembrandt had close contacts with Jan from 1645 to 1654, so he must have known the family well. Both Pieter and Jan were art collectors. Either at this time or later, Jan wrote a poem in Latin about a portrait of his brother (though he does not name the painter), which includes the following couplet: 'His giving nature shows in golden yellow hair / And purity of soul in features white and fair' (quoted Schwartz, 1985, p.259).

These lines would certainly fit the Faringdon Collection portrait, the most striking characteristic of which is the sitter's luxuriant blond hair. He also has an almost white moustache, beard and eyebrows, which, but for the fact that he has dark rather than pale pink eyes, might suggest that he was an albino. The identification of the sitter as Pieter Six is further borne out by the sitter's apparent age. The portrait can be dated on stylistic grounds to about 1650, when Six was just under forty.

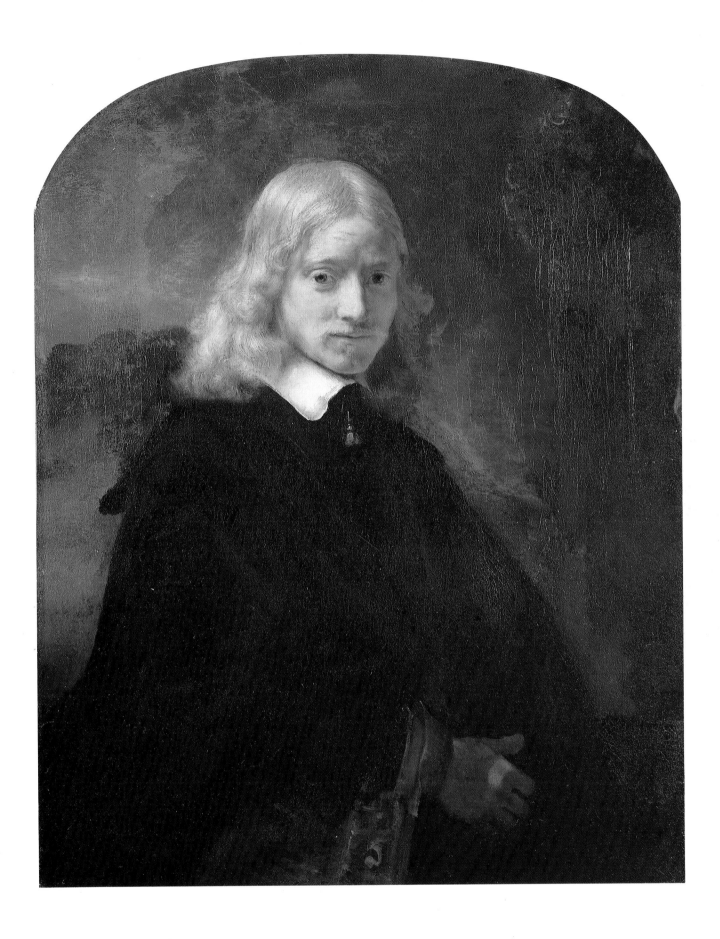

Signed 'Rembrandt f.1653'. Canvas, 143.5 x 136.5 cm.
Metropolitan Museum of Art, New York

Rembrandt painted this impressive if unusual picture for the Sicilian collector, Don Antonio Ruffo of Messina (1610-78). It is one of the few works by him known to have been commissioned by a foreign patron. Ruffo, who never travelled and who formed his collection through dealers and by correspondence, would have heard of Rembrandt through his contacts in Italy, where the artist had a considerable reputation for his etchings. Besides *Aristotle contemplating the Bust of Homer*, ordered in 1653, he commissioned two further pictures from Rembrandt in 1660: an *Alexander the Great* (possibly the painting now in the Gulbenkian Foundation, Lisbon, Br.479, of which the superb picture in Glasgow, Br.480, may be an earlier, rejected version), and a *Homer teaching* (now, cut down, in the Mauritshuis, Br.483). Rembrandt wrote that all three should be hung together, with *Alexander the Great* in the middle. In 1669, Ruffo also bought a large group of Rembrandt's etchings.

Besides noting the identities of the two persons represented in the *Aristotle contemplating the Bust of Homer*, scholars have speculated for some time over the deeper meaning of the picture and over the relationship to it of the other two paintings. (J. Held's 'Rembrandt's *Aristotle*', 1966, most recently reprinted in the author's *Rembrandt Studies*, 1991, is the most comprehensive investigation.) Nothing quite like this picture had ever been painted before. As to its meaning, it may be unwise to seek too far. Two treatises associated with Aristotle perhaps offer a clue. One is his *Poetics*, in which he reveals his admiration for Homer above all other epic poets. The other is the *Physiognomics*, though this is now thought to be by a different, unknown author. Physiognomics is the study of the relationship between physical appearance, on the one hand, and intelligence and character on the other, and, if this is alluded to in the painting, Aristotle placing his hand on Homer's skull would be an appropriate gesture. It is interesting to note that the Italian artist Guercino, who was sent a drawing of the *Aristotle* by Ruffo in order for him to paint a companion piece to it, thought that the picture represented a physiognomist.

Rembrandt's choice of subject in the other two paintings may have equally been conceived as acts of homage. Alexander the Great had been tutored by Aristotle, who had fired him with an admiration for Homer; Alexander thus pays homage to both philosopher and poet. Finally, Homer himself as teacher would have been a suitable subject to conclude the series, which as a whole may be thought of as a celebration of the greatest of ancient Greek poets.

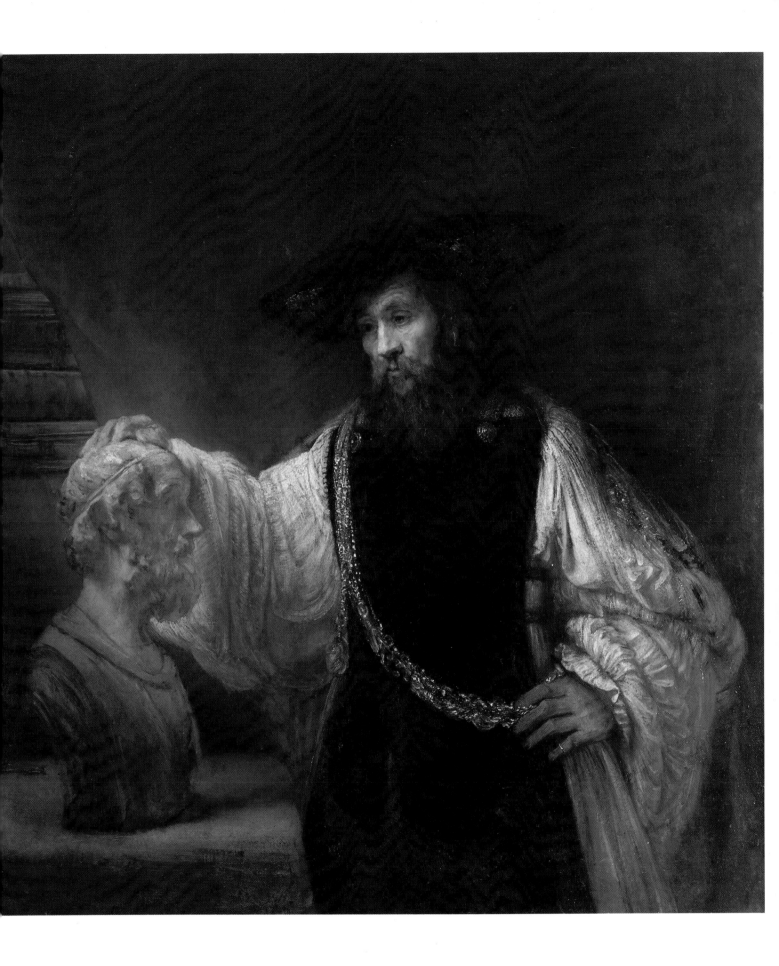

Portrait of Jan Six

1654. Canvas, 112 x 102 cm. Six Collection, Amsterdam

Fig. 29
Detail from the
'Portrait of Jan Six'

At a time when commissions from the *haute bourgeoisie* were few and far between (see Plate 27), Rembrandt painted, in this portrait of the wealthy magistrate, man of letters and connoisseur, Jan Six, one of his greatest masterpieces of the genre. The sitter wears a long, buttoned coat of fashionable cut with, over one shoulder, a heavy, gold-braided red cloak. He draws on his gloves and looks slightly questioningly towards the observer, as if he has been accosted when on the point of leaving his house. The fact that the figure is placed a little to one side of the canvas enhances this effect, as it gives him room to move. Yet while there is a hint of the instantaneous in this portrait, the artist's interpretation generally is restrained and dignified. The low viewpoint, allowing little space between the top of the hat and the frame, combined with the width of the clothes, produce an image of controlled power. The shadow cast over the upper part of the face by the hat is another effective pictorial device; by encouraging the observer to read more into the eyes than is actually defined by the paint, it makes the sitter's expression seem more alert while his personality remains inscrutable. A similar blend of the qualities of vivacity and mysteriousness is created by the background shadows which cut repeatedly into the figure. At the same time, Rembrandt was never more direct or more vigorous in his handling of paint. Within the outline of the form, the different parts of the clothing are defined by sharp, straight edges; in particular, the two collars, the braid, the tassels at the throat and the open coat-sleeve are treated in this way. The same is to some extent true of the hands and parts of the face. The braid on the cloak is simply suggested by repeated strokes of a broad brush half-charged with yellow paint applied on top of the red. The brushwork is at its most lively, however, in the area of the hands and gloves (Fig. 29), where the forms themselves are less regular and there is a suggestion of movement.

Jan Six (1618-1700) came from a successful merchant family but took up a career as a magistrate and devoted himself to literature, collecting and travel. He was the younger brother of Pieter Six (see Plate 27) and seems to have been the more forceful character of the two, a supposition borne out by their two portraits. Jan Six was in close touch with Rembrandt from 1645 to 1654.

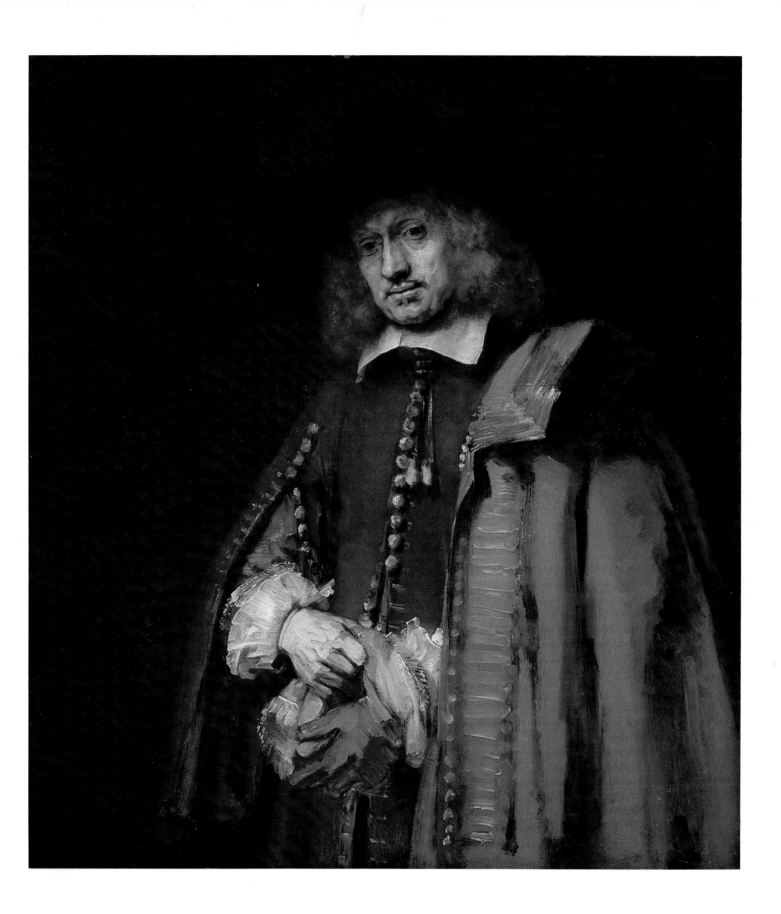

Signed (falsely?) 'Rembrandt f.1659(?)'. Canvas, 101.9 x 83.7 cm.
National Gallery, London

Fig. 30
**Self-Portrait in
Studio Attire**

c.1655. Pen and brown
ink, 20.3 x 13.4 cm.
Rembrandt-Huis,
Amsterdam

Unlike Saskia, of whom Rembrandt made an inscribed portrait-drawing (Fig. 8), Hendrickje Stoffels is nowhere explicitly identified in his art. However, there exist up to half-a-dozen portraits of an attractive, round-faced woman, showing her at different ages, painted during the period when Hendrickje lived with Rembrandt as his mistress, and these are generally agreed to be of her. They reveal an affection and degree of intimacy between artist and sitter that would be inconceivable in a commissioned portrait, and at the same time the face is too strongly characterized for it to be that of an anonymous model.

Hendrickje Stoffels is first mentioned as a member of Rembrandt's household in a document of 1 October 1649. She was then about twenty-three. She bore him a daughter, Cornelia, in 1654 and remained with him until her death in 1663. Rembrandt never married her, presumably because a second marriage would have deprived him of the much-needed income from Saskia's dowry, held in trust under the terms of her will for their son, Titus. Besides sitting to Rembrandt for her portrait, Hendrickje may have modelled for him for such paintings as the *Woman Bathing* (Plate 31) and *Bathsheba* (Fig. 31).

Both the signature and date on the National Gallery portrait may be later additions. There have even been some doubts as to the painting's authenticity, though these are surely unjustified and the picture is accepted as a Rembrandt in the latest edition of the National Gallery *Dutch School* catalogue (by N. MacLaren, revised and expanded by C. Brown, 1991, No. 6432). Some time in the first half of the 1650s seems to be the most likely date on stylistic grounds. The picture shows the increasing breadth of form and handling characteristic of Rembrandt's style in this period. The forms have lost that complexity of structure and quantity of surface detail which they had earlier in his career, while remaining firm and block-like, not flattened out as they were to become by 1660.

The portrait is one of the most private in all Rembrandt's work. It is very quiet and dignified in mood but also sensuous, even sensual, in feeling. It is appropriate to accompany this beautiful portrait with an illustration of a contemporary self-portrait drawing of Rembrandt (Fig. 30) in studio attire. Equally forthright and equally bold and simple in style, it epitomizes the image that Hendrickje would have had of him as he painted her.

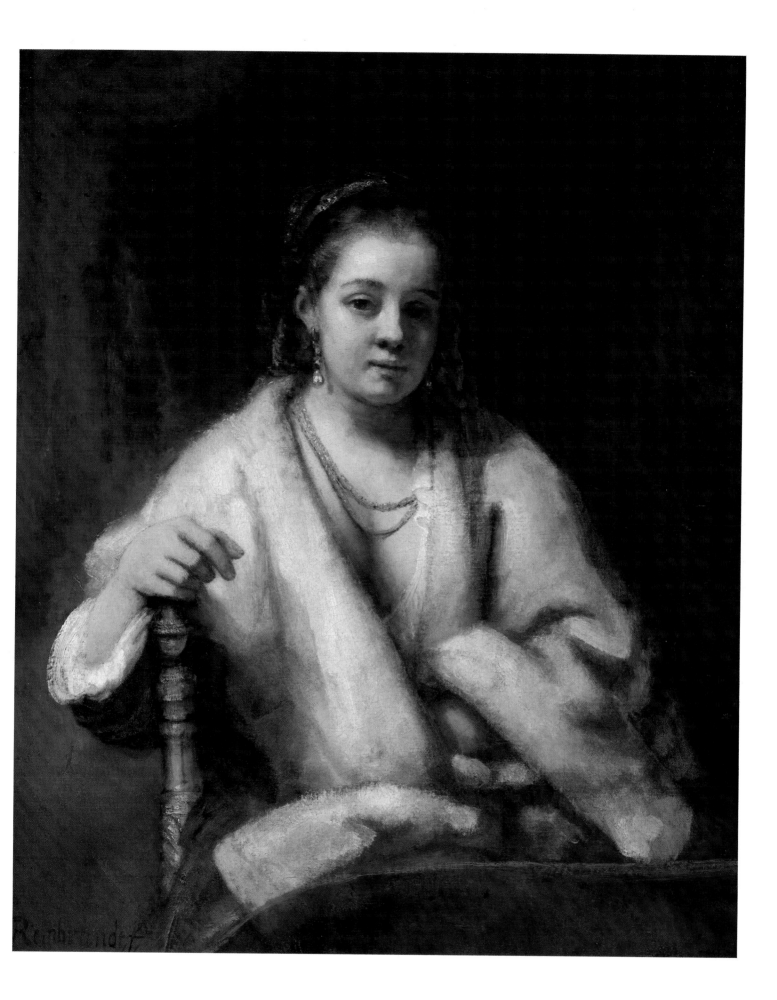

A Woman bathing

Signed 'Rembrandt f 1654', Panel, 61.8 x 47 cm. National Gallery, London

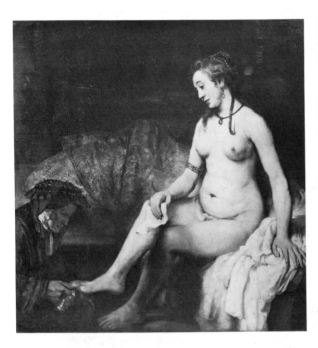

Fig. 31
Bathsheba holding
King David's
Letter

Signed 'Rembrandt
ft.1654'. Canvas,
142 x 142 cm.
Louvre, Paris

Because the face is similar to that in Plate 30 and other portraits of her, it has been plausibly suggested that Hendrickje Stoffels was the model here too. There are overtones in this picture of the biblical subject of either *Bathsheba* (Fig. 31) or *Susanna surprised by the Elders* (Plate 25); this much is made clear by the heavy gold and red cloak behind the figure and by the grotto-like setting. At least in these areas, Rembrandt was seeking to create a romantic effect. Still, as is so often the case in his work, the dividing line between a religious subject and a product of the artist's fancy, with no particular subject intended, is a fine one. The young woman appears completely absorbed in her bathe and shows no sign of the reactions appropriate to either Susanna or Bathsheba. As a work of art, the picture has all the characteristics of an independent study, or a sketch made for its own sake, and the figure, if not the background, was evidently painted from life. The brushstrokes are dashing and impulsive, suggesting rather than defining the forms; except in the head and flesh-parts of the figure, no attention at all is paid to detail. The abiding impression is one of spontaneity and freedom. However, Rembrandt signed and dated the picture and may have sold it or hoped to sell it.

The large finished painting of *Bathsheba* (Fig. 31), though of the same date, is very different. The relationship between form and content here is close and highly expressive. Bathsheba, the beautiful wife of Uriah the Hittite, was washing herself when she was observed by King David from the roof of his palace; he sent messengers to say he desired her, and she consented and went in to him (2 Samuel, Chapter XI). Rembrandt shows her with mingled feelings of regret, submission and anticipation as she sits, holding the King's letter loosely in her hand and pondering the implications of his command. Her pose and that of the woman drying her feet (who discreetly averts her gaze) are taken from an engraving after a classical relief, probably representing a bride being prepared for her wedding-night, and this is also in part how Bathsheba herself is depicted. In consequence, the painting is one of the most profound commentaries on human sexuality in the history of art.

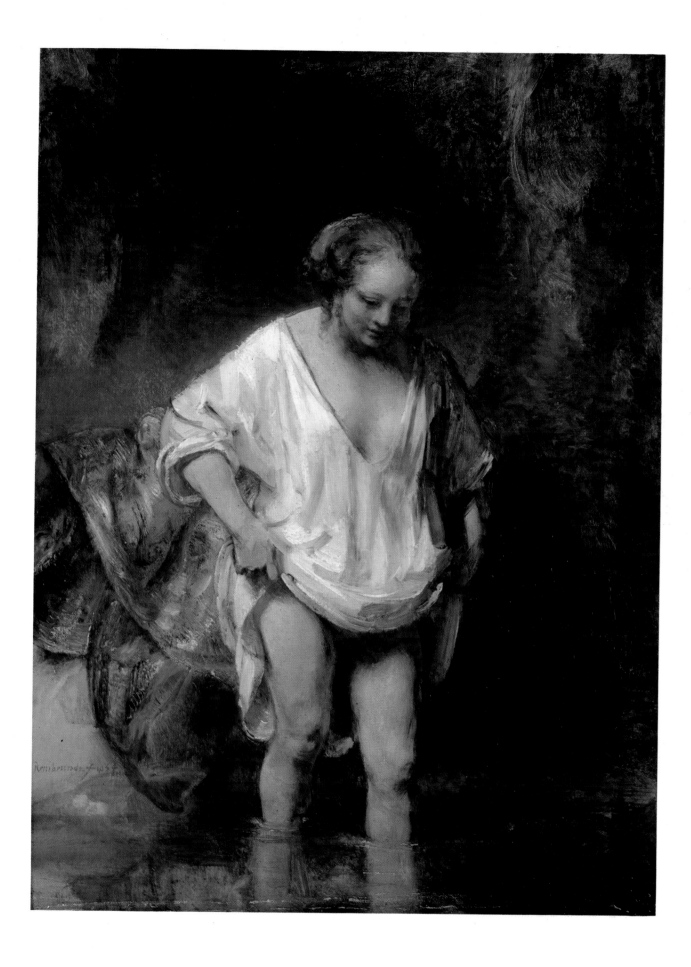

Portrait of Titus

Signed 'Rembrandt f.1655'. Canvas, 77 x 63 cm. Museum Boymans-Van Beuningen, Rotterdam

This is probably the earliest identifiable portrait of Rembrandt's son, Titus (1641-68). He was the last child born to Saskia and the only one to survive infancy. As with Hendrickje, there are no documented portraits of him, but about four or five portraits of the same boy are known, painted between 1655 and about 1662, and it would be unreasonable to doubt that they represent Titus. Rembrandt also made a number of drawings of him and may have used him as a model for religious pictures. Titus himself grew up to be an artist and several of his drawings have been identified. From 1660 he acted jointly with Hendrickje as his father's dealer but he died as a young man in 1668, the year before Rembrandt himself.

What is slightly curious about the Boymans Museum picture is that Titus appears to be represented as a younger boy than he actually was. Shown seated, or perhaps standing, at a desk and puzzling over his homework, he has the large eyes, rounded cheeks and small mouth of a child of eight or nine, rather than those of a boy of his true age, which was fourteen. Perhaps Rembrandt, looking at him one day, recalled him as a child and painted him accordingly. Be that as it may, the portrait is delightfully fresh and spontaneous. For all the advancing mysteriousness of Rembrandt's art, his style could still encompass something quite simple. The same relaxed and observant mood can be seen in his several drawings of lions (Fig. 32) of about this date.

Fig. 32
A Lion resting

c.1651-2. Drawn with the brush and perhaps also with a reed-pen, 13.8 x 20.7 cm. Louvre, Paris

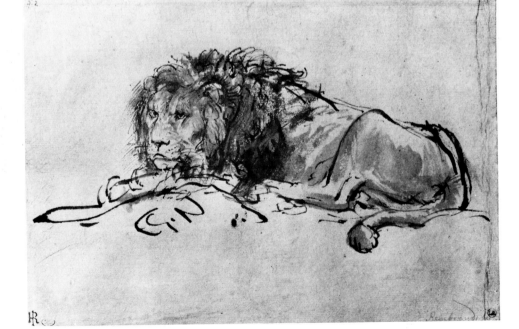

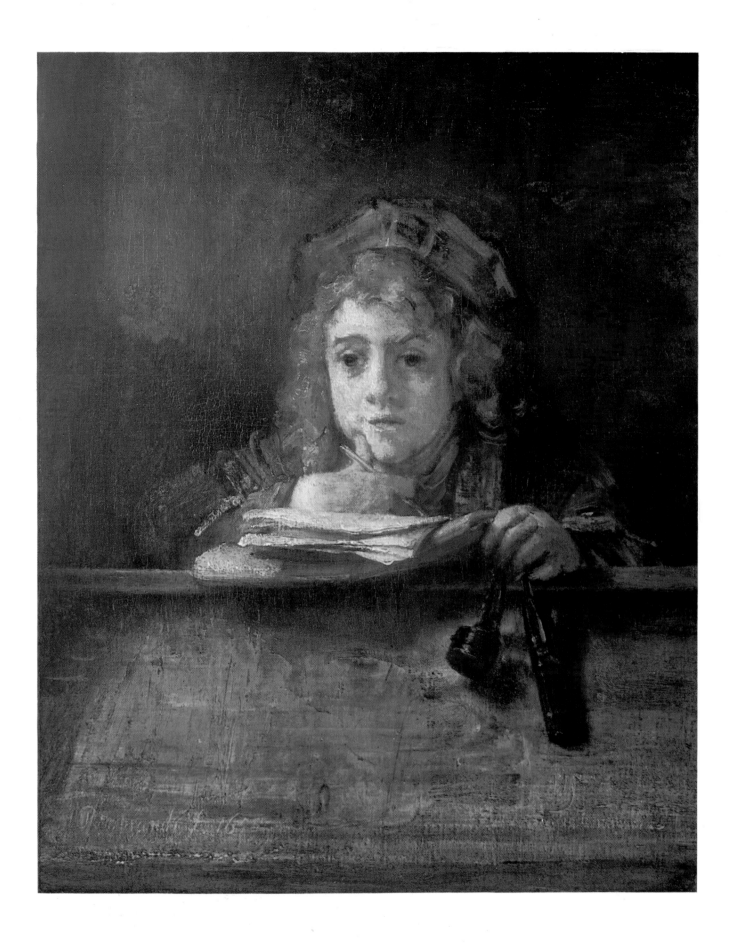

The Polish Rider

Signed (falsely?) 'Re....' c.1655. Canvas, 115 x 135 cm.
Frick Collection, New York

The subject of this picture, long considered the most poetic and curious of all Rembrandt's representations of a single human figure, has given rise to much speculation. Almost the only thing not in doubt is its date, which for reasons of style must be about 1655. The painting is not obviously either a representation of a real or imaginary historical character, a commissioned portrait, or a genre study, though it has elements of all three. It was first called *The Polish Rider* by Henry Clay Frick when he bought the picture from a private collector in Poland in 1910, though the assumption that the figure was Polish, or at any rate Cossack, goes back at least to the eighteenth century.

Modern criticism began with a long article by J. Held in 1944 (reprinted with alterations in 1966 and again, without further changes, in the same author's *Rembrandt Studies*, 1991). Held purged the picture of its Polish associations and re-located it in the Western allegorical tradition, regarding it as a generalized image of the Christian soldier. Other commentators have since put forward broadly similar interpretations. In 1965, however, a Polish scholar, Z. Zygulski, writing in the *Bulletin du Musée National de Varsovie*, revived, with some plausibility, the idea that the rider is a Cossack cavalryman of the seventeenth century. Zygulski drew on a wider range of comparative engravings and of surviving costumes and weapons than was originally available to Held, and he made a strong case. If, as he showed, Cossacks were fairly often to be seen in Western Europe in Rembrandt's time, it would have been typical of him, with his love of the exotic and the picturesque, to have painted one. And there, so far as the subject is concerned, the matter now rests.

Recently, a much more fundamental question has emerged, namely whether the picture is actually by Rembrandt. This point was first raised by J. Bruyn in a book review in *Oud Holland*, vol. xcviii, 1984, p.158, and his opinion, with the new attribution to Rembrandt's pupil, Willem Drost, will doubtless be repeated with supporting evidence in a future volume of *A Corpus of Rembrandt Paintings*. The answer will make a very great difference to how we 'read' *The Polish Rider*. The figure, so tautly composed and so magnetic, is surely worthy of Rembrandt himself. But the vaguely formed landscape and ill-drawn horse, seen pacing towards the river with its hooves barely touching the ground, will only continue to appear mysterious and evocative if the attribution of the painting to Rembrandt is upheld. If it is shown to be by Drost, these elements will seem merely weak.

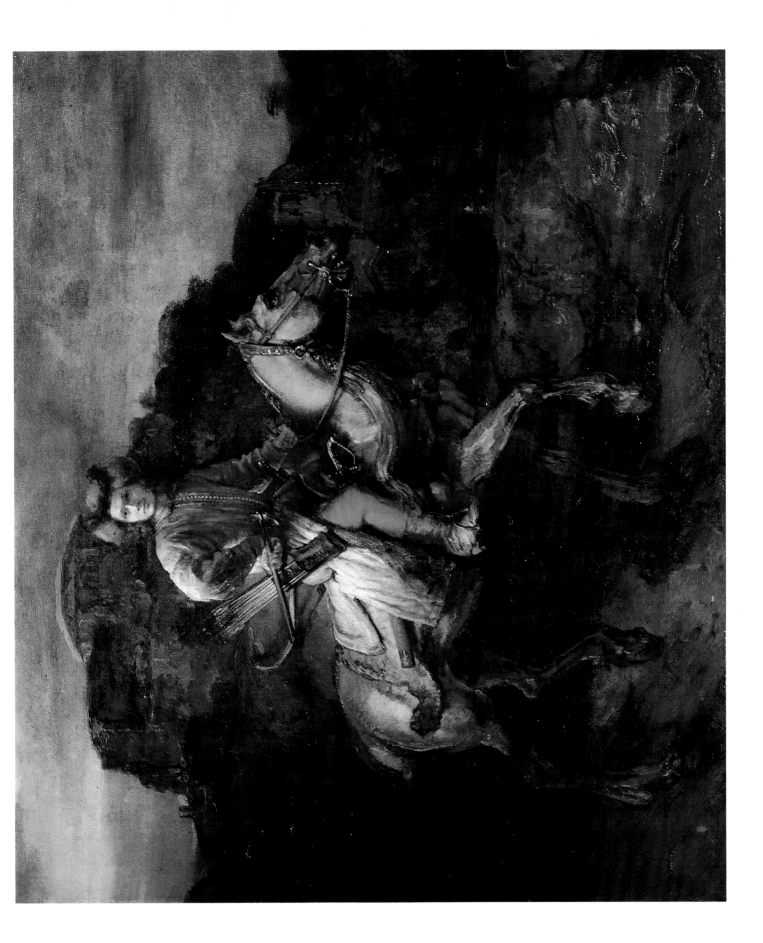

Jacob blessing the Sons of Joseph

Signed (falsely) 'Rimbran...f.1656'. Canvas, 175.5 x 210.5 cm.
Schloss Wilhelmshöhe, Cassel

Fig. 33
Detail from
'Jacob blessing
the Sons of Joseph'

The subject of this picture is taken from the Book of Genesis, Chapter XLVIII. The figures represented are the dying patriarch, Jacob, his son Joseph, and Joseph's wife and two sons, Menasseh (left) and Ephraim. The essence of the story is the unexpected action of Jacob in giving the chief blessing (with his right hand) to the younger son, Ephraim, and the lesser blessing (with his left hand) to the elder, Menasseh. Joseph protests at this and tries to guide Jacob's right hand towards Menasseh's head; however, Jacob refuses to change his mind and predicts that the younger son will become the ancestor of many nations, whereas his brother will be the ancestor of only one.

According to later tradition, Ephraim symbolized the coming of the Christian faith, whereas Menasseh stood for the Jews, and it cannot be by chance that Rembrandt gives Menasseh dark hair, while Ephraim is fair-haired and kneels with his head bowed and hands submissively crossed over his chest, almost in the attitude of the Virgin at the Annunciation. The presence of Joseph's wife, Asenath (Fig. 33), shows, however, that Rembrandt drew on Jewish legend as well as on the Book of Genesis (this was first pointed out by W. Stechow in the *Gazette des Beaux-Arts*, XXIII, 1943). Asenath is barely mentioned in the Bible and she is not recorded as being present at this scene, but one Jewish version contradicts this and says that it was she who persuaded Jacob to give the children his blessing.

Almost certainly painted in the year (1656) that Rembrandt became financially insolvent, this is one of his largest and most awe-inspiring religious pictures. Rembrandt's conception of form here is monumental. Large areas of canvas are covered with broad strokes of comparatively thick paint, on top of which he applied glazes. The forms, such as Jacob's sleeve, Joseph's turban, Asenath's dress and the bed-cover, are massive without being over-solid. The composition is uncluttered and direct, yet subtle. The mood is neither tragic, nor tender, nor serene but what can only be called sublime. The figures loom up before us, frozen for ever in their allotted roles, like participants in a *tableau vivant*. By any ordinary standards, the picture is an inexplicable achievement, created as it was at the lowest point in the curve of the artist's material fortunes. Yet artistically it marked the high-point of his heroic style of the 1650s.

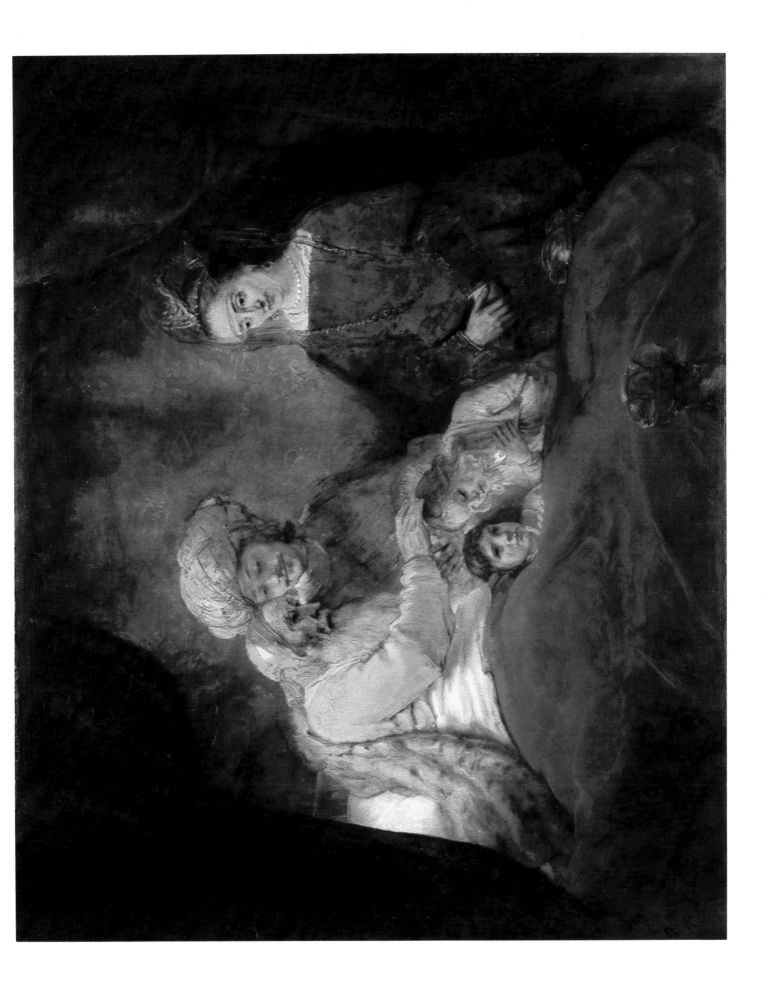

35 The Anatomy Lesson of Doctor Deyman (fragment)

Signed 'Rembrandt f.1656'. Canvas, 100 x 134 cm. Rijksmuseum, Amsterdam

Unlike *The Anatomy Lesson of Doctor Tulp* (Plate 7), this painting originally hung in the Anatomy Theatre in Amsterdam; it was only when a new theatre was built in 1690 that the picture was transferred to the Guild-Room of the Surgeons' Hall. After belonging to an English private collector for part of the nineteenth century, it was bought by the City of Amsterdam in 1882 and deposited in the Rijksmuseum in 1885.

A large part of the picture was destroyed by fire in 1723; it has been calculated that the original dimensions were about 200 x 275 cm. A drawing by Rembrandt in the Print Room of the Rijksmuseum (Ben.1175) shows the layout of the composition. The corpse was centrally placed with the anatomist standing behind it, backed by what is apparently a large canopied throne. Four figures were grouped on each side, one of whom - the Master of the Amsterdam Surgeons' Guild holding the removed part of the skull - can be seen in the part of the picture which survives. The symmetry of the arrangement, the steeply foreshortened corpse and the static poses offer a striking contrast to *The Anatomy Lesson of Doctor Tulp* painted twenty-four years earlier.

The body is opened at the stomach, which would have been done first, but the actual dissection being performed is of the brain. The criminal was Joris Fonteyn, who was hanged for armed robbery on 28 January 1656. The surgeon, Dr Joan Deyman (1620-66), succeeded Dr Nicolaes Tulp as chief anatomist and *praelector* of the Surgeons' Guild of Amsterdam in 1653. The painting was seen in 1781 by Sir Joshua Reynolds, who vividly described the rendering of the dead body, 'which is so much foreshortened that the hands and the feet almost touch each other: the dead man lies on his back with his feet towards the spectator. There is something sublime in the character of the head, which reminds one of Michael Angelo; the whole is finely painted, the colouring much like Titian.' The drawing mentioned above shows not only the composition but also the frame; in fact it has been plausibly argued that this drawing was made after the picture was finished, as a study for the frame. Pilasters are shown at either side, together with a base below and a carved, broken pediment above. It would have set the painting in a kind of tabernacle, of a type similar to the painted frame which surrounds *The Holy Family with a Cat* (Plate 23).

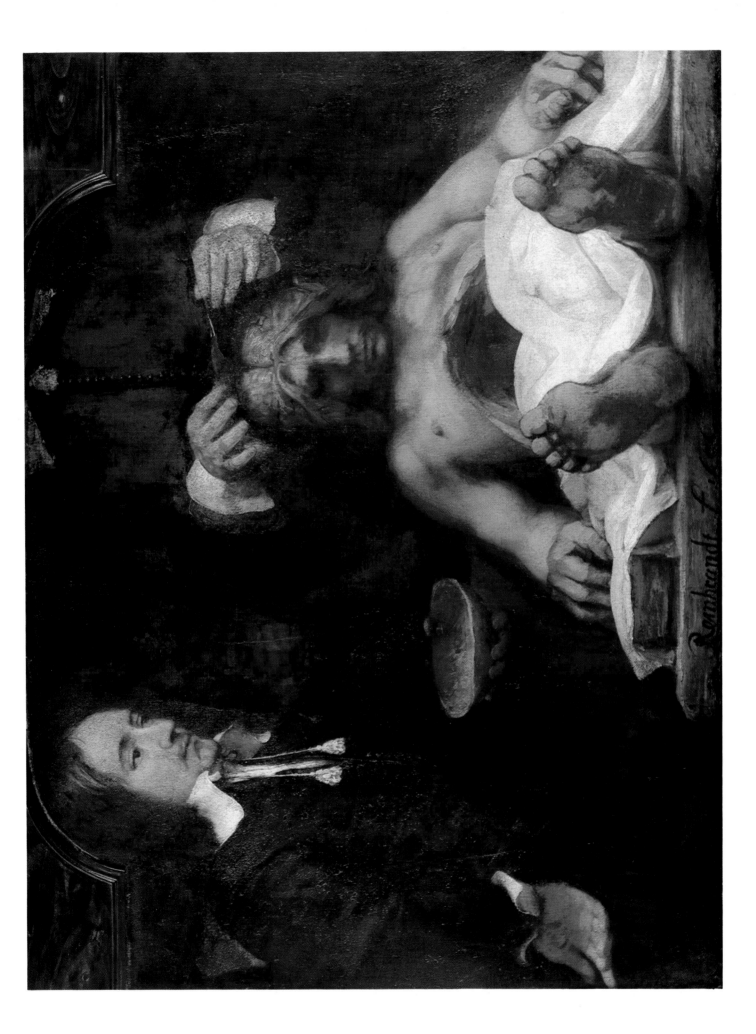

Signed 'Rembrandt f.1657'. Canvas, 123.5 x 95 cm. British private collection

Fig. 34
A Young Woman
seated in an
Armchair

1655-60. Reed pen and
wash in blackish-brown
ink, 16.5 x 14.4 cm.
British Museum, London

The sitter's name and age are inscribed on the canvas in a later hand, 'Catrina Hooghsaet/Out 50 Jaer' (ie. 50 years old). She was the wife of a dyer, Hendrick Jacobsz. Rooleeuw, and Rembrandt may have painted his portrait too, although, if so, all trace of it has been lost. The couple were Mennonites, a flourishing Protestant sect to which Rembrandt also intermittently belonged. Among the restrictions the Mennonites, followers of the sixteenth-century Dutch divine, Menno Simons, imposed on themselves were a refusal to bear arms or hold public office. In this and in other ways they were somewhat like the English Quakers. The sect was popular with artists and craftsmen, as by joining it they were able to escape the control exercised by the clergy over the lives of orthodox Calvinist citizens.

To judge from Catrina's clothes, which are relatively plain but of good quality, her husband was successful in his business. (The bleaching and dyeing of cloth were important Dutch industries.) The pair probably did not belong to the highest social class but Catrina acts almost as if she did. She sits confidently in her chair in a way that is both relaxed and animated, and a quizzical smile plays over her features. The handkerchief she holds in her hand supplies a touch of informality, as does the parrot perched on a ring hanging from the ceiling. Altogether this is a wonderful portrait, vigorous, crisp and surprisingly clear in lighting for its date. The brushwork, moreover, is noticeably smoother than in the *Portrait of Jan Six* (Plate 29), suggesting that Rembrandt may have curbed the broad painterly manner natural to him at this period in deference to the sitter's wishes.

Fig. 34 exemplifies the type of portrait drawing he was making in these years. Here it is the handling that is broad, while the characterization of the sitter seems more introspective. The *décolleté* and puffed sleeves were not part of Dutch fashion at the time, and the drawing may represent Hendrickje Stoffels wearing Italian Renaissance costume.

Jupiter and Mercury visiting Philemon and Baucis

Signed 'Rembrandt f.1658'. Panel, 54.5 x 68.5 cm. National Gallery of Art, Washington DC

Fig. 35
Christ healing Peter's Mother-in-Law

1655-60. Pen and brown wash, 17.2 x 18.8 cm. Institut Néerlandais (Fondation Custodia), Paris

This is a rare instance from the later part of Rembrandt's career of his using a subject from Ovid's *Metamorphoses*. Even so, the picture has more the atmosphere of a religious scene than an episode from classical mythology. The two gods do not wear antique drapery or show the usual partial nudity; the setting is the interior of a Dutch cottage; and a mystic light glows in one corner of the space, leaving much of the rest in shadow. In treatment, this picture might almost be a *Tobit and Anna* or *Supper at Emmaus*.

Unlike most of the stories in the *Metamorphoses*, the episode of Jupiter and Mercury visiting Philemon and Baucis (Book VIII, 618-724) is entirely proper, not to say sentimental. It deals with such matters as marital fidelity, hospitality, trust and divine compassion and has, indeed, parallels in both the Old and New Testaments. The two gods, disguised as mortals, after being turned away at countless doors, are given shelter by an old peasant couple, Philemon and Baucis. The couple provide the best meal they can and are about to kill their most precious possession, a goose, when Jupiter and Mercury reveal themselves. The gods invite them to climb a mountainside and, when they look back, they see all the country flooded except their cottage, which has been transformed into a magnificent temple. As a reward for their spontaneous generosity, Philemon and Baucis are made guardians of this temple for the rest of their lives.

The painting here illustrated is one of the most charming of all Rembrandt's subject pictures, the figure of the youthful Mercury being particularly appealing. The colouring throughout, though subdued, is beautiful. The drawing is simple and economical, with the lines being used not to follow the contours of the form but rather to indicate its position in space. The fine, straight brushstrokes lie either outside or inside the contour line, seldom precisely on it. The same technique can be seen in the pen-and-wash drawing of *Christ healing Peter's Mother-in-Law* (Fig. 35) of about the same date. The style is less dramatic than that of the artist's earlier drawings but it expresses both movement and emotions no less vividly.

St Bartholomew

Signed 'Rembrandt f.1661'. Canvas, 87.5 x 75 cm. J. Paul Getty Museum, Malibu (California)

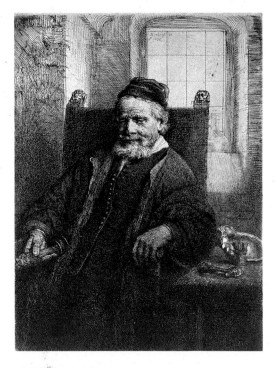

Fig. 36
Portrait of
Jan Lutma

Signed 'Rembrandt
f.1656'. Etching and
drypoint, 19.7 x 14.8 cm.
Fitzwilliam Museum,
Cambridge

In 1661, Rembrandt painted a small group of half-length figures of apostles, each with a strongly individualized character. At present only four seem to be definitely from his hand, though others have been attributed to him. One of the four is this *St Bartholomew* and another, slightly distinct from the rest because Rembrandt used himself as the model, is the *St Paul* reproduced on the next page.

St Bartholomew holds his traditional attribute, the knife with which he was flayed to death. It is, of course, no more than a formal means of identifying him and as such was a common device in art, although in Catholic countries the gruesome scene of St Bartholomew's martyrdom was sometimes depicted. Apart from the knife, there is nothing in Rembrandt's painting to indicate that the figure is a saint; not even his clothes are obviously antique, and he grasps the knife as if he were about to cut something with it. Moreover, there is the curious accident that his short hair, parted almost in the middle, and his wide moustache give him the look of a man of the late nineteenth century. He might almost be a sturdy leather-worker painted by some realist artist of that period, such as Thomas Eakins or Adolf von Menzel. The figure is, indeed, extremely powerfully modelled, and the impasto is so thick that it seems to imitate the very bumps and ridges of the flesh. Yet the facial expression, though proud, is not aggressive and is in its own way thoughtful.

How close this 'saint' comes to the secular can be seen by comparing him with the etching of the goldsmith, Jan Lutma (Fig. 36), who is another sharply delineated character.

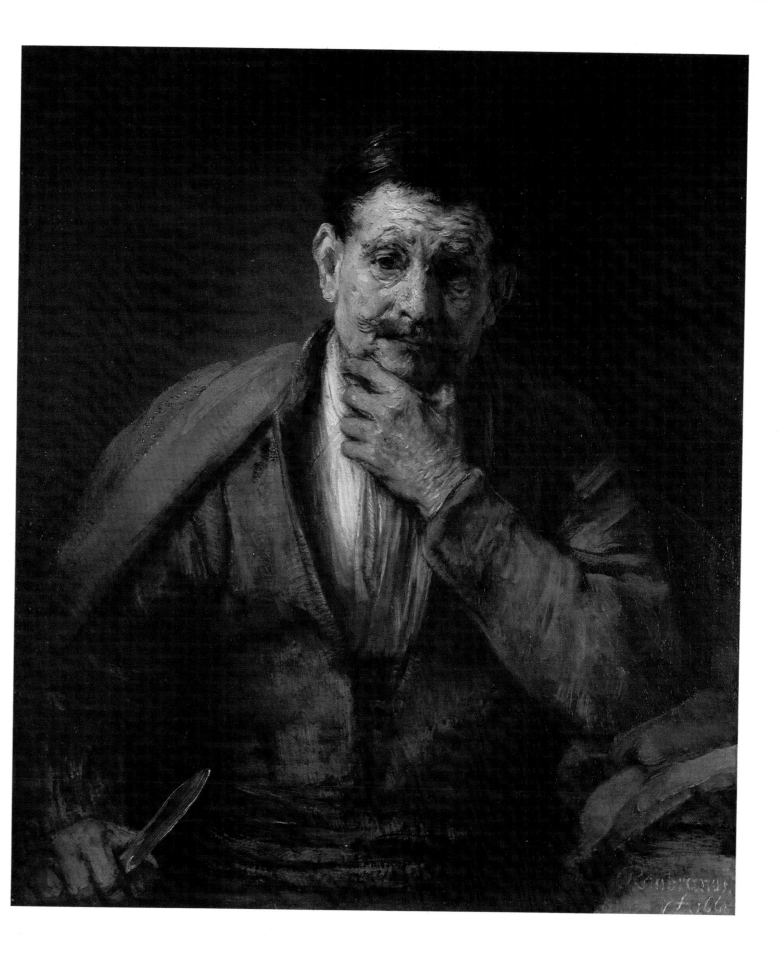

Self-Portrait as St Paul

Signed 'Rembrandt f.1661.' Canvas, 91 x 77 cm. Rijksmuseum, Amsterdam

The figure is identified as St Paul by the hilt of a sword (his traditional attribute) appearing in the opening of his coat. A book or, as here, a sheaf of papers, symbolizing the word of God, is also usually associated with St Paul. It was comparatively rare for artists to depict themselves as saints; it might be considered to smack of pride (though Dürer did not scruple to show himself as Christ). This is not to imply that Rembrandt glorifies himself in the present instance. On the contrary, the mood of his *Self-Portrait as St Paul* is sombre in the extreme, and in this respect it is like the majority of the religious paintings and etchings of his late period. The beginning of this mood can be traced to the first version, dated 1653, of his great etching, *The Three Crosses*, in which the suffering of Christ, the drama of the Crucifixion and the mystery of Christ's sacrifice are the dominant themes. In the revised version of this etching (Fig. 37), produced by extensively re-working the plate about eight years later, the mood is even darker. Great curtains of shadow are drawn over large parts of the composition, almost obliterating the unrepentant thief and leaving space between them only for the dazzling heavenly light which falls on Christ. Rembrandt's use of chiaroscuro here is neither illusionistic nor decorative nor merely poetic but expressive of the circumstances and meaning of the subject in the most literal way possible. A comprehension of events as sublime and sombre as this, as well as his own misfortunes, is revealed in the features of Rembrandt's late self-portraits.

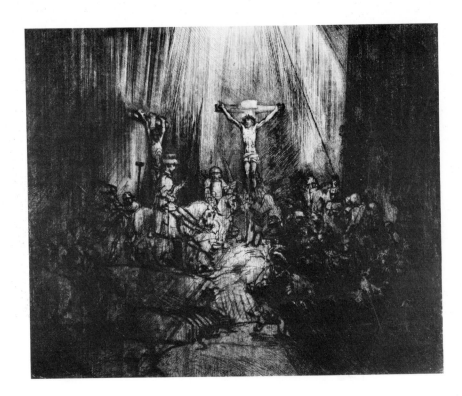

Fig. 37
The Three Crosses

c.1660-1. Etching,
38.7 x 45 cm. Fitzwilliam
Museum, Cambridge

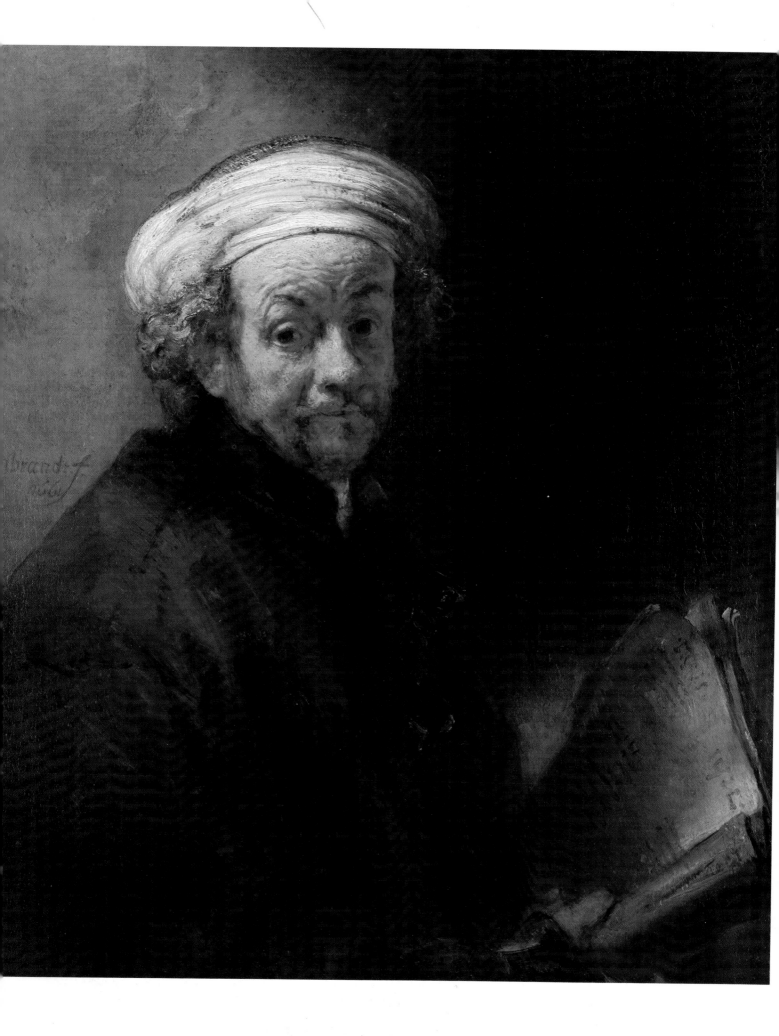

Two Africans

Signed 'Rembrandt f.1661'. Canvas, 78 x 64.5 cm. Mauritshuis, The Hague

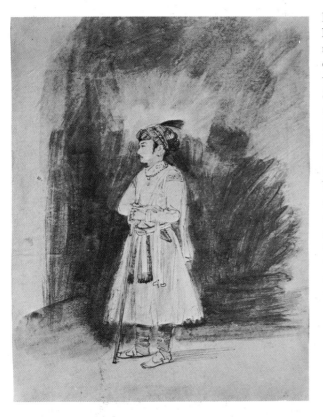

Fig. 38
**An Indian Prince,
after a Mogul
Miniature**

c.1656, Pen and brown
wash, on Japanese paper,
22.5 x 17 cm.
Albertina, Vienna

Rembrandt's long-standing interest in the peoples and costumes of the Near East was extended in the 1650s to embrace the still more exotic regions of Asia and North Africa. His inventory of 1656 contained a reference to a set of Indian Mogul miniatures, now thought to be those which were later taken to Austria and incorporated in the decoration of the Schönbrunn Palace outside Vienna. Rembrandt made about thirty pen-and-wash copies of these miniatures (Fig. 38) and, while his exact purpose in doing this is unknown, the fact that they are so numerous suggests that he wanted the copies for reference rather than that he was simply practising. They show him responding to the awkward proportions, the lack of foreshortening and the facial types and costumes of Mogul art (though he could not resist substituting his own, more spirited pen-strokes for the hard outlines of the originals and adding some washes to indicate light and shade). What the miniatures may have suggested to him, or rather perhaps symbolized, were the advantages to be gained from abandoning the sophisticated, baroque means of rendering form with which he had been brought up and which he had been accustomed to use hitherto. Although the direct influence of these miniatures on his work was very slight, they represented to some extent a parallel approach to his own style in the 1660s.

Something of this can be seen in the angular shapes, flattened forms and seemingly casual composition of the *Two Africans* (there are analogies here with the Kenwood *Self-Portrait* too). Hitherto, Africans had appeared in European art almost exclusively in the scene of the Adoration of the Kings, one of the kings traditionally being black, but a few other portraits of Africans, including two oil sketches by Van Dyck, are known from the seventeenth century. Rembrandt's painting, however, is the most penetrating and realistic. At one bound, so to speak, he succeeded in rendering the African physiognomy with perfect sympathy and fidelity.

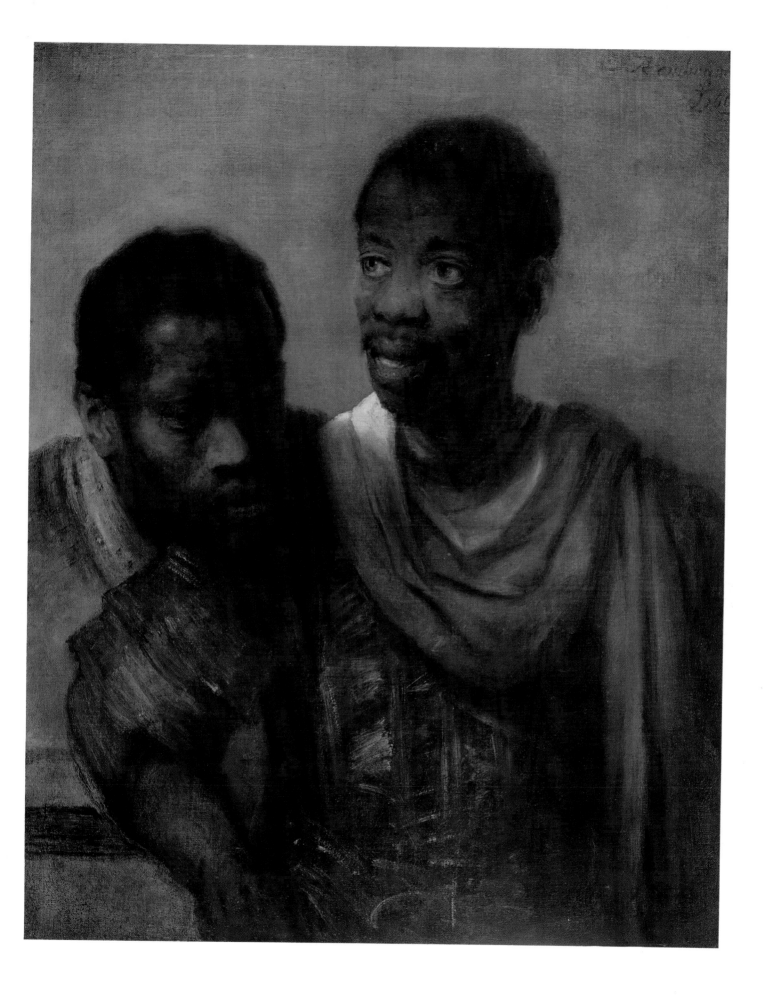

Portrait of Jacob Trip

Signed 'Rembr'. c.1661. Canvas, 130.5 x 97 cm. National Gallery, London

Fig. 39
Portrait of
Margaretha de
Geer, Wife of Jacob
Trip

c.1661. Canvas, 130.5 x
97.5 cm. National Gallery,
London

The means used by Rembrandt to express the sitter's character are discussed in the Introduction. Both the loose robe or gown and the cap worn by Trip are in fact unusual in the artist's late commissioned portraits, as, in such a context, is the loose and broken brushwork. Especially in the lower part of the figure, the folds and texture of the garment are hardly defined, and close inspection of the paint surface reveals a variety of muted colours which seem more to be those of the underpainting than the local colour of the robe itself. In view of this, it is possible that the picture was left not quite complete at the sitter's death. The companion portrait of Trip's wife, Margaretha de Geer (Fig. 39), is somewhat more finished in style, though it is equally impressive as a work of art and similarly austere in characterization. She wears a long black dress with fur trimmings and a ruff of a type which had been out of fashion for thirty years.

Assuming that the portraits were painted in the year of Jacob Trip's death, 1661 - and they cannot be much earlier than that on stylistic grounds - he would have been eighty-six at the time and his wife seventy-eight. She died aged eighty-nine in 1672. Both came from Dordrecht, where their families, and Jacob Trip himself after 1626, were leading iron-masters and armaments manufacturers. In 1660-2 two of their sons, who also dealt in armaments, had the palatial Trippenhuis, one of the finest Dutch townhouses of the period, built for them in Amsterdam, and it may have been for this house that the two portraits by Rembrandt were painted.

The Trips were among the most frequently painted bourgeois couples of the period. Portraits of them by J.G Cuyp, Aelbert Cuyp and Nicolaes Maes, as well as Rembrandt, are known. Another, bust-length, portrait of Margaretha Trip, traditionally attributed to Rembrandt but possibly by a follower of his, dated 1661, is also in the National Gallery, London (Br.395). These portraits must have been made at least partly for distribution to the sitters' numerous relatives, and it was on the evidence of a pair which had descended in the De Geer family that the sitters were first identified by Hofstede de Groot in *Oud Holland*, XLV, in 1928.

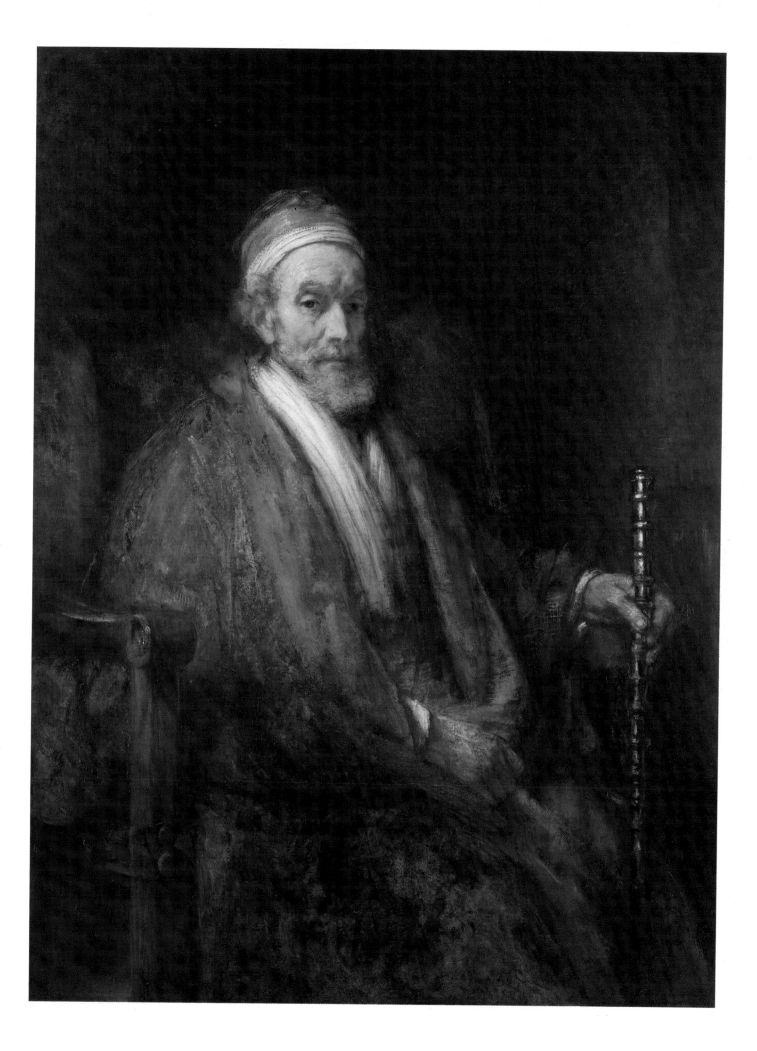

The Conspiracy of Julius Civilis (fragment)

1661-2. Canvas, 196 x 309 cm. Nationalmuseum, Stockholm

The subject is from Tacitus, *The Histories*, Book IV, lines 13-16, which tells of the revolt of the Batavians, the ancient inhabitants of The Netherlands, against the occupying Romans. The leader of the revolt was the one-eyed Julius Civilis (also called Claudius Civilis), who assembled the chiefs of the Batavians in a sacred wood under the pretence of holding a banquet. There he made them swear on oath to fight for their liberty. This revolt was commonly seen by Rembrandt's contemporaries as a prototype of William of Orange's sixteenth-century war of independence against the Spaniards.

Rembrandt painted the picture, which illustrates the first episode in the revolt, as one of a series of eight canvases by different artists designed to fill the arched spaces in the great gallery of the new Amsterdam Town Hall. He received the commission in 1661 and his painting was in place the following year. However, it was removed almost immediately for alterations and in 1663 was replaced by a picture by Rembrandt's former pupil, Jurigen Ovens. Rembrandt himself seems to have cut the painting down and altered the central part in an effort to make it more saleable. In its original form, the canvas was fully 5 metres in both dimensions (larger than *The Night Watch*), with an arched top. A drawing in Munich (Ben.1061) shows the composition before it was reduced. The table and conspirators were seen across a vast empty foreground and above them was a huge vault.

Even - or perhaps especially – in its mutilated state, the painting is an incredible work. The wild handling and primitive forms are as if specifically designed for the archaic and barbarous subject. Perhaps most remarkable is the colour, here inseparable from the lighting. As was so often his practice, Rembrandt places a source of light in the centre of the figure group, concealing it from direct view. Yet the amount of light emitted from this source is far greater than it would be if it were merely natural. At its most intense, the light is white; where it becomes pale yellow, it suggests not only strong light but also great heat. The image conjured up at the left of the picture is that the figures are not merely swearing an oath but are beating out their weapons at a forge, and even being hardened in the fire themselves. To the right and in the foreground, red is the dominant colour and this too suggests fire.

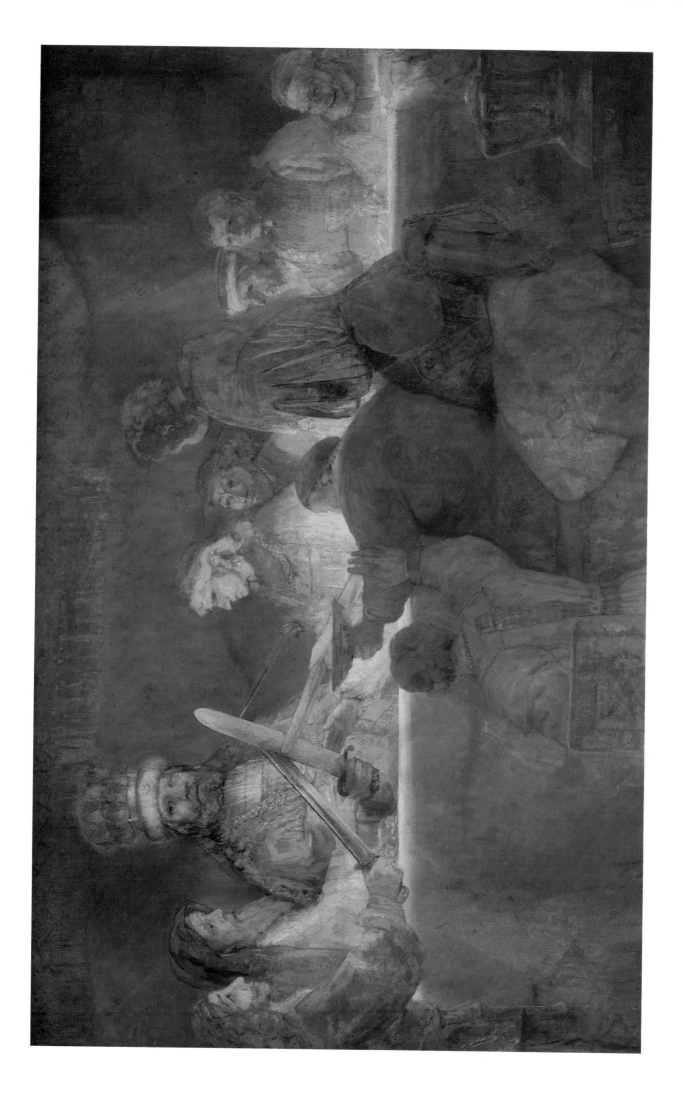

The Sampling-Officials of the Amsterdam Drapers' Guild ('The Staalmeesters')

Signed 'Rembrandt f.1662'. Canvas, 191.5 x 279 cm. Rijksmuseum, Amsterdam

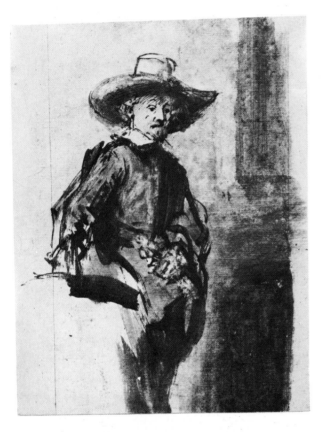

Fig. 40
Study for 'The Staalmeesters'

1662. Pen and brown wash
with white heightening,
22.5 x 17.5 cm.
Museum Boymans-Van
Beuningen, Rotterdam

This painting, sometimes incorrectly called *The Syndics*, formerly hung in the Hall of the Drapers' Guild in the Staalstraat. It was acquired by the City of Amsterdam in 1771 and transferred to the Rijksmuseum in 1808. The original signature and date, 1662, are on the tablecloth; those at the top right are probably a later addition.

The persons represented, whose names are known from contemporary documents, were the controllers of cloth-samples - *staal* simply means 'sample'. They were appointed by the Burgomaster of Amsterdam to regulate the quality of cloth sold in the city, and the book in front of the chairman is probably the account book in which the names of the drapers whose samples had been approved, together with the date and the fees they paid, were recorded. The officials met in private, and thus the popular belief that the figure second from the left is rising to answer a question from the audience at a public meeting is erroneous (see H. van de Waal in *Steps towards Rembrandt*, 1974). The main determinant of the composition is the pictorial requirements of the work of art, and Rembrandt considered the relationship of the figures to each other with great care. Three drawings (Ben.1178-9 and Fig. 40) survive for the three figures at the left showing that he tried out different positions for them, and X-rays of the picture reveal that the servant (bareheaded, in the background) was also moved several times. As van de Waal has suggested, the low viewpoint was probably chosen not to indicate that the table is raised on a dais but to correspond to the destined position of the picture above a chimney-piece. Another striking, if not immediately obvious, fact is that the table is placed with its short side towards the front, not extended across the width of the composition as it appears to be at first sight.

However, if there was no imaginary audience implied by this picture, there was nevertheless a real one: the observer. At least four of the six figures are fully intent on the observer, and he or she is both the psychological and the visual focus of the composition. The participants are as strongly concentrated on something outside the picture as those in *The Anatomy Lesson of Doctor Tulp* are on something within it.

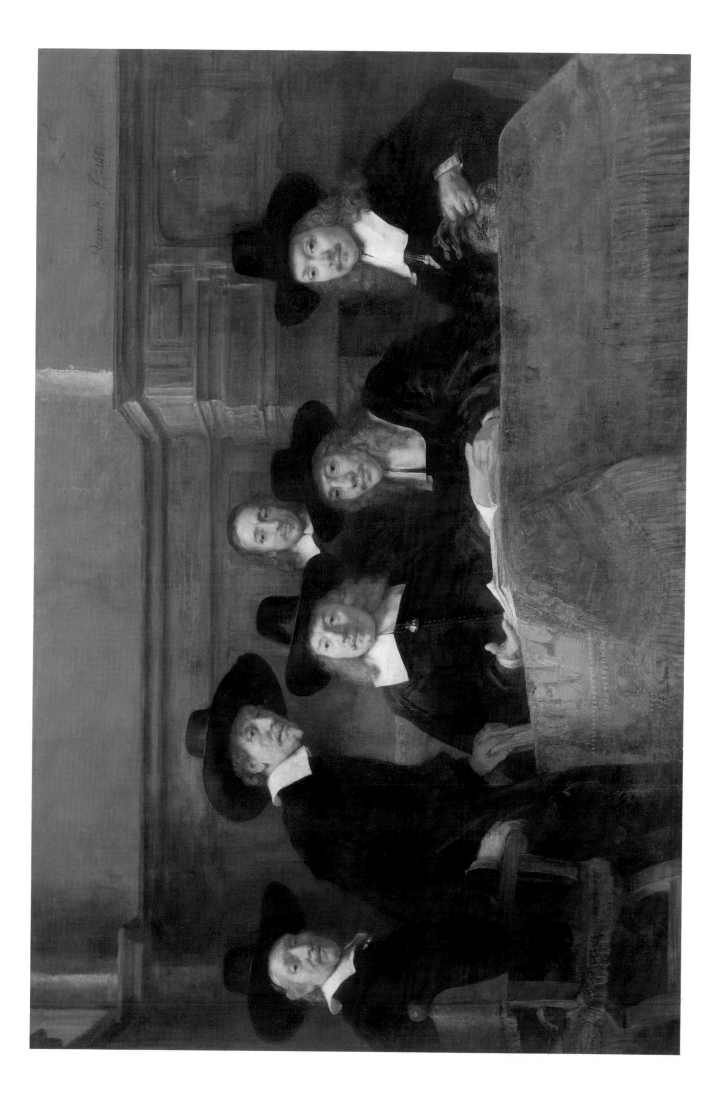

c.1665. Canvas, 114 x 94 cm. The Iveagh Bequest, Kenwood, London

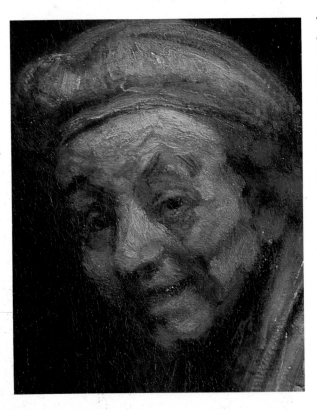

Fig. 41
**Self-Portrait
(detail)**

c.1665. Canvas,
82 x 63 cm. Wallraf-
Richartz Museum,
Cologne

This is one of the noblest and most poetic of all Rembrandt's self-portraits; of the three-quarter length ones it is also among the most personal. The head is fully worked up, the body much less so, while the hands are scarcely indicated at all. Being an 'unfinished' self-portrait, it would not have been signed or dated (though its authenticity is unquestionable). In conception, it still shows much of the breadth of form which the artist had favoured in the late 1650s, both in his subject pictures, like *Jacob blessing the Sons of Joseph* (Plate 34), and in other self-portraits. On the other hand, the forms have become flatter and the facial expression less aggressive. It is as if Rembrandt had wished to show himself as more forlorn. There is no play-acting here, as in some earlier self-portraits (see Plates 4 and 15). In the Kenwood picture, Rembrandt shows himself in the one role that was not a 'role' but the very justification of his existence: that of the painter who by his art is also a seer. He gazes out at the observer, defiant and immovable. This is an attitude which he seems to have made explicit in the only late self-portrait (detail, Fig. 41) in which his expression is not impassive. In that portrait, the smiling artist taps with his maulstick a statue of the Roman god, Terminus (a boundary mark), the implied significance of which is *concedo nulli* – 'I yield to no-one'.

The stylization of the forms in the Kenwood *Self-Portrait* springs from the aim of relating everything as closely as possible to the picture surface. Except in the head, there is very little modelling and no foreshortening. Rather than foreshorten the arms below the elbow, Rembrandt reduces one in length, so that it appears to be withered, and virtually leaves out the other altogether. (X-rays show that the right arm - Rembrandt's left as he looked at himself in the mirror - was originally raised and the hand held a brush in the act of painting. However, he changed his mind about this and moved the arm and hand to where they are now.) Both the brushes and the maulstick are made to lie parallel to the picture plane, and the perspective of the palette is distorted to prevent it from receding into depth. The mysterious circles on the wall, though clearly behind the artist's head, reinforce the sense of a composition conceived as a surface design. No one has yet succeeded in explaining these shapes satisfactorily but, in the absence of a convincing iconographical solution, a formal one seems as useful as any.

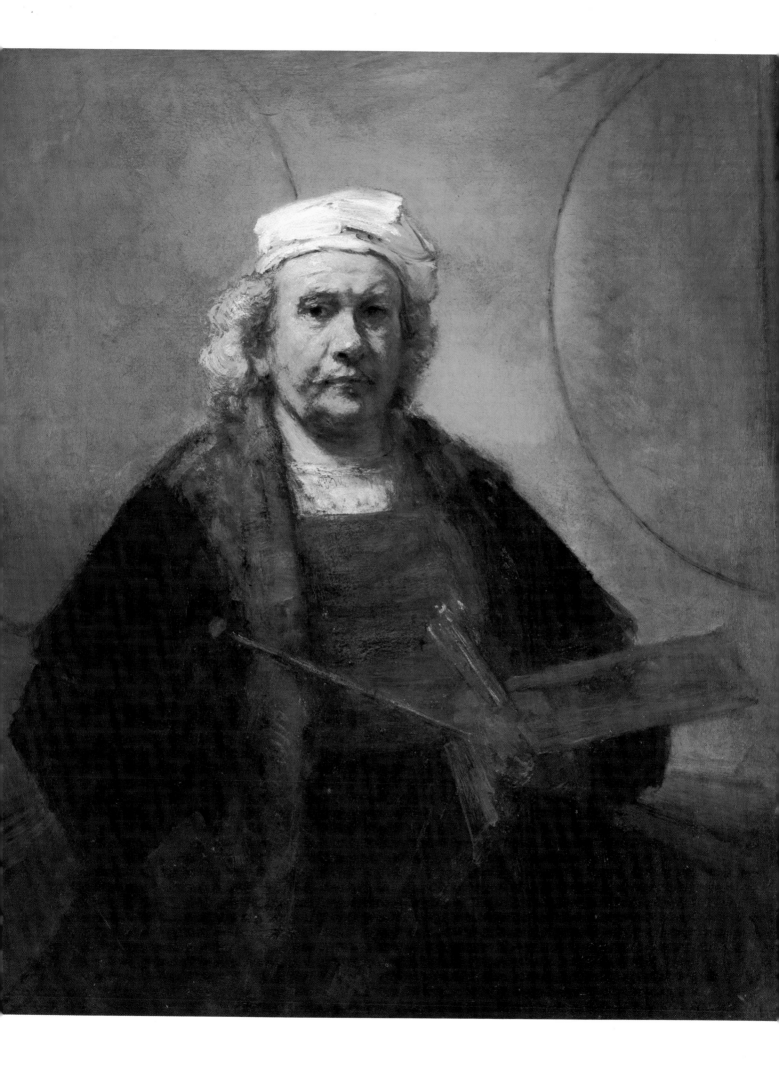

Signed 'Rembrandt f.1665'. Canvas, 112 x 87 cm.
Metropolitan Museum of Art, New York

Fig. 42
Bartholomeus van
der Helst:
Portrait of Paulus
Potter

1654. Canvas, 90 x 80 cm.
Mauritshuis, The Hague

The identity of the sitter was established early this century by comparison with the engraved portrait of him in Houbraken's *De Groote Schouburgh* (1718). As that and other engravings show, he had distinctive and rather unfortunate features: a snub nose with no bridge to it, bulging eyes and exaggeratedly thick lips, all of which Rembrandt to some extent disguises in the portrait. Gérard de Lairesse (1641-1711) was a prolific painter, etcher and writer on art. Born and trained in Flanders, he settled in Amsterdam in 1665, the year in which Rembrandt painted him. Although at first he admired Rembrandt's work, he later repudiated it and became identified with the growing taste in the leading Dutch cities in the last quarter of the seventeenth century for French fashions in the theatre, literature and manners. His own painting was decorative and 'baroque-classical'. Lairesse went blind in 1689-90 and from then on devoted himself to art theory. His major work, *Het Groot Schilderboek* (1707), was a comprehensive guide to current international artistic theory and practice and was translated into several languages, including English. It remained in use in North European academies of art throughout the eighteenth century.

It would be intriguing to know what impression this young, fashion-conscious painter made on the ageing Rembrandt during their sessions together. Rembrandt portrays him with something of the vigour and elegance he used for the *Portrait of a Man holding Gloves* (Fig. 43), but the treatment is less formal as the sitter is a fellow artist. It is interesting to compare this portrait with Van der Helst's *Portrait of Paulus Potter* (Fig. 42) of eleven years earlier. The juxtaposition of the two shows that, once the chiaroscuro is penetrated, the designs of Rembrandt's late commissioned portraits are not so different from those of more fashionable artists of the time as is often supposed. Rembrandt, too, created bold and well-balanced compositions, with confidently articulated forms and an easy, decorative use of the blacks and whites of contemporary costume, relieved by the colour of the sitter's hair. Where he differs is in achieving elegance and expressive power through the chiaroscuro rather than through sweeping, rounded forms and affected poses.

Portrait of a Woman holding an Ostrich-Feather Fan

Signed 'Rembrandt f.166.' Canvas, 99.5 x 83 cm. National Gallery of Art, Washington DC

Fig. 43
Portrait of a Man holding Gloves

c.1666-9. Canvas,
99.5 x 82.5 cm.
National Gallery of Art,
Washington DC

This painting and the companion portrait of the sitter's husband (Fig. 43) seem to belong to the last two or three years of the artist's life. This is suggested by the very strong chiaroscuro, the abstractedness of the facial expressions and the quietness of the poses. On the other hand, it would be unwise to read too coherent a stylistic development into the work of Rembrandt's last decade. In common with most artists, his development slowed down in late middle-age, while his style varied more than before in response to the occasion. During the 1660s, for reasons which remain mysterious, the Amsterdam merchants and upper bourgeoisie returned to Rembrandt for their portraits in some numbers (though fewer than in the 1630s), and he would have considered it inappropriate to use too experimental a manner for such works. While never betraying the essence of his art, he adapted the surface qualities of his style as necessary and became as forceful a portrait painter in the current idiom as anyone. The *Man holding Gloves* and the *Woman holding an Ostrich-Feather Fan* are eloquent testimony to this.

It is not known who the sitters were and it may be suspected that Rembrandt did not know them very well either. He does not show the same insight into character as he had in the portraits of Jan Six or Jacob Trip (Plates 29 and 41). He concentrates rather on characteristics of rank and physical appearance and emphasizes the qualities of formal design. For the man, he uses a low viewpoint and elegantly turned pose, with the body in three-quarter view, the head looking more towards the observer and the hands held rather self-consciously in front of him. It is a type of pose that Van Dyck had made fashionable, and Rembrandt himself had employed it two or three times in the 1630s. The composition of the woman's portrait, though equally graceful, is more specific to its period. The pose is almost frontal, and Rembrandt makes calculated play with the shapes created by the two lighted areas. These form two equilateral triangles, the lower one inverted, with a band of black between them. The very dark backgrounds of both portraits, almost as dark as the black of the clothes, are further striking characteristics.

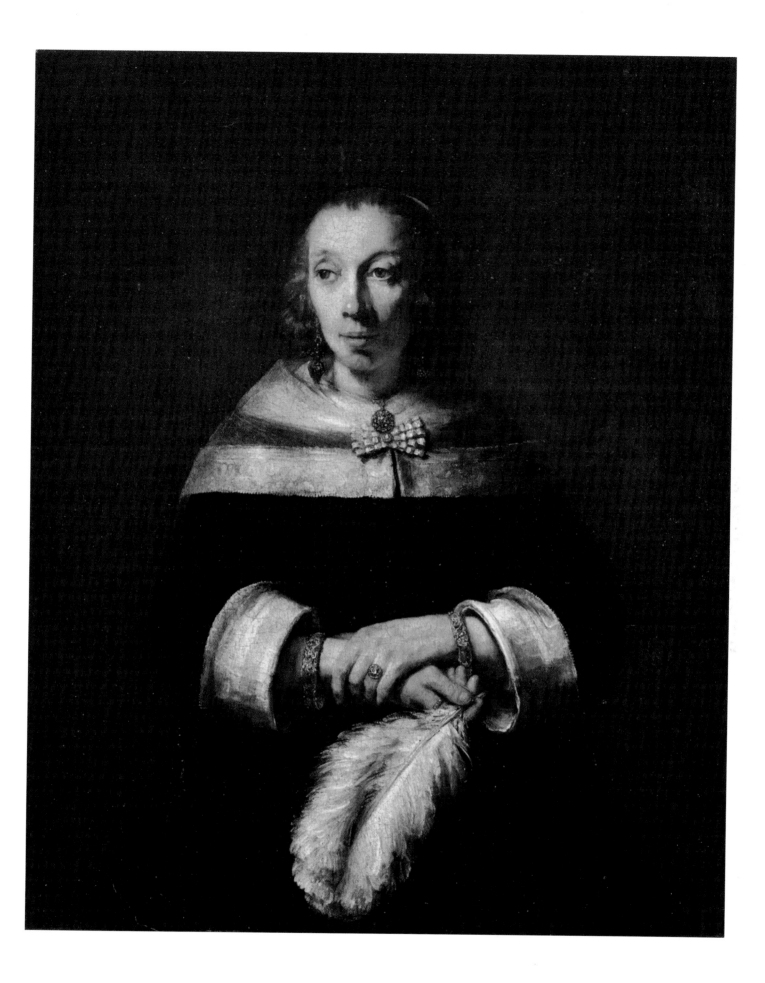

The Jewish Bride

Signed 'Rembrandt f.16..'. Canvas, 121.5 x 166.5 cm. Rijksmuseum, Amsterdam

Like *The Night Watch*, this is another misnamed masterpiece by Rembrandt which it would be insensitive to re-title. To be sure, the painting does not represent a Jewish bridal couple in the sense which the nineteenth century, which invented the title, would have had in mind. The picture would then have been regarded as a romantic costume-piece, its very strangeness and aura of secretiveness suggesting that it showed some exotic rite, which was outside the experience of a predominantly Christian society.

There can be no doubt, however, that an intimate relationship between the two figures was intended by the artist. The man places his hand on the woman's breast, while she moves instinctively to protect her modesty, in the classic pose of the *Venus pudica* which Rembrandt would have known from engravings or casts of classical statues. Yet the couple show every sign of tenderness towards each other, so this is not a common seduction scene (a frequent enough subject in Dutch painting). The theme most widely favoured by modern scholars is Isaac embracing his wife Rebecca while they were being spied on by Abimelech (Genesis, Chapter XXVI), which Rembrandt had previously represented in a drawing (Ben.988). To summarize the Bible narrative, Isaac, staying in the land of the Philistines, passes off Rebecca as his sister, because, if the Philistines had wanted to seduce her and had known she was Isaac's wife, they would have felt obliged to kill him first. One day, Abimelech, the Philistine King, observes the couple from a window making love in secret and guesses the truth, namely that they are man and wife. He reproves Isaac for the deception, pointing out that any man might have lain with Rebecca in all innocence, not realizing she was a married woman, and would thus have brought dishonour on himself and his people.

Rembrandt himself was no stranger to voyeurism, but in this painting he thrusts it into the background. The pair could scarcely be more covered up and they embrace each other gravely and almost chastely. Some critics have supposed the models to be the artist's son, Titus, and Magdalena van Loo, who were married on 10 February 1668. Others, however, have described the man as middle-aged - which only goes to show how unspecific in these matters Rembrandt's works often are.

All this apart, *The Jewish Bride* - to revert to its popular title - is one of Rembrandt's most poetic pictures. In mood it is at once intimate and serene. As a piece of painting it is almost miraculous. The forms are broad yet flattened, as so often in his late period. These forms provide a surface - or rather, a screen - on which countless overlapping brushstrokes of gold and red are laid, the colours increasing or dying away in intensity as they move into or out of the light.

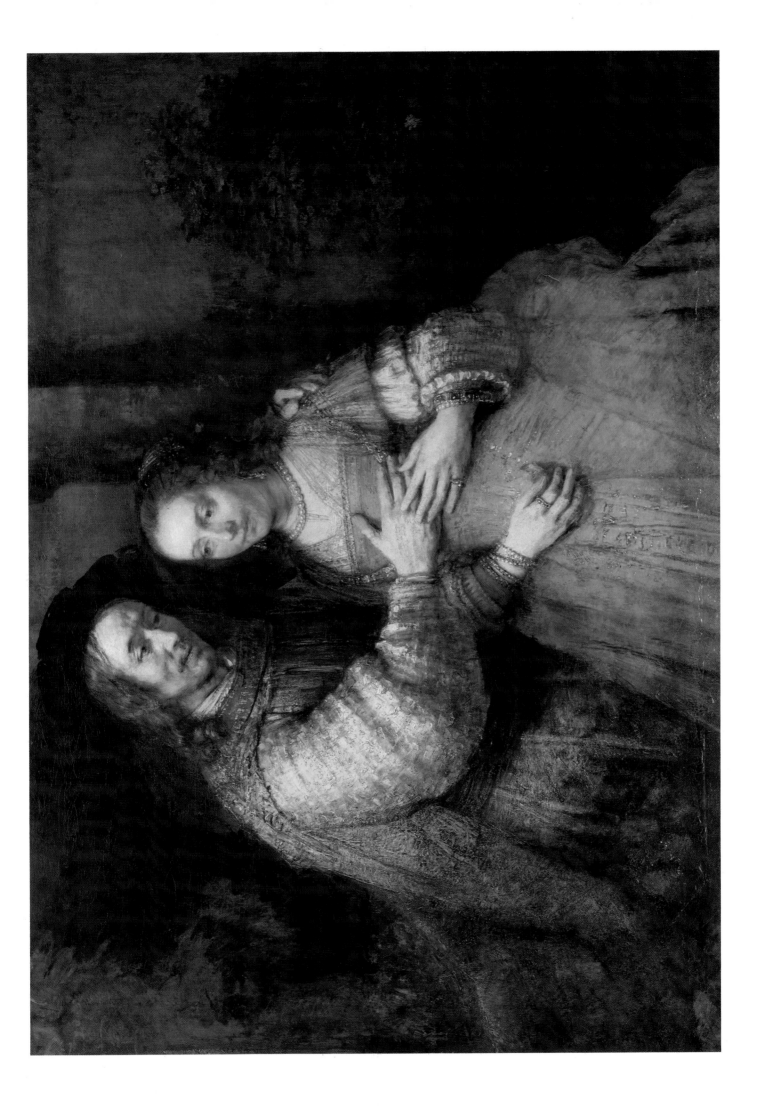

The Suicide of Lucretia

Signed 'Rembrandt f.1666'. Canvas, 111 x 95 cm. The Minneapolis Institute of Arts

Fig. 44
A Woman with an
Arrow

Signed 'Rembrandt
f.1661'. Etching and
drypoint, 20.3 x 12.3 cm.
British Museum, London

The subject is taken from Book I of Livy's *History of Rome*. According to this, the chaste Lucretia was ravished by Sextus Tarquinius, the son of the last king of Rome, and after revealing her defilement to her husband she took her own life. In most paintings of this subject Lucretia is nude, which gives a sly erotic undertone to the situation, but Rembrandt shows her robed to the neck in fine clothes, like the noblewoman she was. In the picture, she has already driven the dagger into herself and has pulled it out, and the blood seeps through her dress. Although her body remains upright she lurches sideways from the hips as she clutches the bell-rope, and her face has the pallor of approaching death. As Michael Hirst has observed (*Burlington Magazine*, CX, 1968, p.221), the pose, set of the head and expression are startlingly reminiscent of Caravaggio's *David with the Head of Goliath* in the Borghese Gallery, Rome. It is not impossible that Rembrandt came across an engraving or copy of this painting, which prompted him to conceive the sombre and pitiful interpretation illustrated here.

The motif of the hand clasping the tasselled rope, however, is a reminder of the common studio practice whereby a model posing with his or her arm raised would support it by means of a rope or sling. Fig. 44 is a late etching by Rembrandt showing this practice, although what was plainly a rope when the artist was working on the figure from the life has been turned, enigmatically, into an arrow with the tip pointing downwards. This etching is a reminder that Rembrandt did not give up his interest in the female nude - and the young female nude at that - in his last years.

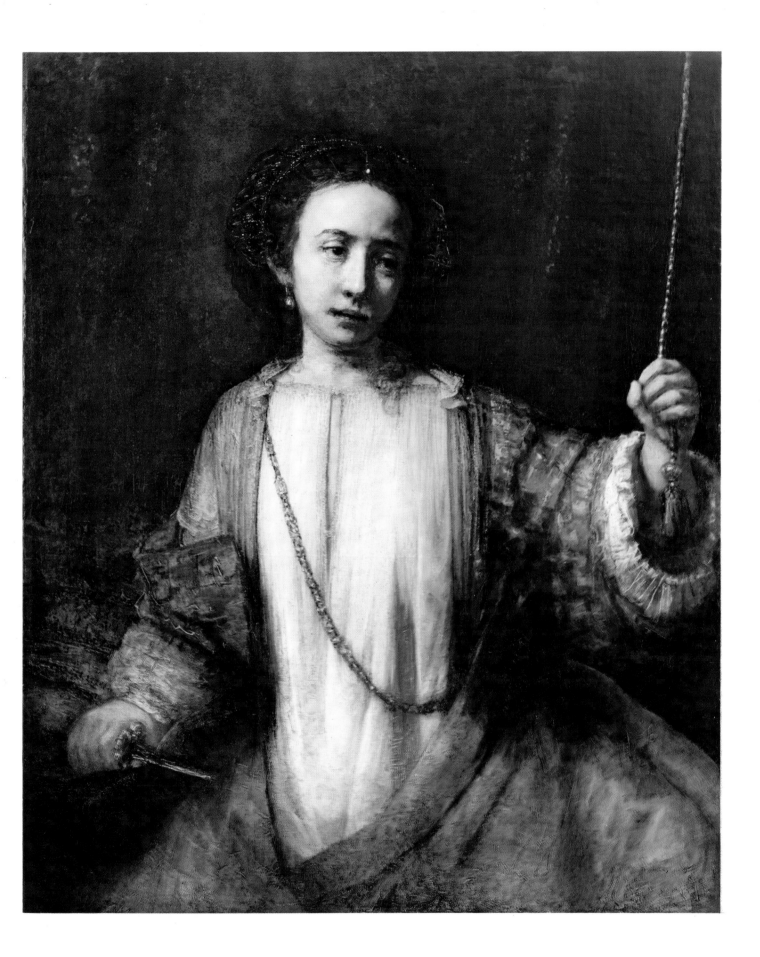

PHAIDON COLOUR LIBRARY
Titles in the series

FRA ANGELICO
Christopher Lloyd

BONNARD
Julian Bell

BRUEGEL
Keith Roberts

CANALETTO
Christopher Baker

CARAVAGGIO
Timothy
Wilson-Smith

CEZANNE
Catherine Dean

CHAGALL
Gill Polonsky

CHARDIN
Gabriel Naughton

CONSTABLE
John Sunderland

CUBISM
Philip Cooper

DALÍ
Christopher Masters

DEGAS
Keith Roberts

DÜRER
Martin Bailey

DUTCH PAINTING
Christopher Brown

ERNST
Ian Turpin

GAINSBOROUGH
Nicola Kalinsky

GAUGUIN
Alan Bowness

GOYA
Enriqueta Harris

HOLBEIN
Helen Langdon

IMPRESSIONISM
Mark Powell-Jones

**ITALIAN
RENAISSANCE
PAINTING**
Sara Elliott

**JAPANESE
COLOUR PRINTS**
J. Hillier

KLEE
Douglas Hall

KLIMT
Catherine Dean

MAGRITTE
Richard Calvocoressi

MANET
John Richardson

MATISSE
Nicholas Watkins

MODIGLIANI
Douglas Hall

MONET
John House

MUNCH
John Boulton Smith

PICASSO
Roland Penrose

PISSARRO
Christopher Lloyd

POP ART
Jamie James

**THE PRE-
RAPHAELITES**
Andrea Rose

REMBRANDT
Michael Kitson

RENOIR
William Gaunt

ROSSETTI
David Rodgers

SCHIELE
Christopher Short

SISLEY
Richard Shone

**SURREALIST
PAINTING**
Simon Wilson

**TOULOUSE-
LAUTREC**
Edward Lucie-Smith

TURNER
William Gaunt

VAN GOGH
Wilhelm Uhde

VERMEER
Martin Bailey

WHISTLER
Frances Spalding